the essential
WILDLIFE
photography manual

Chris Weston

RotoVision

A RotoVision Book
Published and distributed by RotoVision SA
Route Suisse 9
CH-1295 Mies
Switzerland

RotoVision SA, Sales & Editorial Office
Sheridan House, 112/116A Western Road
Hove BN3 1DD, UK

Tel: +44 (0)1273 72 72 68
Fax: +44 (0)1273 72 72 69
Email: sales@rotovision.com
Web: www.rotovision.com

10 9 8 7 6 5 4 3 2 1

ISBN: 2-88046-808-6

Designed by Fineline Studios
Art director Luke Herriott

Reprographics in Singapore by ProVision Pte. Ltd
Tel: +65 6334 7720
Fax: +65 6334 7721

Printing and binding in Singapore by ProVision Pte. Ltd

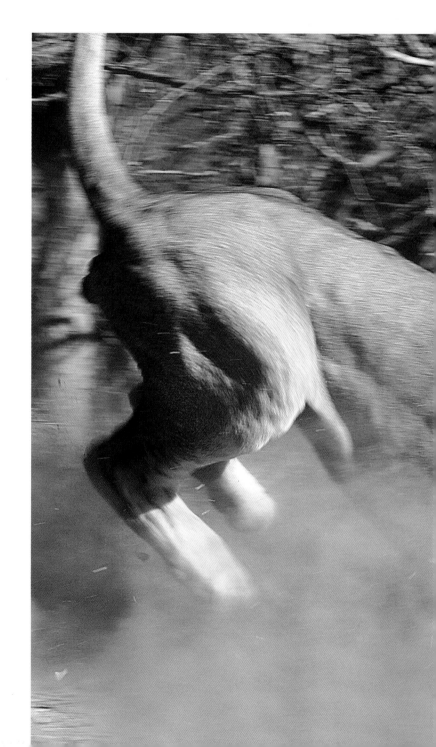

the essential
WILDLIFE
photography manual

Contents

Preface

The wildlife photographer's code of field ethics

On an assignment photographing grizzly bears in Katmai National Park in Alaska, I was working with an eminent field biologist. I had persuaded him, somewhat reluctantly, to take me along the river bed in search of brown bears. Geared up in chest-high waders, we found some bears, and with his help I took some compelling images. Despite the photography going well, after two hours in the river I suggested we leave. "Two hours with me is enough for anyone, let alone a bear," I quipped. The biologist almost fell over in surprise. Later, in the bar, I asked him what had made him so nonplused. He told me he had never before come across a wildlife photographer who put the welfare of the animal ahead of getting the picture.

I tell this story not to blow my own trumpet, but to illustrate how some professionals and associations in the environmental field regard wildlife photographers. Their distrust is well founded. There are known cases where photographers—professionals included—have destroyed sites to ensure exclusivity of their images, and use live bait to capture "once-in-a-lifetime" pictures.

On a smaller but no less harmful scale, and through ignorance rather than malice, protective vegetation is often cut down, leaving nest sites exposed to predators;

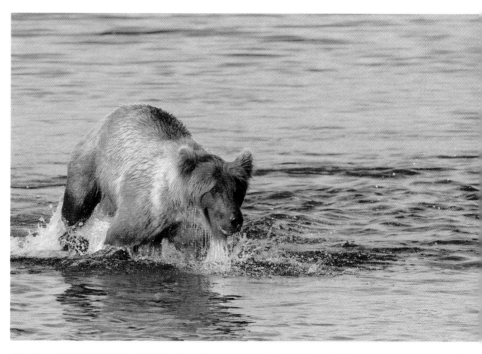

It is impossible to tell how exactly an animal will react to your presence. A rudimentary knowledge and understanding of animal behavior will ensure you're in the position to make the right decisions during close encounters. Nikon D100, 800mm lens, 1/500 sec. @ f/8.

adult birds are disturbed near the nest, causing them to abandon their young; dens are intruded on; and animals are chased and cornered by vehicles. And even if the damage isn't perpetrated by one photographer, careless talk can reveal the location of endangered species to those with fewer scruples. Such acts undermine our reasons for taking photographs of wildlife, and make photographers unwelcome in some places.

No animal should suffer distress simply so that its picture can be taken. Of course, sometimes it's impossible to tell how an animal will interpret our actions, but a knowledgeable photographer learns to recognize the signs of distress, and is the first to back away from a confrontation.

I am reminded of a tale I heard about a photographer who was lecturing on a trip to Africa. He had come face to face with a black rhinoceros. "Don't worry," the photographer assured his audience, "I was escorted by an experienced field ranger who had a rifle in case the rhino charged." A member of the audience raised his hand. "I'm interested," he said. "If the rhino *had* charged, and push had come to shove, do you really think the ranger would have shot you?"

Wildlife photography and the law

Many countries have laws that define the rules by which we should take wildlife photographs. For example, in the United Kingdom it is unlawful to photograph certain bird species at or near their nest without an appropriate license. There are many wildlife laws, and they are subject to continual change. It is the responsibility of the photographer to ensure that he is aware and respectful of the environmental laws of the country he is photographing in. You can obtain information from government embassies or consulates, or by contacting the government ministry in charge of wildlife affairs in the country concerned.

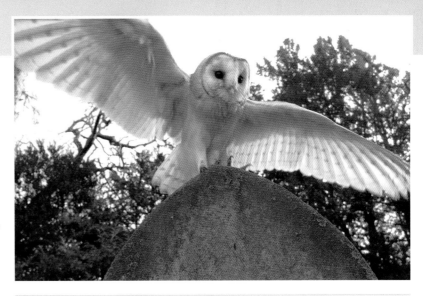

Many countries have laws concerning human interaction with wildlife. In the UK, for example, you'll need a special license to photograph nesting birds such as the Barn owl. Nikon D100, 20mm lens, 1/320 sec. @ f/8.

Wildlife photography and the law— useful contacts

Royal Society for the Protection of Birds (RSPB)
Web site: www.rspb.org.uk
The RSPB, The Lodge, Sandy, Bedfordshire, SG19 2DL, UK
Tel: +44 (0) 1767 680551

BirdLife International
Web site: www.birdlife.net
Wellbrook Court, Girton Road, Cambridge, CB3 0NA, UK
Tel: +44 (0) 1223 277318
E-mail: birdlife@birdlife.org

BirdLife Africa Regional Office
c/o ICIPE Campus, Kasarani Road, off Thika Road, Nairobi, Kenya
Postal address: PO Box 3502, 00100 GPO, Nairobi, Kenya
Tel: +254 2 862246
E-mail: birdlife@birdlife.or.ke

BirdLife Americas Regional Office
Vicente Cárdenas, 120 y Japon, 3rd Floor, Quito, Ecuador
Postal address: Casilla 17-17-717, Quito, Ecuador
Tel: +593 2 453 645
E-mail: birdlife@birdlife.org.ec

Birdlife Asia Regional Office
Toyo-Shinjuku Building, 2nd Floor, Shinjuku 1-12-15, Shinjuku-ju, Tokyo 160-0022, Japan
Tel: +3 3351 9981
E-mail: richardg@indo.net.id

Birdlife European Community Office (ECO)
Rue de la Loi 81A, B-1040 Brussels, Belgium
Tel: +32 2280 08 30
E-mail: bleco@birdlifeeco.net

Birdlife Middle East Regional Office
c/o Royal Society for the Conservation of Nature, PO Box 6354, Amman 11183, Jordan
Tel: +962 6 535 5446
E-mail: birdlife@nol.com.jo

US Fish & Wildlife Service
Web site: www.fws.gov
Tel: 1-800 344 9453 (within US only)

The Wildlife Trusts
Web site: www.wildlifetrusts.org
The Kiln, Waterside, Mather Road, Newark, Nottinghamshire, NG24 1WT, UK
Tel: +44 (0) 870 036 7711

A genuine passion for Nature and her ways should be the motivation for your wildlife photography. Nikon D2H, 80–400m VR lens set at 400mm, 1/350 sec. @ f/8.

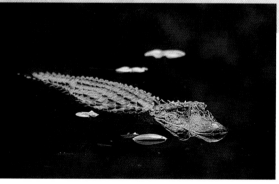

Photography is an art, and subject to the same design principles that govern any other art form. Knowing how to manipulate the elements of design into a cohesive whole will help you create aesthetically pleasing images. Nikon F5, 300mm lens, 1/250 sec. @ f/11, Fuji Provia 100F.

Learning how to find and stalk animals in the wild is an important aspect of improving your wildlife photography. Nikon D2H, 24–120mm VR lens set at 65mm, 1/320. sec @ f/11.

Introduction

Since turning professional in 1998, and for many years previously, I have had the privilege of traveling through the world's wildest and most beautiful regions, photographing majestic and enigmatic creatures, some of which may become extinct within my lifetime.

It is, perhaps, the greatest job on earth—to witness first-hand the intricate beauty of nature through the viewfinder of a camera. Nothing compares with the thrill of seeing a cheetah in full-speed pursuit, witnessing the delicate care of a crocodile with her young, or laughing at the clumsiness of a yearling grizzly bear learning to catch salmon. Wildlife photography is about so much more than simply taking pictures. It is a passion that fills our senses and, for moments or lifetimes, leaves us humbled by the sheer wonder of it all.

In the beginning, most of my photographs were instinctive. I was in the right place at the right time—though more by luck than judgement—and somehow managed to coerce the appropriate camera functions to realize decent images. I was happy if, out of a 36-exposure film, I managed to achieve two good shots.

However, it wasn't long before my imagination caught up with me, and my desire to learn and expand my knowledge took over. I studied books and read magazines. I learned from my own mistakes, correcting them through hours of dedicated practice in the field. I sought inspiration from the world's pre-eminent wildlife photographers, and honed my skills so that I might emulate their success.

I soon realized that photographic skill and camera technique alone do not create compelling images. A genuine passion for nature, and an understanding of its ways, is intrinsic to emotive and informative photography. All told, it has been a long and intriguing journey, and one that I will continue. But over the years I have learned enough to carve out a career as a wildlife photographer.

It is this knowledge that I want to share with you in this book. From the basics of choosing the best equipment, through mastering photographic and camera techniques, to coping with hostile environments, plus practical hints and tips on field craft, you will find everything you need to shoot like a professional.

Wild events happen in moments, and being adept in photographic and camera techniques will give you the opportunity to capture the images you see in your mind's eye. But the skills of the great wildlife photographers aren't measured simply in terms of technical ability and practical application. Wildlife photography is an art, and so subject to the laws of craft and design, the fundamental elements of which are covered in this book. Learning to interpret the image space as an artist views his or her canvas is essential in creating emotive images.

Whether you photograph wildlife in faraway places, or simply enjoy photographing creatures in your own backyard, this book will help you capture them in a way that transcends the ordinary. I hope, in some small way, it also encourages you to do more of what you love.

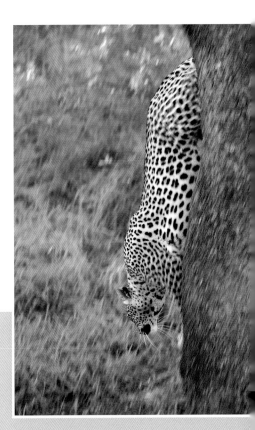

» I had less than one second to capture this image. Instincts born of field practice made certain I did. Nikon D2H, 80–400mm VR lens set at 80mm, 1/90 sec. @ f/4.5.

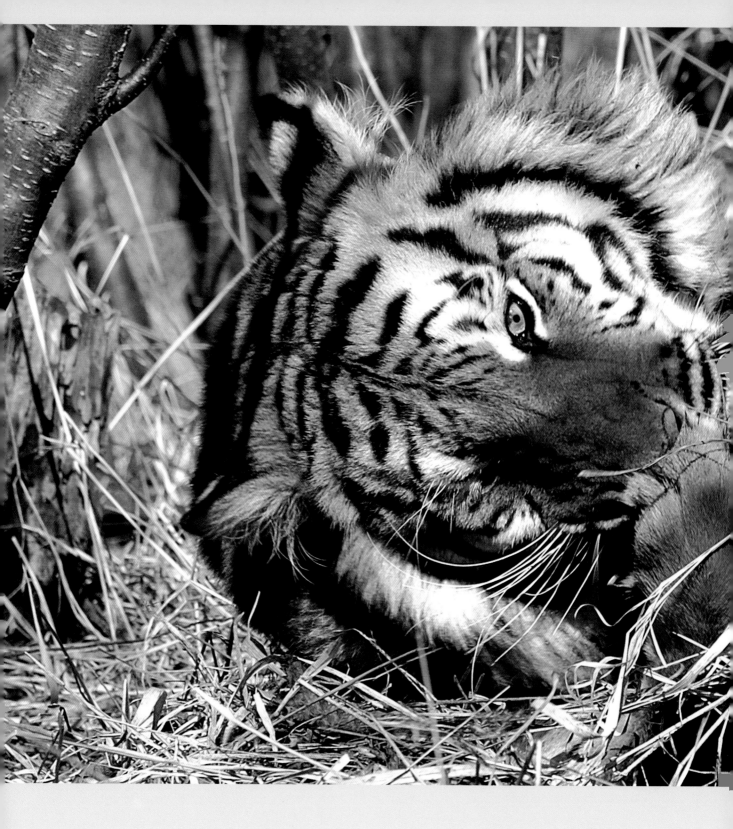

The camera body

When buying a camera, first and foremost, it must meet your personal needs—does it feel comfortable to hold, and do you find it easy to work with and operate? The camera I use not only provides the system back-up and quality I need, but it just feels right. Other brands might provide greater flexibility for my style of work, but I simply don't feel at home with them.

Your personal style of wildlife photography will also influence your choice of camera and system. For instance, if you intend to hike across the wilderness for days on end, a lightweight system will be desirable. If you intend to photograph just birds, then fast, responsive auto-focus is essential. And if you plan on going into hostile environments, then a full-specification professional model will be needed, just to survive the journey. Consider all these kinds of questions before making your selection.

Modern cameras, such as this professional-specification Nikon F5, are ideal for photographers serious about imaging wildlife. Top-of-the-range functionality means that missing the shot is usually down to user error.

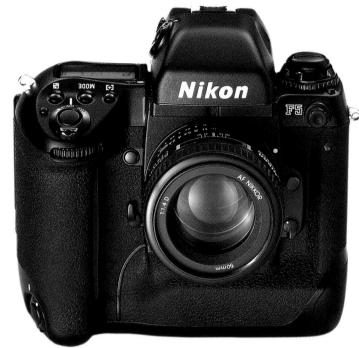

To capture this Griffon vulture in flight, I used the responsive auto-focus (AF) function in my Nikon F5 camera. AF has made photographing fast action a simpler task. Nikon F5, 800mm lens, 1/1000 sec. @ f/5.6, Fuji Provia 100F.

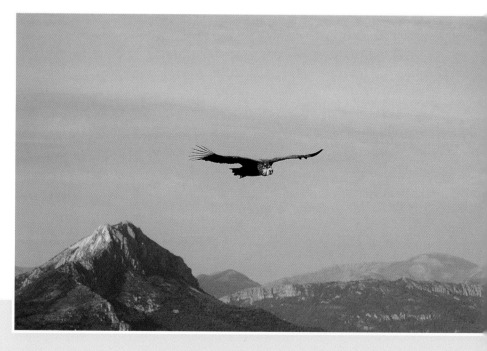

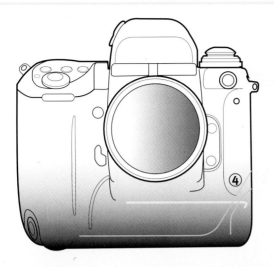

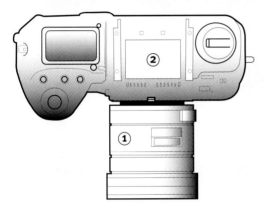

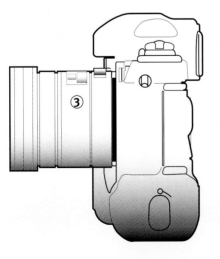

What your camera should have

A camera intended for wildlife photography should have the following specifications and features:

- A wide range of interchangeable lenses ①

- Resistance to water, moisture, dust, and shocks

- Viewfinder coverage between 95–100% ② of the picture space

- Auto-focus system with focus sensors that ③ can be selected independently, and a "continuous" AF mode (see page 14)

- Auto-exposure system with both multi-segment and spot metering modes

- Fast top-end shutter speeds (a minimum of $1/1000$) and high-speed flash synchronization (up to $1/250$ or more)

- Auto-bracketing in $1/3$ or $1/2$ stops

- Exposure compensation

- Through-the-lens (TTL) flash metering

- Aperture-priority, shutter-priority, and manual metering modes

- High burst rate (digital cameras only)

- Manually adjustable white balance settings (digital cameras only)

- Compatibility with "professional" compact flash cards for fast write speeds (digital cameras only)

- Instant shutter release with no time lag (digital cameras only)

- Silent motor drive and film rewind ④ (film cameras only)

Features and functions

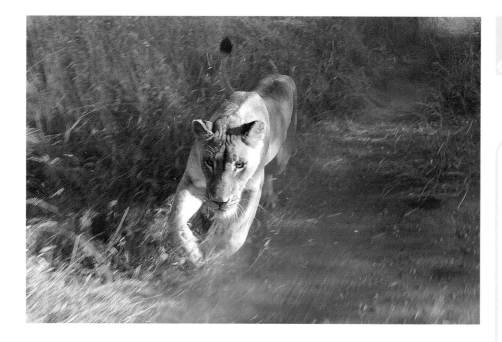

When photographing subjects on open ground, a wide-area AF sensor helps to keep the subject in focus. Nikon D2H, 24–120mm VR lens set at 45mm, 1/160 sec. @ f/8.

AUTO-FOCUS (AF)

Wildlife photography often involves snapping fast-moving creatures, and the ability of the auto-focus (AF) system to keep up often makes the difference between getting the shot and not. Some AF systems are faster than others, and AF speed can also depend on the lens used.

Canon has long been the AF market leader, but Nikon's latest design has raised the stakes somewhat. An important feature of an AF system is the type of sensor available. For fast-moving animals on open ground, a wide-area sensor will help keep the subject in focus. In undergrowth, however, the opposite is true, and you will need to be able to switch to a very selective sensor. Otherwise, you'll find the AF system spends too much time "hunting," and the moment is lost.

Some of the more sophisticated AF systems have a function known as focus tracking, where the camera literally follows the movement of the subject, switching between AF sensors automatically to keep the animal in focus, even if it momentarily moves out of sight. This facility is invaluable for some subjects, particularly birds in flight and animals giving chase.

AF modes

Some of the more advanced AF cameras come with two different AF modes: single and continuous servo. Which mode you select will depend on what you're shooting.

Single-servo mode

In single-servo AF mode the camera first detects focus and then locks focus until the shutter is fired or the shutter-release button is released. If the subject moves away from the point of focus after focus has locked, focus distance remains unchanged and the subject will become out of focus. Priority is usually given to focus, and the shutter will only activate once focus is locked. This setting is ideal for static subjects, such as animal portraits.

Continuous-servo mode

When continuous-servo AF mode is selected, the camera will detect focus but focus remains unlocked. If the subject moves away from the point of focus the AF system will track the movement of the subject within the picture frame, adjusting focus as necessary to keep the subject in focus. Priority is usually given to the shutter, and the shutter will activate whether or not the subject is in focus. This is an ideal setting when photographing fast-moving and erratic-moving subjects, such as birds in flight.

To capture this impala I switched to a selective AF sensor to avoid AF "hunting"—a common problem when photographing subjects in undergrowth. Nikon F5, 80–400mm VR lens set at 300mm, 1/500 sec. @ f/5.6, Fuji Provia 100F.

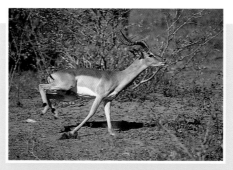

AUTO-EXPOSURE (AE)

Auto-exposure (AE) systems are now highly sophisticated, which means that most images today are well-exposed. Multi-segment metering divides the image space into different areas (the number of areas will depend on the camera model.) It then analyzes the light pattern and compares it with a database of images stored in the camera's memory before selecting an exposure based on the closest match. This system is highly effective, and under normal lighting conditions is relatively foolproof.

For more complex lighting situations, such as high-contrast scenes (perhaps a dark animal against a backdrop of snow, or a white animal in very bright sunlight,) you'll need to take more control over the exposure settings. In these cases, it is useful to have a spot metering facility, which allows you to meter a tiny portion of the picture space (often as little as 2%,) and base your exposure on that light reading.

Other features may also come into play here, such as exposure compensation and auto-bracketing (taking the same shot at different exposure settings,) and sometimes it is better to switch the camera to manual mode. But, however you arrive at the appropriate settings, you'll need a camera that gives you the flexibility to control exposure as you see fit.

The digital histogram

One of the great photographic advances brought about by the advent of digital-capture technology is the histogram. This is a graphic representation of the tonal range of an image. Basically a bar chart, each vertical bar represents the number of pixels having a given brightness value. The far left of the chart represents black (value = 0,) and the far right represents white (value = 255.) The middle of the chart is the equivalent of medium-tone gray.

You can use the histogram in the field to evaluate the accuracy of your exposures. If the histogram is skewed to the left, then the image is underexposed. If it is skewed to the right, the image is over-exposed. In digital photography, this is the worst-case scenario, since burned-out highlights retain no value and so cannot be processed post-camera using image-processing software. An ideal exposure is one where there is an even spread of tones between black and white.

Learning to use the histogram in the field will greatly aid your ability to capture perfect images every time. If time and opportunity allow, I usually run some test shots and check the histogram values before I get down to serious shooting. In changing lighting conditions, I will repeat the process whenever I get the chance.

Interpreting the histogram

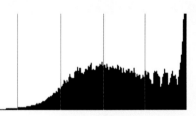

1. The high proportion of pixels to the extreme right of the histogram, and a lack of data in the shadow area indicates an overexposed image.

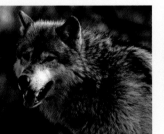

2. The high proportion of pixels to the extreme left of the histogram, and a lack of data in the highlight area indicates an underexposed image.

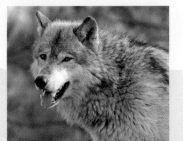
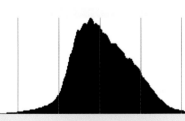

3. An even spread of pixels across the histogram, with a peak in the mid-tone area, shows a well-exposed image with a full tonal range.

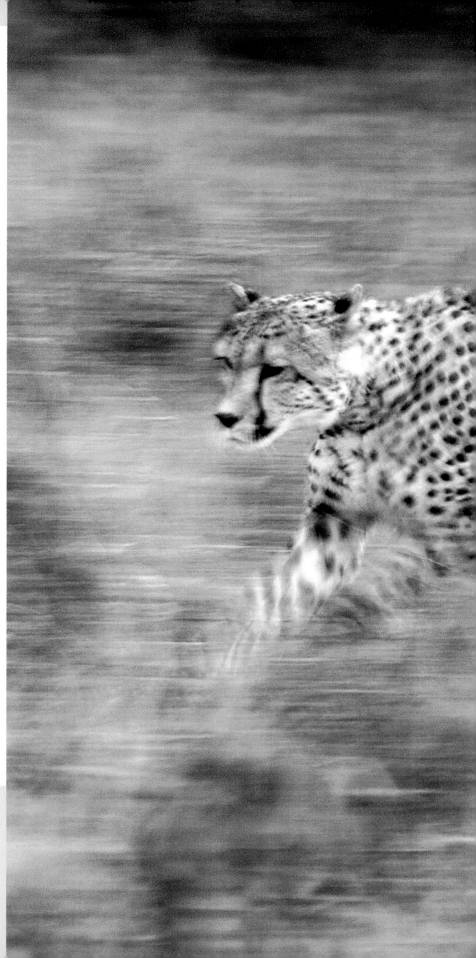

SHUTTER

The shutter controls the length of time the film or digital pixel sensor (DPS) is exposed to light. How accurately it does this will affect the quality of your photographs. Professional cameras have shutters that are manufactured using stronger materials, such as carbon fiber, than the so-called amateur models, which are often constructed from plastic. Some of the more sophisticated cameras (e.g. Nikon's F5) have a self-diagnostic system that constantly monitors the accuracy of the shutter and automatically makes adjustments when needed.

Most shutters work using a system of two "curtains." The first uncovers the film/DPS to allow exposure, while the second covers the film/DPS to close exposure. To achieve very fast shutter speeds, the second curtain starts to cover the film/DPS before the first curtain has travelled all the way across it, creating a traveling window of light.

The point at which the whole frame is exposed determines the flash synchronization speed. In many cameras this speed is 1/125, but more recent cameras have a flash synchronization speed upwards of 1/300.

Use the shutter to control the length of time the film/DPS is exposed to light and, therefore, how movement is depicted in your images. Nikon D2H, 24–120mm VR lens set at 120mm, 1/30 sec. @ f/5.6.

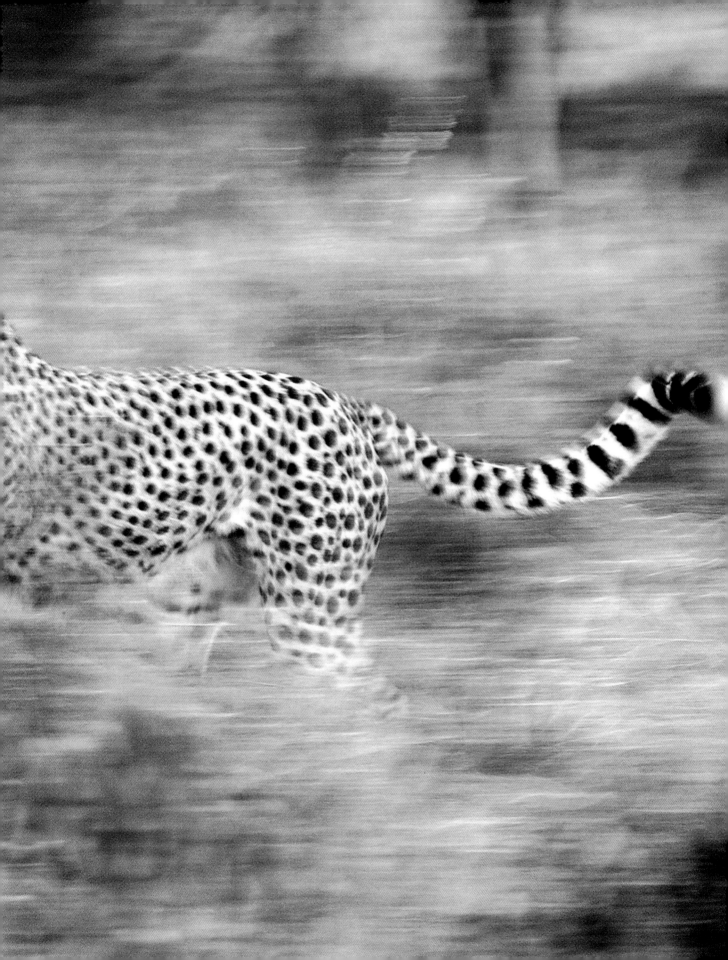

CONTINUOUS SHOOTING AND BURST RATE

Nearly all modern SLR (single-lens reflex) cameras now have an automatic frame advance, usually operating in two modes: single and continuous.

Continuous frame advance allows you to take a sequence of pictures simply by holding down the shutter release button. In professional-specification cameras, this can be at speeds of up to 10 frames per second (fps). In less sophisticated cameras, it is likely to be closer to 3fps. While high-speed frame advance isn't always necessary, it does allow you to capture images that would have been impossible in the past.

When considering digital cameras, another aspect comes into play—burst rate. The burst rate of a digital camera determines how many images can be exposed before the memory buffer in the camera is full and data must be downloaded to the memory card. In early digital models, this rate was quite low, and so very limiting for fast-action photography. More recent models, however, have higher burst rates of 25–40 shots in succession—about the length of a roll of film.

BUILD QUALITY

Wildlife photography will almost certainly put your camera to the test. It will have to cope with inclement weather, dust, moisture, and other camera-hostile elements. Not all cameras are built in the same way, and some are more up to the task than others.

Professional-specification cameras are more likely to withstand wear and tear, be manufactured using strong but lightweight materials, such as magnesium alloy, and have complex sealing systems to keep dust out of openings.

Such added toughness isn't always necessary, but if you're going to be spending a lot of time in areas not meant for precision electronics and processors, then it may be worth the extra investment.

A word on digital

One of the differences between film cameras and digital cameras is the amount of work that is done in camera. Photography is a two-part process— image-capture and image-processing. Both film and digital cameras capture the image, but only in a digital camera can image-processing take place.

Between the DPS and the storage device of a digital camera, a digital image passes through a microprocessor. This processor can be set to perform a number of actions, including sharpening, tone control, noise reduction, and setting the color space. How the camera handles these processes will greatly influence the quality of the output image from a digital camera, and is one reason why digital image quality cannot be determined by megapixel count alone.

Continuous automatic frame advance can be used to capture sequences of images that highlight behavioral characteristics. Nikon D2H, 300mm lens, 1/250 sec. @f/11.

Lenses

Lenses come in all shapes and sizes. Knowing when to use which lens will help you create compelling images.

In general, there are five things you should consider when buying lenses: lens mount; focal length; speed; quality; and price. Arguably, wildlife photographers use long focal length lenses more than any other, and in the past the cost of these lenses has been prohibitive to all but professionals and very keen enthusiasts. However, it is now possible to get long lenses at reasonable prices, although you will have to compromise in other areas, such as lens speed and performance.

Perspective

Wildlife photography isn't just the realm of the long-lens photographer. Switching to shorter focal lengths and even to wide-angle lenses can create stunning effects that help your images stand out from the crowd. Choosing lenses is always a question of deciding on perspective and the effect you want.

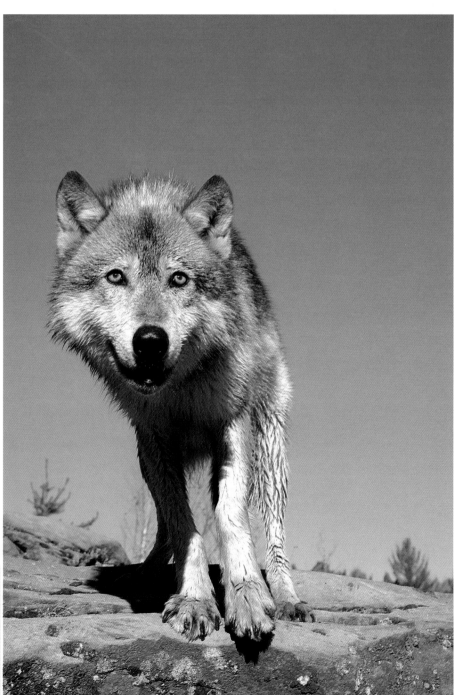

To create this jarring image of a lone wolf, I got in close and used a wide-angle lens. Using lenses to alter your perspective will enhance your pictures. Nikon D2H, 24–120mm VR lens set at 35mm, 1/800 sec. @ f/8.

Proprietary versus independent lenses

The majority of camera manufacturers have their own lens-mount design. This means that once you've bought a camera body, you pretty much have to use lenses from the same manufacturer. For example, you can't use a Nikon lens on a Pentax body. Although there are purpose-made converters that allow you to interchange lenses and cameras from different manufacturers, in all cases you will lose any automatic and electronic functions, and the lens will only operate in full manual mode.

As well as own-brand lenses, some independent lens manufacturers build lenses for many camera makes, notably Nikon, Canon, Pentax, and Minolta. These independent manufacturers, such as Tamron, Tokina, and Sigma, have agreements with the proprietary companies to use the patents for their particular lens mount, so enabling compatibility. In the past, lenses from the independents were believed to lack the quality of the own-brand equivalents, and were sold as a cheaper alternative. Today, most independents produce two ranges of lens, one aimed at the professional market, and the other at the amateur market. I have tested some of the former against my own own-brand lenses and have been pleasantly surprised by the quality of the results.

Independent lens manufacturers produce a range of lenses to fit most popular camera makes. Many have a "professional" range, such as Tokina's ATX and Sigma's EX models.

In looks alone, it is often impossible to tell the difference between a proprietary and non-proprietary lens. Usually, the difference is in the optical quality of the glass used during manufacture.

Lens speed

The speed of a lens is determined by its maximum aperture, and refers to its ability to gather light. The larger the maximum aperture, the more light it can gather, and the faster the lens is said to be.

The advantage of a fast lens to the wildlife photographer is greater choice in selecting exposure settings—the faster the lens, the faster the potential shutter speed. Most professional lenses will have fast apertures (f/4 or f/2.8 for super-telephoto lenses, and f/2.8, f/2 or even f/1.8 for shorter focal length lenses). Those aimed at the enthusiast market tend to have f/5.6 as their fastest aperture.

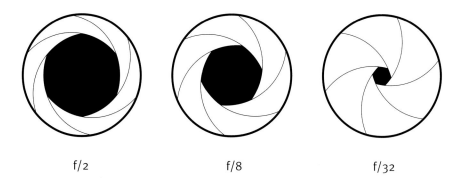

f/2 f/8 f/32

The diaphragm controls the aperture of the lens. The larger the aperture range, the greater versatility you have in the field.

Despite a low level of woodland light, using a "fast" lens has allowed me to set a fast shutter speed that has frozen the action of this running wolf. Nikon D2H, 24–120mm VR lens set at 90mm, 1/640 sec. @ f/8.

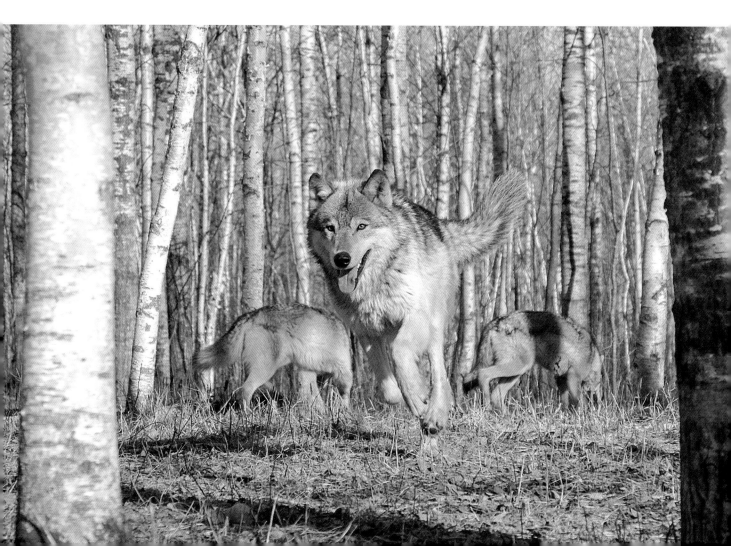

The difference is not just in price, though this can be significant (a 300mm f/2.8 lens is likely to cost about $4,000/£2,230, compared to $800/£445 for a 300mm f/4,) but also in size and weight. To achieve a maximum aperture of f/2.8 on a 300mm or 400mm telephoto lens takes an enormous front element and lots of glass, while the same focal length lens with a maximum aperture of f/4 or f/5.6 will be far smaller and easier to use in the field.

Which you decide to opt for will depend on where you're prepared to compromise. If portability is more important than speed, then the slower lens should be your choice. But, if getting the image at all costs is more important, then you may prefer to fork out the extra few thousand bucks and suffer the extra weight.

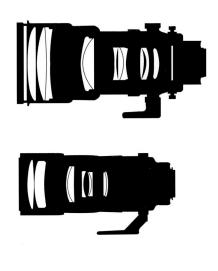

The speed of the lens will affect its size and weight. Compare these two 300mm lenses, one an f/2.8 (large.) the other a 1-stop slower f/4 (small.)

Prime lenses versus zoom lenses

Historically, prime lenses (those that have a fixed focal length) were of far superior quality to zoom lenses. This was because of the extra glass needed in the latter, and the necessary physical movement of the optics inside the lens to alter focal length. Modern lens design has greatly improved the optical quality of zoom lenses, and their versatility can provide distinct compositional advantages.

If opting for a zoom lens, I would steer clear of those with a wide focal length range, such as 28–300mm and 50–500mm, as their extreme nature will only degrade image quality. Prime lenses are still the preferred option for image quality, and the only real option at the super-telephoto end of the optical spectrum (500mm, 600mm, and 800mm).

Optics explained

The lens focuses the rays of light reflecting off a subject onto the film/DPS. It uses anything from a minimum of one lens element (usually in very inexpensive cameras) up to many elements to optimize the transmission of the image.

The focal length is the distance between the optical center of the lens (not necessarily the same as the physical center) and the film/DPS plane, or focal point. Focal length is described in millimeters (mm), and is related to the magnifying power of the lens. In 35mm film photography, a 50mm lens is referred to as a "standard" lens because it is closest to the human field of vision. (In fact, 43mm—the diagonal of the 35mm frame—is the true equivalent to human vision, but 50mm was decided upon by the manufacturers to avoid complicating the issue.)

With the standard set at 50mm, a 100mm lens magnifies the image two times, the 200mm four times, and so on. Below 43mm a lens is referred to as wide-angle. Below 24mm, it is a super wide-angle. A lens above 60mm focal length is said to be telephoto. Above 300mm, it is super-telephoto.

The speed of a lens is determined by dividing its focal length by the diameter of the front element. So, a 200mm lens with a front element of 50mm will have a maximum aperture (lens speed) of f/4 (200/50 = 4). The same aperture for a 600mm lens would require a front element of 150mm, which is why fast super-telephoto lenses are so big.

You can adjust the amount of light passed by the lens by adjusting the aperture. This is done using a mechanical diaphragm. The diaphragm opens and closes the iris to make it larger or smaller, and is controlled by a rotating ring on the lens barrel or, more commonly with modern cameras, via a command dial on the camera.

Lens aperture is represented by a series of markings known as f-stops or stops—typically f/1.8, f/2, f/2.8, f/4, f/5.6, f/8, f/11, f/16, f/22 and f/32. These rounded values correspond to the focal length and aperture diameter, and the area of the aperture doubles with each increase in stop. For example, an aperture of f/2.8 lets in twice as much light as an aperture of f/4).

Optical stabilization lenses

A recent development in image quality control are optical stabilization lenses. These lenses, currently produced only by Canon (Image Stabilization), Nikon (Vibration Reduction), and Sigma (Optical Stabilization), compensate for the photographer's movements using a series of in-built motors to minutely adjust the lens elements. They allow hand-holding of the camera at relatively slow shutter speeds without causing the traditional image blur from camera shake. They have undoubtedly opened up new opportunities for wildlife photographers and made photographing subjects such as birds in flight far easier.

In low-light conditions, when using a tripod is not an option, image stabilization lenses are a successful alternative for ensuring a sharp image. Nikon D2H, 24–120mm VR lens set at 120mm, 1/320 sec. @ f/11.

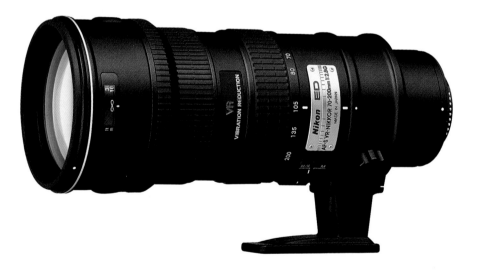

Optical stabilization lenses use a system of motors to counteract the effect of camera shake. Used knowledgeably, they can increase hand-holding capability by about 3-stops.

Konica-Minolta anti-shake technology

Rather than building image stabilization technology into its *lenses*—as is the case with Nikon, Canon, and Sigma—Konica-Minolta has introduced its equivalent technology, anti-shake technology (AST,) into some of its *camera bodies* instead. This has the significant advantage of stabilizing the image irrespective of the lens used. Konica-Minolta claims it allows hand-holding up to shutter speeds three times slower than normal. I haven't tested this system but, knowing the technology derives from the video world, its benefits are apparent.

Alternatives to super-telephoto lenses

Teleconverters are an inexpensive means of acquiring extra focal length. They fit between your existing lens and the camera body, and increase focal length by a factor of 1.4x, 1.5x, 2x, or 3x, depending on the model used. For example, a 300mm lens with a 2x teleconverter will give you a focal length of 600mm.

There are some downsides to this set-up, though. Firstly, teleconverters reduce image quality because of the extra glass the light has to pass through. Secondly, you will lose some light because of the extra distance between the image plane and the lens. Typically, this equates to minus 2-stops for a 2x converter, and minus 1-stop for a 1.5x converter. So, a lens with a maximum aperture of f/5.6 will have an effective maximum aperture of f/11 with a 2x converter fitted, or f/8 with a 1.4x or 1.5x converter.

However, as an economical alternative to telephoto lenses, they can produce some excellent results, and I would recommend carrying one with you for bird photography and photo safaris in regions such as Africa.

Tip!

Teleconverters and depth of field
When using a teleconverter, how much of the image appears sharp (depth of field) is affected by the increase in focal length and change in aperture. There is no discernable difference in depth of field when using a 200mm lens with a 2x converter at, say, f/5.6 (which becomes f/11 when the light reduction factor is applied), compared with a 400mm lens set at f/11.

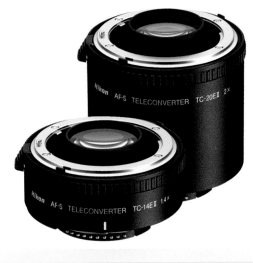

Teleconverters are an inexpensive alternative to buying super-telephoto lenses. They come in two main sizes: 1.5x and 2x multipliers. (1.7x and 3x are also available from some manufacturers.)

Tip!

Teleconverters and minimum focusing distance
The minimum focusing distance of a lens is unaffected by the addition of a teleconverter, which can be exploited particularly in close-up and macro wildlife photography.

I purposefully used a teleconverter on this shot to exploit the minimum focusing distance of the shorter focal length lens. Nikon D2H, 400mm lens, with 2X converter, 1/125 sec. @ f/5.6.

Focal length, magnification, and perspective

Lenses come in varying focal lengths, from super wide-angle to super-telephoto. The focal length will determine image magnification. For example, a 50mm lens has an image magnification factor of 1. A 100mm lens will double the size of the image (magnification factor 2x), a 200mm lens will quadruple the size of the image (magnification factor 4x), and so on up. A 24mm wide-angle lens, on the other hand, will roughly halve the size of the subject in the frame (magnification factor 0.5x), and a 12mm lens will reproduce an image a quarter of the size of a 50mm lens (magnification factor 0.25x). When photographing small animals or subjects that are some distance away, a telephoto lens will magnify the subject so that it takes up more of the image space.

More than increasing subject size, however, your choice of focal length will also influence perspective and spatial relationships. By moving closer to your subject with a wide-angle lens you can maintain subject size in relation to the image space, but completely alter the relationship the subject has with its surroundings. A wide-angle lens increases the space between pictorial elements, giving a perception of wide-open spaces. A telephoto lens, on the other hand, compresses the distance between objects, and so isolates a subject from its surroundings.

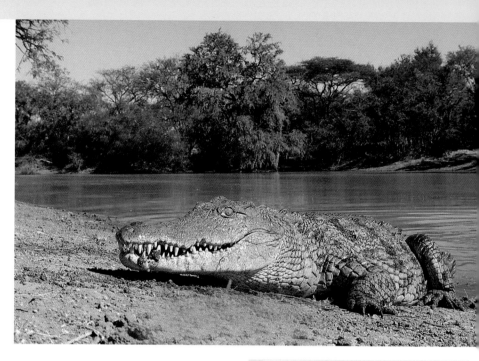

Here, I used a wide-angle lens to accentuate the feeling of wide-open space. Wide-angle lenses increase spatial relationships. Nikon D2H, 24–120mm VR lens set at 24mm, 1/500 sec. @ f/8.

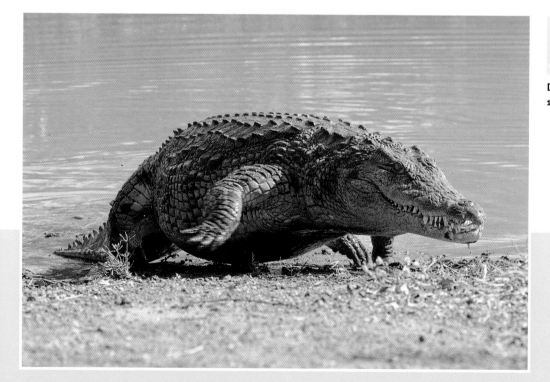

A longer focal length lens has isolated the crocodile from its surroundings, giving the image a very different appeal. Nikon D2H, 80–400mm VR lens set at 102mm, 1/320 sec. @ f/11.

In these two images, the subject fills about the same proportion of the picture space, yet the visual impact varies considerably. Here, I have given the image of the lion cub a sense of place. Nikon D100, 24–120mm lens set at 120mm, 1/350 sec. @ f/8.

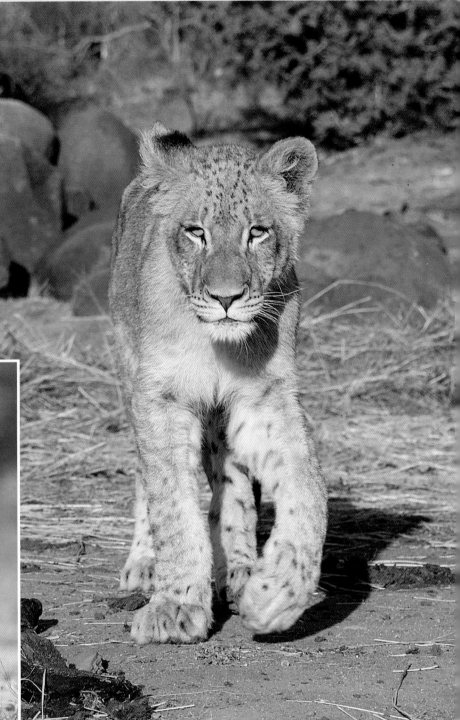

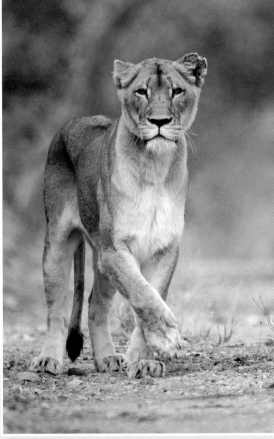

Switching to a longer focal length for the image of the lioness, however, has placed the emphasis on the subject. Nikon D100, 800mm lens, 1/350 sec. @ f/5.6.

A word on digital

Many digital cameras boast a focal length "magnification factor" due to the reduced size of the DPS compared with 35mm film. (This is not true of "full-frame" digital sensors, which are the same size as a 35mm film frame.) This is seen as a real advantage for wildlife photographers because a 400mm lens has an effective focal length of 600mm.

However, this increase is achieved by reducing the field of view, not by changing the actual focal length of the lens. It's important, then, to realize that the physical size of the subject will remain unchanged. For example, if you photographed a lion with a 35mm film camera and a 400mm lens, and the image of the lion on the film was 18mm in height, it would still be 18mm if photographed with a small-frame digital camera with a 400mm lens, although the reduced field of view would remove some of the visible space around the lion.

This distinction is important when it comes to enlarging the image, as both the film and digital images would require the same amount of enlargement to produce a print where the lion was, say, 180mm in height—that is, 10 times the original.

Focal length conversion chart

Use the table below to ascertain the 35mm equivalent focal length for different film/digital formats.

Format	35mm	6x45 MF	Full frame digital	Nikon DX digital	Canon non-full-frame digital	Four Thirds Digital
Effective FL magnification factor	1x	0.6x	1x	1.5x	1.6x	2x
Focal length in mm	20	12	20	30	32	40
	24	14.4	24	36	38.4	48
	28	16.8	28	42	44.8	56
	35	21	35	52.5	56	70
	50	30	50	75	80	100
	70	42	70	105	112	140
	80	48	80	120	128	160
	105	63	105	157.5	168	210
	135	81	135	202.5	216	270
	180	108	180	270	288	360
	200	120	200	300	320	400
	210	126	210	315	336	420
	300	180	300	450	480	600
	400	240	400	600	640	800
	500	300	500	750	800	1000
	600	360	600	900	960	1200
	800	480	800	1200	1280	1600

Angle of view

The same focal length lens used with a 35mm film camera and a small-frame digital camera will produce a different angle of view with each format.

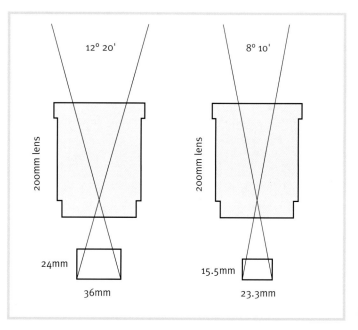

This illustration shows the effect of using a lens designed for a 35mm film camera on a small-frame digital camera. Although focal length remains the same in both formats, the smaller size of the photo-sensor, compared to 35mm film, leads to a reduced angle of view, making subjects appear closer to the camera.

This picture of an Eagle owl shows the telltale signs of fill-in flash—catch lights in the eyes, which add life to dark pupils and are an important consideration for anyone wanting to sell their photographs. Nikon D100, 80–400mm VR lens set at 400mm, 1/60 sec. @ f/8, built-in Speedlight.

FLASH

Like lenses, flash units are produced for specific cameras by the same manufacturer or by independent companies. Compatibility is the most important consideration, as systems work by passing information between the flash unit and the camera. While compatibility is assured with an own-brand model, not all independently manufactured units are that compatible.

Check out reviews on web sites and in photography magazines, and always read the specifications carefully. Flash speeds written as "1/30,000 sec" rarely match with reality, where a figure half that is more typical—and 1/15,000 isn't fast enough to freeze the rapid motion of a Hummingbird's wings, or a snake striking.

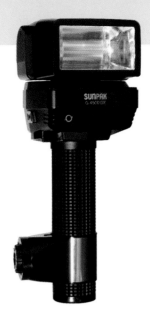

Powerful, off-camera flash units, such as this "hammerhead" flash by Sunpak, are a useful tool for the wildlife photographer.

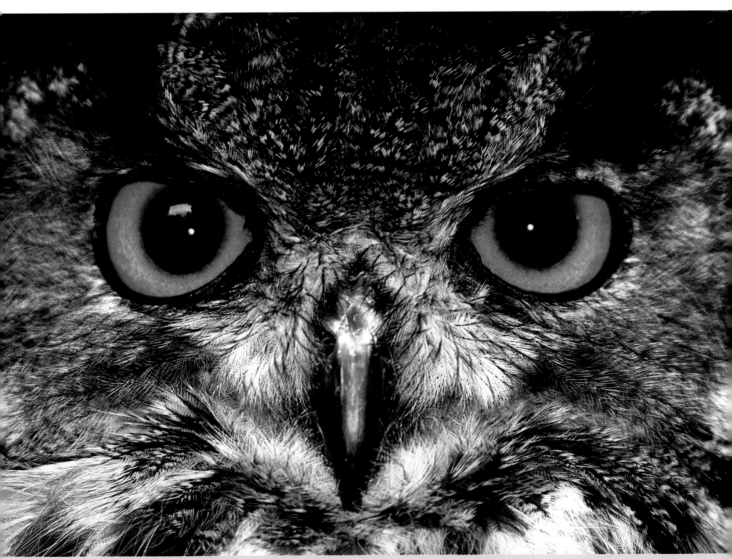

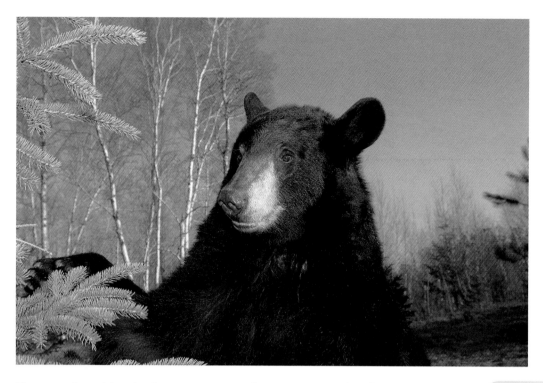

The second consideration is power output, usually represented by the unit's guide number (GN). Generally speaking, the more powerful the flash, the greater the control you have over lighting and exposure. Be careful when comparing the GN of flash units, as the calculations used for marketing purposes are not standardized. While one manufacturer may quote a GN for a 100 ISO film/DPS, another may use a 400 ISO film/DPS as the base, which will make comparing the two units more difficult (see page 69 for how to calculate flash exposures using GN).

Because most modern flash units operate via TTL-exposure control, calculating flash exposures is now relatively simple. Whether you're using flash to provide fill lighting, or as the main light source, the combination of the flash unit and camera computers will give you perfect exposures most of the time. However, remember that the middle-tone exposure rule still applies (see page 59).

The advantage of on-camera flash

Many cameras come with a small, built-in flash unit that usually sits within the viewfinder housing. Typically, these units have insufficient power for any practical wildlife photography application. However, when used in conjunction with a telephoto lens and at some distance from the subject (ideally just within the flash unit's range), they are ideal for adding light to an animal's eyes in overcast conditions, bringing life to what may otherwise be a flat scene.

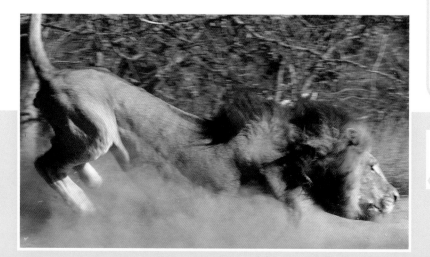

FILTERS

I rarely use filters in wildlife photography but there are times when they can be useful. When I do use one, it's either a polarizing filter, an ultraviolet (UV) filter, or the 81 series of "warm" filters.

Polarizing filters

Though less useful in wildlife photography than they are in landscape photography, polarizers can sometimes add to the richness of colors in a wildlife picture. The disadvantage is that you lose up to 2-stops of light, which can be too much if rapid motion is involved.

When using polarizers with AF and AE system cameras, you will need to use the circular variety. Linear polarizers will make AE and AF systems unreliable.

Ultraviolet (UV) filters

The only time I use these filters is when I want to protect my lens from the elements in hostile conditions. I may be in very dusty environments, such as the African savannah, or close to the sea, when salty sea spray can ruin the lens.

81 series warm filters

For film cameras, an 81A or 81B warm filter helps to accentuate the golden light of early morning and late afternoon, and reduce the cool blue overtones of light on overcast days and during the middle of the day. The same effect can be achieved on digital cameras by using the white balance control (see page 33).

Filters used in wildlife photography can help to accentuate colors, or overcome the limitations of film in certain lighting and/or environmental conditions.

Compare these two images and notice the effects of using an 81A filter. The cool blue tone in the image above has been replaced with a warmer, more appealing tone in the image on the left. Nikon D2H, 24–120mm VR lens set at 120mm, 1/500 sec. @ f/7.1.

Using filters with digital cameras

Most filter types work in just the same way with a digital camera as they do with film. And to achieve certain results, you must use a filter because some effects are impossible to recreate accurately digitally in-camera or in post-processing. For example, a computer cannot easily replicate the effects of polarizing filters, which are dependent on the direction and angle of light.

Digital cameras and color temperature filters

On the other hand, filters that alter the color temperature of light, such as the 81 series of warm filters, and the 80 series of cool filters, work less well on digital cameras.

The white balance function on many digital cameras will allow you to more accurately adjust the way the sensor reacts to the color temperature of light than an optical filter, particularly those cameras that have an option to set a specific Kelvin (the measurement used for color temperature) setting.

Similarly, when these filter types are used in conjunction with the auto-white balance setting, the camera will, to some extent, compensate for the effects of the filter used, neutralizing its effectiveness.

Using UV filters with digital cameras

A DPS is less prone to UV light than film, making the technical use of UV filters unnecessary in most circumstances. Of course, they can still be applied for their protective properties.

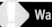

Warning!

Don't confuse a UV filter with a Skylight filter—they are different things. A good quality UV filter will be completely clear, and won't affect the color of light passing through it. A Skylight filter has a slight pink tone that will tint your pictures. A good way of checking the neutrality of a filter is to place it on a sheet of white paper. Any color tones will soon become apparent.

Taken with a digital SLR camera, I used the WB function in place of an 81A filter to achieve the same effect when photographing this hippopotamus. Nikon D2H, 80-400mm lens set at 400mm, 1/250 sec. @ f/8.

White balance (WB)

Digital capture technology gives far more control to the photographer than film does. For example, while film, at the point of manufacture, can be balanced only for a single color temperature (usually daylight or tungsten light), a DPS can be balanced for different color temperatures with each new shot.

Many digital cameras come with white balance (WB) settings pre-programmed, the more common of which are listed in the table on the right, along with their relative color temperature equivalents. More advanced digital cameras also allow you to match exactly the color temperature at the point of shooting, which gives you the greatest level of control over all conditions.

I often use another WB setting than that recommended by the camera. For example, under average daylight conditions I will set the WB to "cloudy" rather than "direct sunlight." This is because, more often than not, my style of photography dictates that my images have a warm color cast. The settings I generally use are shown in the table on the right. These settings are personal preferences and, to some extent, are a commercially based decision. Whether you follow my lead is a conclusion you must come to based on your own experience and experimentation.

Common pre-programmed WB settings

WB setting	Approximate color temperature	Light source
Incandescent	3,000K	Household light bulb (a similar setting to tungsten balanced film)
Fluorescent	4,200K	Fluorescent strip lighting often found in offices
Direct sunlight	5,200K	Sunlight at midday (a similar setting to daylight balanced film)
Flash	5,400K	Electronic flash unit
Cloudy	6,000K	Overcast day
Shade	8,000K	Subject positioned outside in shade

Recommended WB settings for different lighting conditions

Light source	WB setting
Clear blue sky	Shade
Shade on sunny day	Shade
Overcast (cloudy) day	Cloudy
Noon sunlight	Cloudy
Average daylight (4 hours before sunset and 4 hours after sunrise)	Cloudy
Early A.M./late P.M.	Cloudy
Sunset	Cloudy
Electronic flash	Flash

Warning!

Any additional piece of glass in the light path between the scene you're photographing and the film/DPS has the potential to degrade image quality via, for example, internal reflections (lens flare), dirt, or aberrations. Some people advocate always using a UV or Skylight filter to protect the front element of the lens from damage. My advice is to use filters only when absolutely necessary to avoid compromising image quality.

Camera supports

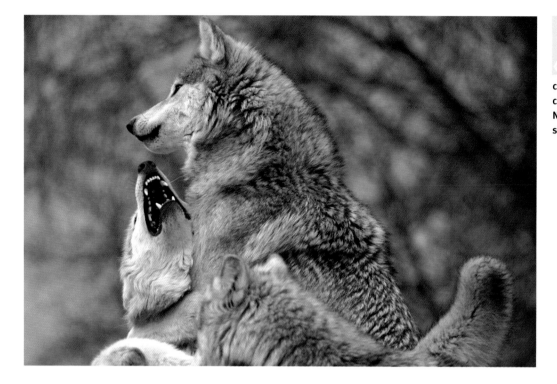

Using a tripod successfully in wildlife photography takes some practise, as following the action can prove a real challenge. However, the benefits can be seen in pin-sharp images. Nikon D100, 800mm lens, 1/500 sec. @ f/5.6.

Camera shake is a constant companion for the wildlife photographer—big, heavy lenses and chunky professional cameras are not conducive to hand-holding. Optical stabilization lenses have made a difference, allowing hand-holding up to shutter speeds two or three times slower than normal. However, in my opinion, you can't beat a good camera support for pin-sharp images.

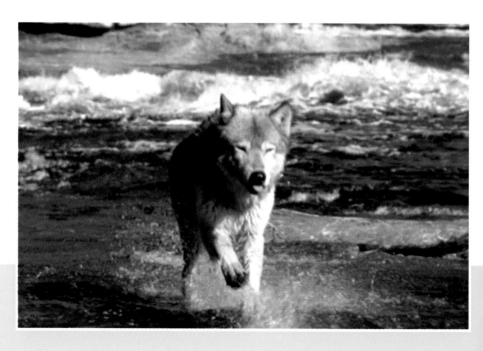

Here, an accumulation of elements—low light, a big, heavy lens, and no proper camera support—has resulted in blur caused by camera shake. Nikon D2H, 400mm lens, 1/60 sec. @ f/11.

Beanbags

Beanbags are a must for the wildlife photographer. Made from a cloth bag filled with rice, maize, or polystyrene, they are ideal for supporting long lenses, both in the field and when shooting from a vehicle. The malleable filler molds itself around the lens and absorbs vibrations, producing a very stable platform for the lens and camera.

Different versions are available, from single bags to bags designed specifically to fit over the ledge of a car window or hide. I tend to use the latter because they provide greater flexibility for the different shooting conditions I find myself in.

Beanbags are one of the most useful and versatile camera supports. Here, one is used on the fly with a convenient fence post.

 Tip!

When using especially long lenses, a small beanbag placed over the lens when the camera is supported on a tripod will help to reduce lens movement in windy conditions, and reduce the effects of vibrations.

Monopods

Another option is a monopod—a rigid, telescopic pole that has a standard mount at its head, which screws into the tripod socket on the camera. The height is adjustable, giving you a stand that can be used almost anywhere. The advantage of a monopod is that it's easy to carry and relatively compact. When it's used well, you can usually gain an extra couple of stops before camera shake shows.

Warning!

Synthetic, beanbag fillers, such as polystyrene, tend to flatten out over time and will need to be replaced regularly. Rice and maize are better options—however, they can attract the attention of hungry elephants, as I found out to my cost in Kruger National Park!

Tip!

When traveling overseas with beanbags, empty them of their contents before packing to reduce size and weight and refill them once you reach your destination.

When photographing from a car, a beanbag is the most reliable form of camera support. The bag shown here is a "double" that fits securely over the car doorframe.

Ball-and-socket heads provide the greatest flexibility for wildlife photography.

Used properly and within their limits, tripods provide the sturdiest form of camera support. Lightweight, carbon fiber models make field-use more practical.

The pan-and-tilt head is less suited to wildlife photography but can be used successfully once you're familiar with it.

Tripods

For the ultimate in camera support, you can't beat a good tripod. You need to ensure that the tripod you use can support your camera and heaviest lens (look on the side of the box to see how much weight the tripod can hold), and that you can carry it comfortably in the field, particularly if you regularly hike long distances.

Modern, carbon fiber models weigh two-thirds the amount of metal tripods, making them easier on the muscles, though the extra cost is harder on the pocket. Ultimately, it comes down to a balance between rigidity and portability, and my advice is to opt for the sturdiest model you can carry comfortably.

The sturdiness of a tripod is directly associated with its center of gravity. A tripod has two centers of gravity: from the ground to the top of the legs, and from the top of the legs to the camera plate. The lower the center of gravity, the more stable your tripod and camera will be. Avoid, if possible, extending the center column, as this will greatly reduce rigidity (my main tripod doesn't even have a center column). Also, extend the tripod legs only as far as is necessary.

Weighting the tripod by hanging your camera bag (making sure it's securely fastened first) or a bag of stones from the legs will also help to make things sturdy.

Some tripod manufacturers also supply a "fourth arm" that attaches the camera body to one of the tripod legs, giving greater stability.

Most tripods allow you to change the type of head you're using. For lenses in the super-telephoto range I recommend a Wimberley head (see right). Alternatively, a solid pan-and-tilt or ball-and-socket head will provide good support, as long as it is designed to carry the weight of the system you're using.

Tip!

In windy conditions, hang your camera bag from the tripod to gain extra stability. Alternatively, use one of the purpose-made rock bags that attach to the legs of the tripod.

Wimberley heads

The Wimberley tripod head is specially designed for use with super-telephoto lenses. It has a gimbal-type design that makes manipulating very long lenses simple and effective.

It incorporates an elevated tilt mechanism and an adjustable platform to perfectly align the centre of gravity of a long, heavy lens with the tilt axis of the head. This results in a perfect balance and, once pointed at a subject, the lens will remain static until moved by the photographer.

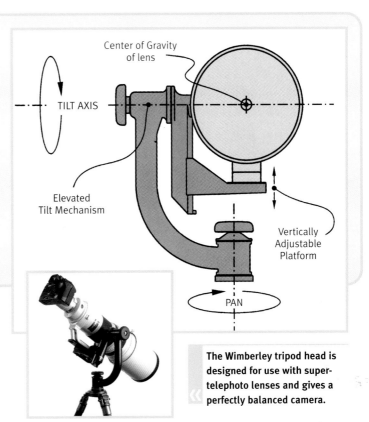

Center of Gravity of lens

TILT AXIS

Elevated Tilt Mechanism

Vertically Adjustable Platform

PAN

The Wimberley tripod head is designed for use with super-telephoto lenses and gives a perfectly balanced camera.

Tip!

To ensure you seldom miss a shot, attach a quick-release plate to all your frequently used gear, including all your camera bodies and any lenses that have a tripod collar.

Quick-release plates

The difference between getting the shot and not can often be a matter of a few seconds. A quick-release plate that allows for speedy removal and attachment to a tripod when switching between camera bodies will save time.

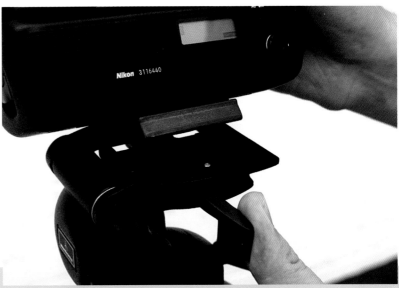

Nikon 3116440

Using quick-release plates makes for speedy interchanging of cameras when in the field. I have these plates fitted to all my camera bodies and long lenses.

Tip!

Always make sure that quick-release plates are securely attached to the camera body or lens collar, particularly when using heavy lenses. This will ensure the camera doesn't slip when turned to the vertical shooting position.

Equipment for spotting wildlife

As well as cameras and camera-related equipment, a successful photo shoot relies upon you first spotting an animal to photograph. And then, of course, you must be able to carry your equipment safely and comfortably.

Binoculars

You should always carry a pair of binoculars when photographing wildlife. Otherwise, how else are you going to spot the lion meandering through tall grass, or the eagle perched high on a cliff face?

For general use, an 8 x 32 (8x magnification, 32mm diameter) pair will suffice. However, if you're likely to be working in low light, such as at dawn and dusk, opt for a model with greater light-gathering ability, such as an 8 x 40 or even 8 x 56, the latter being suitable for observing animals at night. For improved optical quality, some binoculars are designed with very low dispersion glass that is essential for well-defined images.

Binocular designs

To provide correctly oriented images, binoculars use image-erecting prisms. There are two principal design types: the Porro prism, which has an off-set barrel, and the Roof prism, which has a straight barrel.

Porro prism

Traditionally, binoculars using the Porro prism design were far larger and heavier than their counterparts. However, modern design technology means that newer models are lighter and smaller, and more on a par with Roof prism designs. They deliver a wide field of view with excellent image quality and are often far less expensive than the alternative.

Roof prism

Binoculars with a roof prism design tend to be more streamlined than Porro prism types and are better in environmentally challenging conditions because their compact optical design makes them more tolerant of rough treatment. Most models have an internal focusing mechanism, and their structural integrity makes them less susceptible to internal fogging and penetration by dust, dirt, and moisture. On the downside, they are generally more expensive than Porro prism-type binoculars because of the complexity of their design.

Light-gathering ability

The larger the exit pupil of binoculars, the better their light-gathering ability. To calculate light-gathering ability, divide the binoculars' diameter by their magnification. For example, an 8 x 32 pair has a 4mm exit pupil (32/8 = 4); an 8 x 40 pair has a 5mm exit pupil (40/8 = 5).

I always carry a pair of Steiner Wildlife binoculars with me in the field.

Spotting scopes

Spotting scopes have longer focal lengths than binoculars, and so are better for spotting very small or very distant subjects. And because they have interchangeable objectives, it's a simple process to alter their magnification. Long focal lengths and high magnification, however, can compromise image quality, and satisfactory sharpness is only assured if the scope has achromatic optics.

For the ultimate in quality, look for spotting scopes that are fitted with fluorite lenses and/or very low dispersion glass, sometimes referred to as "panchromatic." Panchromatic glass helps to stop the optics from acting like a prism, and avoids image blur.

In my experience, a scope with a diameter of 60mm, a fixed eyepiece, a magnification between 20x–30x, and mounted on a tripod, will give reasonable results for wildlife spotting.

Warning!

Avoid the temptation to use the spotting scope as an alternative to a long focal length camera lens. The quality will never match that of a photographic optic, and will rarely give satisfactory results.

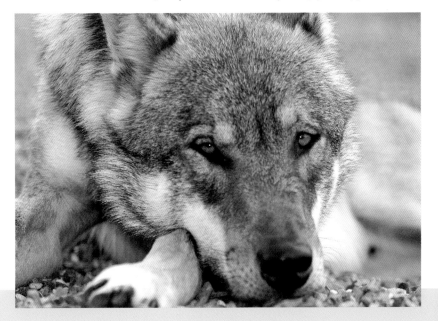

Often, wildlife is at it's most active during periods of low light, such as dawn and dusk. A quality pair of high-definition binoculars will help you to spot those fleeting moments that make great wildlife images. Nikon D100, 80–400mm VR lens set at 400mm, 1/60 @ f/5.6.

Spotting scopes are less versatile for fieldwork than binoculars, but can be a useful tool when working from a fixed, semi-permanent position. They're best used in conjunction with a tripod.

Tip!

If you do a lot of photography during low light (dawn and dusk), which can often be the case for wildlife photographers, consider using a pair of high-definition binoculars, such as those manufactured by Steiner, made specifically for low-light conditions.

Exposure value

"Exposure Value" (EV) is used to explain exposure differences. A difference of 1 EV is equivalent to 1 f-stop.

Film

Your choice of film will make a difference to how your images look once they're processed. Color film is almost always used in wildlife photography, though it is worth experimenting with black and white film at some stage. Your first decision will be between negative (print) film and positive (transparency/slide) film.

Negative film is easier to work with because it has broader latitude (-1 to +3 EV, or Exposure Value), giving greater flexibility and tolerance when it comes to exposure. The downside is image quality, which is reduced due to the two-part process required to get a positive image (development then printing), and for this reason it is very rarely used in print reproduction to professional standards.

The majority of professional wildlife photographers shoot with color transparency film, such as Fuji Velvia, Fuji Provia, and Kodak Kodachrome. The main advantage of slide film is that every picture is an original—it doesn't need to go through the rigors of printing. The result is richer density, saturated colors and a sharper image, which is far better suited for reproduction in books and magazines, and on posters and cards.

Positive film is, however, harder to work with, being far less tolerant of even slight exposure miscalculations.

Film speed

I am often asked what speed (ISO) film to use for wildlife photography. The answer isn't a simple one, and depends on numerous factors, including the weather conditions and personal preference. In good lighting I find ISO 100 speed films, such as Fuji Provia 100F, produce consistently good results with no noticeable grain. In low-light conditions, I prefer to either push a 100 ISO film to 200 ISO, or opt for a professional 400 ISO film, such as Fuji Provia 400F. A 400 ISO film will show more grain but, with a high-end brand, this will only become noticeable when greatly enlarged (beyond Letter/A4).

These films are capable of producing images suitable for publication. I also find the colors in Fuji Provia to be more natural for wildlife than the more saturated Velvia, which is often used in landscape and nature photography. Provia 100F also produces better results when pushed one stop than many ISO 200 films.

Digital pixel sensors (DPS)

The increasing quality of digitally captured images means that more and more professional photographers are using this technology. Ultimately, the quality of a digital image has much to do with the type of digital pixel sensor (DPS) installed in the camera.

There are now three main sensor types in use: the CCD (Charged Couple Device), CMOS (Complementary Metal Oxide Semiconductor), and the new proprietary Nikon LBCAST sensor. CCDs have become the most popular type because they produce stable and consistent image quality across their surface area. However, they are expensive to produce and consume a lot of power. CMOS devices use less power but require extra circuitry to compensate for differences in sensitivity across their surface, which can result in higher digital noise affecting image quality. Nikon's LBCAST sensor, which is only available in its latest range of professional digital cameras, is based on an architecture known as JFET, which is optimized for use in digital photography, with low power consumption and reduced noise.

The sizes of digital sensors vary from full-frame (the same as 35mm format-film) to less than half full-frame size. The optimal size of the sensor is one where the image circle is exactly half that of the lens mount. Because photodiodes give optimal performance when light strikes them head-on (unlike film, which can expose accurately light falling at an acute angle), this 1:2 ratio will give superior results. The number of pixels created by the photodiodes will also have a big influence on image quality. Digital images are created using a system that resembles painting-by-numbers. The sensor is divided into a grid of minute squares (sometimes octagons), with each square being given a numeric value that corresponds to the brightness of the light that falls on it during exposure. In general, the greater the number of pixels, the smaller each "dot" of light appears, and the better the image quality.

The Four Thirds digital photography standard aims to improve digital image quality by applying the 1:2 ratio of image circle to lens mount.

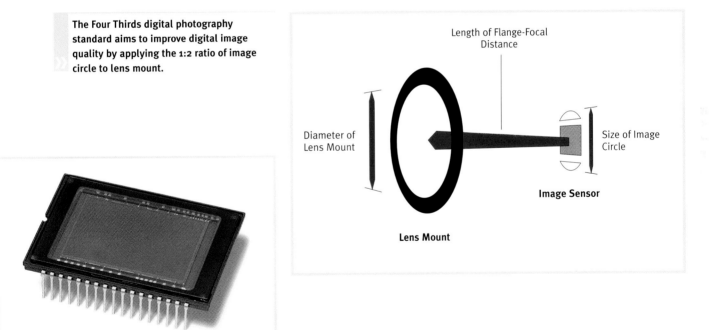

Length of Flange-Focal Distance

Diameter of Lens Mount

Size of Image Circle

Image Sensor

Lens Mount

In digital cameras, film is replaced as the light-recording mechanism by a digital pixel sensor, which come in various sizes and types. Shown here is Nikon's DX CCD sensor.

Protecting your equipment

Keeping equipment safe is an on-going job for the wildlife photographer. Hard knocks, dust, sand, scratches, and moisture can quickly ruin your gear. Professional-specification cameras are designed to repel the elements, and have dust-proof seals and water-resistant coatings to help protect them in camera-hostile environments. For those using less robust consumer-specification cameras, there are some simple, practical precautions you can take to help keep your equipment working for a lifetime.

To protect your camera from rain and sea spray, wrap it in a waterproof plastic bag made of clear material (so you can still see the camera controls). You can buy purpose-made rain covers for cameras, but any strong plastic bag will do the trick. Add a UV filter to protect the front element of the lens, then secure the bag around the lens with an elastic band.

If you're using your camera on the water, it is worth buying one of the small watertight bags sold in outdoor equipment stores for canoeing trips. If you're storing a lot of equipment on board a vessel, consider buying a large waterproof camera pack that will keep everything safe should it fall into the water.

In more arid conditions, where dust is the main problem, I have found the plastic bag solution to work effectively. I have tried using a cloth variant, but found that the dust tended to cling to the cloth more aggressively. When not using your equipment, always put it away in a quality zippered bag, which will keep the elements at bay. A UV filter will provide protection to the front element of lenses.

When cleaning dust from your camera and, in particular, from the lens optics, use a photographic air spray. Used properly, they are more efficient and safer than lens cloths, which can cause the dust to scratch delicate surfaces.

Yes, that's a real bear with my case! When the worst that can happen happens, you need to know your photo gear is well protected. I use Storm hard cases manufactured by Hartigg Industries for protecting my valuable equipment from overzealous baggage handlers. Nikon D2H, VR 80–400mm lens set at 80mm, 1/250 sec. @ f/8.

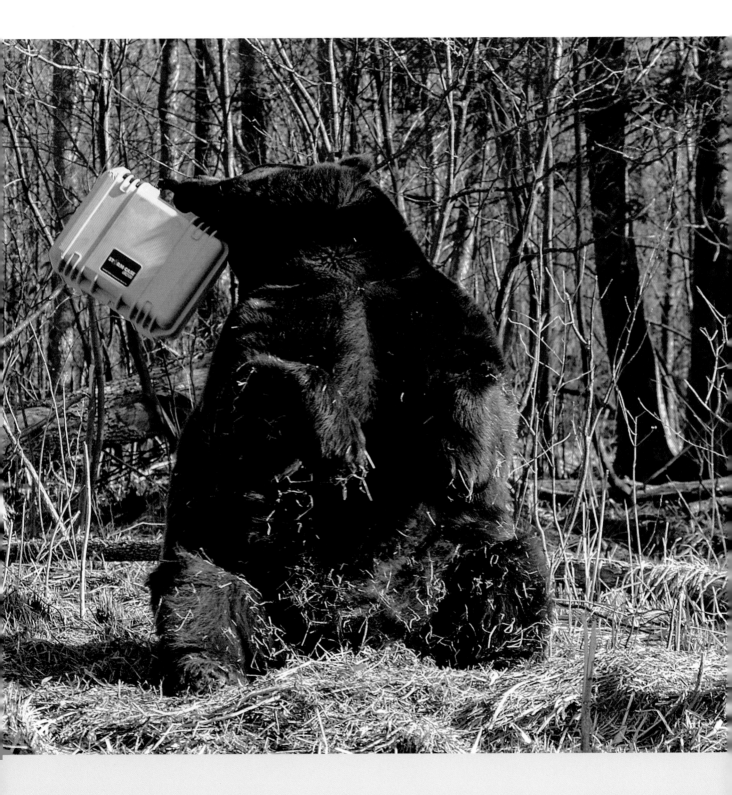

Carrying equipment

Photo backpacks are the best way to carry gear in the field. They are designed for trekking, and provide adequate protection against damage. I prefer a compartmental bag, which helps keep all my equipment neat and tidy, and provides easy access when I need to get at anything in a hurry.

When choosing a suitable pack, check that it is large enough to hold all the gear you may carry at any given time, and that you can comfortably manage the weight of it when it's full. It's also worth opting for a model that allows a tripod to be added to the front or side.

In the field I transfer everything into a Crumpler photo backpack, which makes light work of hauling camera gear into inhospitable environments.

Tip!

With the greater use of digital-capture technology, laptop computers are now often carried in the field. Some photo-packs are designed to hold a laptop safely and securely, such as the model I use, manufactured by Crumpler. Should you want to leave the computer behind, the laptop pouch can be easily removed from the bag and stored at the camp before venturing out into the field.

Traveling overseas with equipment

When traveling, I have two main concerns about my equipment—will it arrive undamaged, and will it arrive at all? To prevent a complete disaster should my luggage end up in Shanghai while I'm in Seattle, I carry on board a small pack that holds a camera body, two lenses (a 24–120mm VR zoom, and a 80–400mm VR zoom), and a small flash unit. If my bags do go missing, I at least have enough equipment with me to continue working.

I pack most of my equipment in a large hard case that gets placed in the hold. The case is manufactured by Storm. It is both watertight and airtight, and is built to withstand aggressive handling.

If you are carrying film, always carry the film with you on board an airplane—never place it in your hold baggage (see Airports and X-rays, page 46).

Specially designed, air- and watertight cases keep my cameras and lenses safe when I'm traveling overseas. The foam insert is cut to fit specific pieces of equipment, giving greater protection during transit.

Tip!

Because large photo cases tend to attract the interest of thieves, carry yours in an old army or navy haversack, which can be bought from most military surplus stores.

Airports and X-rays

The X-ray machines used for checking hand luggage are of a lower power than those used for hold baggage, so should not affect film, even after several passes. Place all of your film canisters upright in a clear container, so that the X-rays don't fall directly on the film. Then pass this through the X-ray machine. I have been traveling with film this way for many years and have never had a problem with film fogging—even after passing the same film through 20 different X-ray machines.

Tip!

If you are traveling in a developed country, have any exposed films processed before you depart. I often do this when working in the US and Europe, in particular, and it does save subjecting unprocessed films to unnecessary X-rays.

Tip!

Consider asking for a hand inspection of film at the airport, rather than putting it through the X-ray machine. However, be prepared for the security staff to decline, particularly at very busy international airports. They are not being difficult, it is their job to ensure the safety of the aircraft and they may have more pressing matters to attend to.

Warning!

Never place your film in one of the lead-lined bags often sold as X-ray-proof. The lead stops the operator from seeing what's in the bag, so she will increase the power of the X-ray, which will then damage your film.

When I'm away for any length of time without access to a computer, I use a portable hard-disk drive to store my digital images.

A word on digital

Of course, the best way to ensure your film is unaffected by X-rays is to leave it at home and shoot digital. Digital Compact Flash memory cards are impervious to X-rays, being neither light-sensitive nor magnetic. Therefore, they can be passed through airport X-ray machines without fear of data loss.

Some storage media, such as portable hard disk drives and IBM micro-drives, are not light-sensitive either, but they are magnetic. However, popular scientific opinion is that airport X-ray machines are unlikely to affect the magnetism of these devices. An alternative to storing digital images on a portable hard disk drive is to store them on compact disk (CD). Again, CDs are impervious to airport X-rays.

What's in the bag?

For general shooting, my wildlife photography kit bag contains the following:

Camera bodies
- Nikon D2H D-SLR
- Nikon D100 D-SLR
- Nikon F5 SLR

Lenses
- Sigma 800mm f/5.6 Super telephoto
- Nikon 300mm f/2.8 telephoto
- Nikon 80–400mm f/3.5–5.6 VR zoom
- Nikon 24–120mm f/3.5–5.6 VR zoom
- Nikon 2x teleconverter
- Nikon 12–24mm f/4 zoom

Accessories
- Nikon SB-800 i-TTL flash unit
- Nikon SB-28 D-TTL flash unit
- Electronic cable release with extension

- Infrared remote shutter release
- Gitzo carbon fiber G1548 MK2 tripod, with Wimberley Head or G1570 magnesium pan and tilt head
- Velbon carbon fiber Sherpa Pro tripod, with Manfrotto 329 pan and tilt head
- 81A & 81B warm filters, UV filters, 2-stop ND filter, and circular polarizing filter
- Sekonic L608 hand-held light meter
- Steiner Safari 8 x 40 binoculars
- Spare batteries

Digital accessories
- Apple iBook, with Adobe Photoshop and Nikon Capture 4 image-processing software
- 1 x 1gb CF card
- 2 x 512mb CF cards
- 1 x 256mb CF card
- Apacer Disc Steno portable CD writer
- Phototainer portable HDD
- DPS cleaning accessories

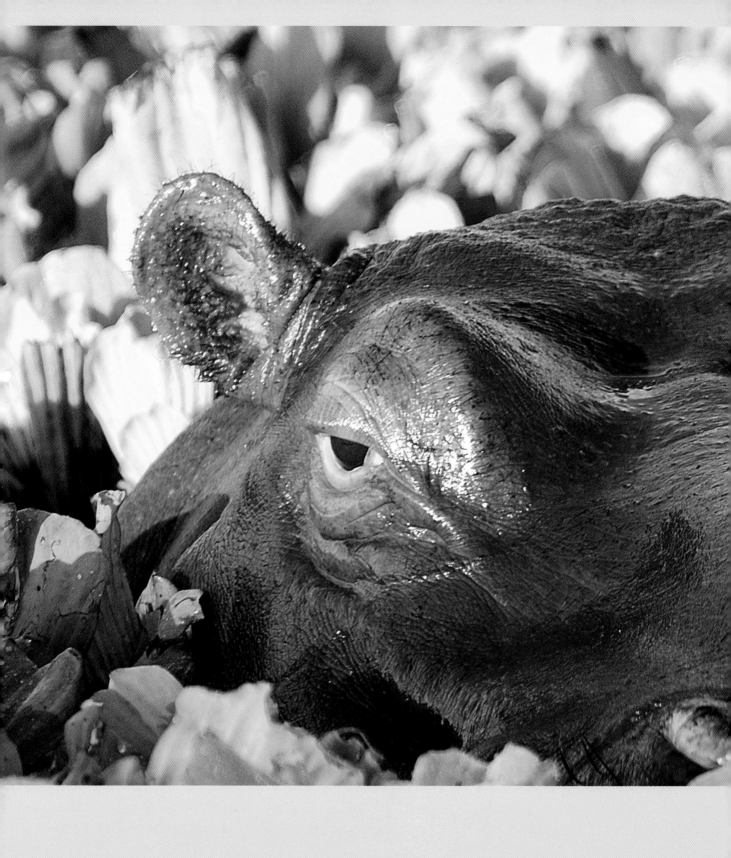

Light

Light is the critical factor in photography. Without the golden glow of morning light, or the vivid red light of late afternoon, photographs can appear flat or harsh, and lacking in visual character. The nuances of light are very apparent to the professional wildlife photographer, and waiting for the perfect juxtaposition of atmospheric illumination and animal behavior is the key to creating compelling images.

Many has been the time that I have sat in a hide, cooped up, cramped, and hungry for days on end, waiting for good light and a great subject to occur simultaneously. If you were unaware of it before, you now know that the foremost attribute of a successful wildlife photographer is patience!

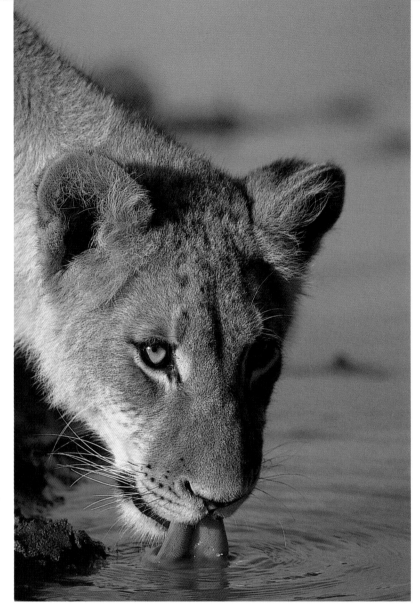

The beautiful early morning light enhances this shot of a lioness drinking at a waterhole in southern Africa. Nikon F5, 300mm lens, 1/250 sec. @ f/4, Fuji Provia 100F.

With creative exposure techniques, I have used the confluence of light and form to render this image of a buffalo as an abstract. Nikon D2H, 80–400mm VR lens set at 300mm, 1/3000 sec. @ f/8.

> **⚠ Tip!**
>
> The sunrise and sunset times for anywhere in the world at any time can be found on the US Naval Observatory web site: http://aa.usno.navy.mil/data/docs/RS_OneDay.html.

Light and the seasons

In summer, the best time for wildlife photography is generally before 10am and after 5pm. At these times, the sun's rays are softer, and their quality is enhanced by the thicker atmospheric layer. In the middle of the day, when the rays fall vertically, the quality of light is lost, and shadows appear harsh and unflattering. Try to avoid this time, as it is generally unsuitable for photography.

The type of light more conducive to outdoor photography is most common in winter. Of course, this is also the time of year when wildlife can be least visible and active. You, too, may be less likely to want to venture outside (after patience, tenacity is the most important attribute of a wildlife photographer).

For the adventurous photographer, however, the winter sun rarely rises high enough to lose its magical qualities, and the thicker atmospheric layer causes light to appear warmer throughout the day, even at noon.

The intermediate seasons of spring and autumn produce a quality of light with a special charm for wildlife photographers, combining the outstanding elements of summer and winter sunlight. Concurrently, nature is at its most active—mating, migrating, breeding, and growing—providing the photographer with countless subjects.

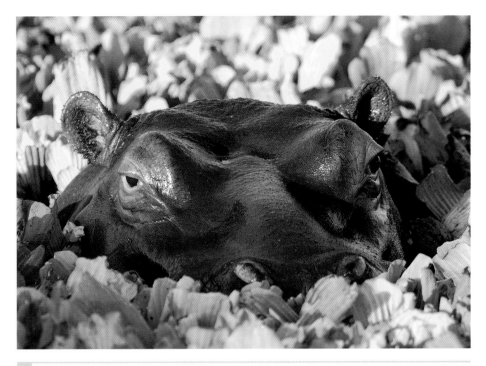

The early bird catches the hippo. I was out at first light to capture this evocative image of a hippopotamus catching the early morning rays during winter in Africa. Nikon D100, 800mm lens, 1/125 sec @ f/5.6.

Fall is a time of beautiful color and golden light. I made the most of both to capture this image of a coyote stalking prey in woodlands in the USA. Nikon D100, 80–400mm VR lens set at 185mm, 1/60 sec. @ f/16.

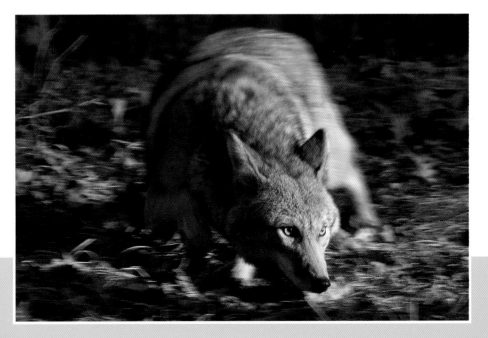

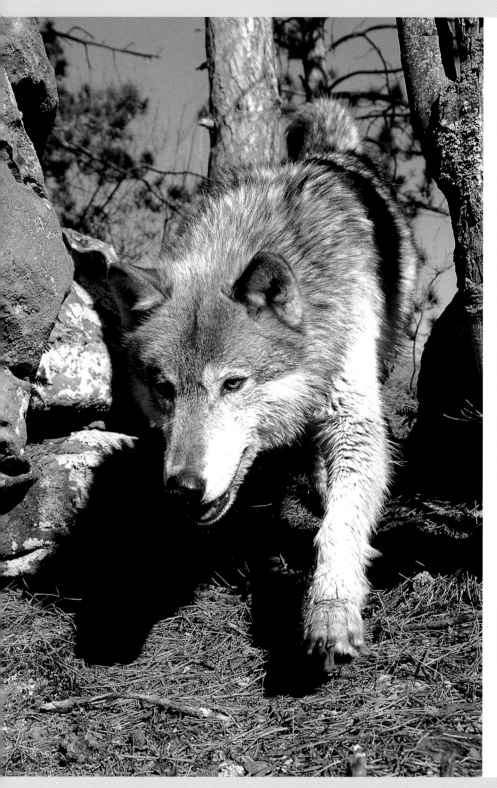

Light and the weather

The weather is another influencing factor over light quality. Simply stated, light can be described as hard or soft. Hard light radiates from a point source, such as direct sunlight or a flash unit, and is rich in contrast, producing well-defined shadows with hard edges. When coming from directly overhead, hard lighting is unflattering to wildlife subjects and is best avoided. Earlier in the day, however, when light is less intense, the same contrast helps the photographer to render form, giving his images a greater sense of depth and three-dimensional character.

When the sky is overcast (or when a flash unit is used in conjunction with a diffuser), light rays fall from all directions, and the quality of light is soft. Shadows have a lower density and their edges are less well defined. Soft lighting produces a more even range of tones, and can be exploited when photographing subjects high in contrast, such as zebras, or animals in water. However, soft lighting needs to be used skillfully, otherwise pictures can look flat and uninteresting.

Direct light from the sun creates shadows and contrast that give an image depth. Nikon D2H, 24–120mm VR lens set at 32mm, 1/750 sec. @ f/8.

Direction of light

The direction of light relative to your subject will make a significant difference to your pictures. Light coming from the side will help to create shadows and contrast that accentuate form and depth. If side lighting is combined with the warm illumination of early morning and late afternoon, your subject will be bathed in a glorious radiance that is perfect for photography.

Front lighting and lighting from above, on the other hand, should be avoided in most instances. Front lighting eradicates shadows and leaves photographs looking flat and dull, while lighting from above causes harsh shadows under protrusions, such as noses.

Back lighting can help create powerful graphic representations and atmospheric images, depending on how you expose the picture. Set exposure for the highlights and you will render the subject in silhouette. Expose for the shadows and you will create a wonderful "halo" of light around the subject. Both compositions work well in wildlife photography, and are something you should look out for when the sun is just above the horizon.

When photographing high-contrast subjects, such as this zebra, omni-directional light from a diffused source helps to reduce contrast. Nikon F5, 300mm lens with 2x converter (600mm), 1/500 sec. @ f/5.6, Fuji Provia 100F.

Once again, early morning light from the side has helped me to create an image full of warmth and character. Nikon D2H, 80–400mm VR lens set at 165mm, 1/500 sec. @ f/5.6.

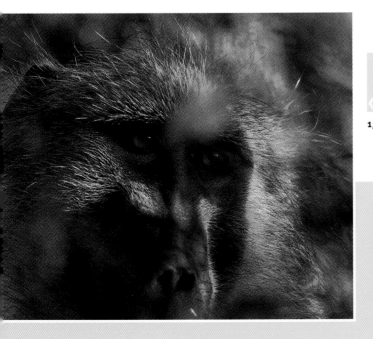

This shot of a baboon in Kruger National Park works only because of the glorious lighting from the side and slightly behind the animal. Waiting for the right moment is often the difference between a good image and a great one. Nikon D100, 80–400mm VR lens set at 400mm, 1/60 sec. @ f/8.

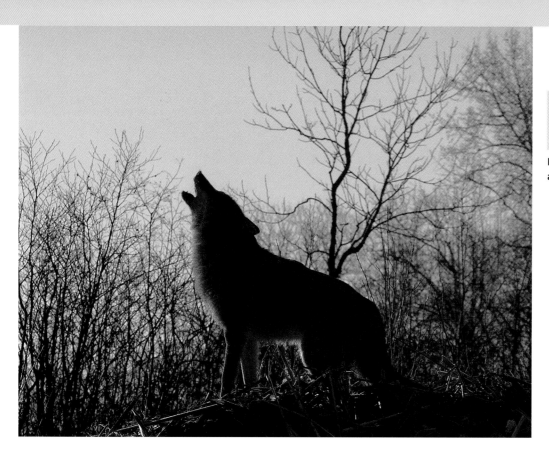

Low light

It is one of the quirks of nature that wildlife is at its most active when the light is low. The reason for this is that it's much cooler and safer for animals to move around in the semi-dark or dark. It's at times like these that you will need to squeeze every last ray of light through your lens.

A fast (f/2.8 or wider aperture) lens will give you an edge. It will add about 2-stops in light-gathering ability than slower consumer-grade lenses, which often have a maximum aperture of f/5.6 at the telephoto end of the focal length scale.

If you find your options for exposure settings are still restricted, then switch to a faster ISO rating film (I have found Provia 400F to be an exceptional fast film), or adjust the sensitivity of your DPS to a faster ISO-E (ISO equivalency). Be aware that the greater the sensitivity of your film/DPS, the more grain (film) or noise (DPS) will be apparent on your images (see page 60).

For extra stability, and to reduce the likelihood of camera shake degrading image quality, use a tripod. In some instances a beanbag can be equally effective. If all else fails, consider using artificial light as the main light source (see page 66).

Exposure

The basics of good exposure are simple once you understand how exposure meters work. The fundamental principle of exposure is getting just the right amount of light on the film/DPS. Too much light and the image will appear washed out (overexposed), while too little light will cause a dull, dark image (underexposured). The lens aperture and shutter speed govern how much light is let into the camera. Getting the combination right will achieve perfectly exposed images every time.

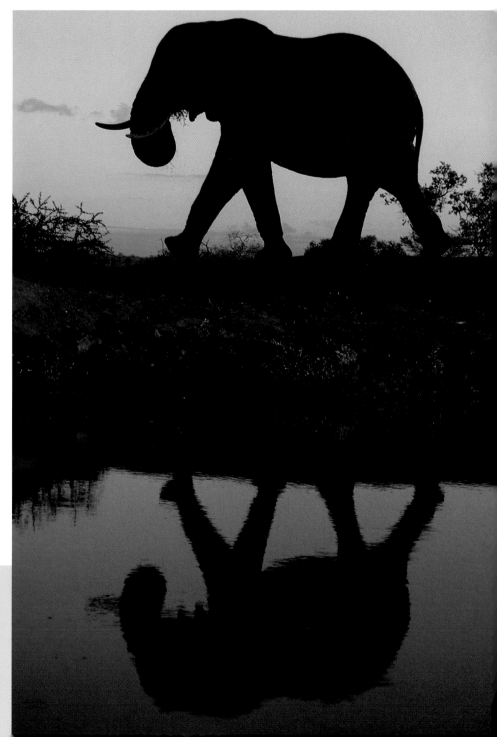

Understanding the principles behind exposure is essential to creating emotive, compelling wildlife images. NikonD100, 80–400mm lens set at 400mm, 100 sec. @ f/8

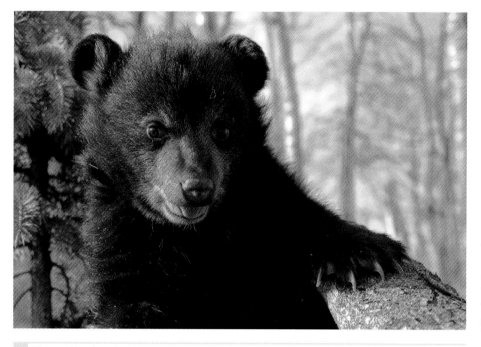

The combination of shutter speed and lens aperture control exposure and determine the aesthetic qualities of the final image. Nikon D2H, 24–120mm VR lens set at 45mm, 1/4000 sec. @ f/7.1.

F-stops, shutter speed and aperture

In photography, light is measured in "stops." In sophisticated cameras, lens aperture and shutter speed can be adjusted in $^1/_3$-stop increments. Some less expensive cameras may only allow these adjustments in 1/2- or 1-stop increments. Whatever camera type you're using, changing either the shutter speed or the lens aperture will increase or decrease the amount of light entering the camera.

The shutter speed determines the length of time the film/DPS is exposed to the light, and is used to control how motion appears in the picture. Most cameras have shutter speeds ranging from several seconds to 1/1000 sec. or faster. Altering the shutter speed from, say, 1/30 sec. to 1/60 sec. is a 1-stop increase in shutter speed, and halves the length of time the film/DPS is exposed. Conversely, an alteration from 1/250 sec. to 1/125 sec. is a 1-stop decrease in shutter speed, and doubles the length of time the film/DPS is exposed.

Shutter speed is used in conjunction with the lens aperture to control exposure. It determines the length of time the film/DPS is exposed to light, and controls how movement is depicted in the final image. Nikon D100, 24–120mm lens set at 52mm, 1/750 sec. @ f/5.6.

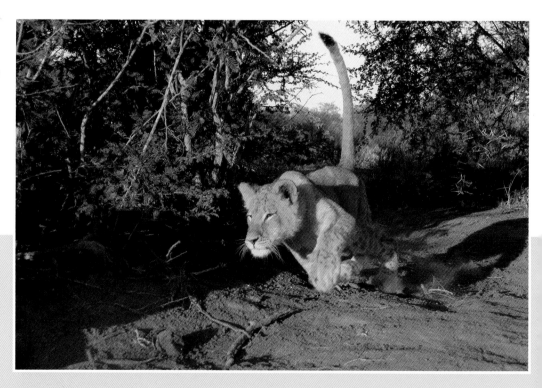

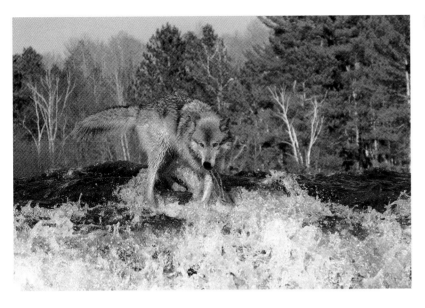

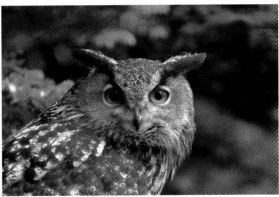

The lens aperture controls the quantity of light entering the camera, and affects how much of the image appears sharp (depth of field). The size of the aperture is set via a diaphragm in the lens, which is mechanically adjusted via an aperture ring on the lens or via a command dial on the camera. The aperture range varies depending on the lens, but usually starts at about f/2 (maximum aperture) and goes up to about f/32 (minimum aperture). Like shutter speed, any adjustments are measured in stops. For instance, changing the aperture from f/5.6 to f/8 is considered a 1-stop decrease in aperture, and will halve the quantity of light entering the camera. Adjusting the aperture from f/16 to f/11 is a 1-stop increase in aperture, and will double the amount of light entering the camera.

For this picture of an Eagle owl, I used lens aperture to control depth of field. Nikon D100, 80–400mm VR lens set at 400mm, 1/20 sec. @ f/5.6.

Reciprocity law

Because each adjustment in shutter speed or aperture alters the level of light reaching the film/DPS by an exact amount, any change in one setting can be compensated for by an equal and opposite change in the other. This is known as the law of reciprocity.

For example, if the original exposure setting for a particular image is 1/125 sec. at f/8, then any of the following combinations of settings would result in exactly the same level of light entering the camera:

	Shutter speed (secs.)	Lens aperture
	1/2000	F/2
	1/1000	F/2.8
Adjusted settings	1/500	F/4
	1/250	F/5.6
Original exposure setting	**1/125**	**F/8**
	1/60	F/11
	1/30	F/16
Adjusted settings	1/15	F/22
	1/8	F/32

Taking a meter reading

In order to assess the brightness of a scene, we use a light meter. There are two versions of light meters: an "incident meter" that measures the amount of light falling on a subject, and a "reflected light meter" that measures light reflecting off a subject. Because the former generally require being adjacent to the subject, they are not ideal for wildlife photography. For the purposes of this book, I will concentrate on light readings taken with a reflected light meter, such as the TTL (through-the-lens) meters built into modern SLR cameras.

When you point your camera (or a hand-held meter) at a subject, sensors inside the device assess the level of light reflected from it. Because the camera has no knowledge of the color (or tone) of the subject, it makes its assessment by assuming the subject is middle-tone gray

(sometimes referred to as 18% gray). This middle-tone reading is the industry standard "line in the sand." So, a photographic light meter will always give a technically accurate light reading for a middle-tone subject.

But what if the subject isn't middle-tone? What if you're photographing an arctic fox or black panther, subjects that are lighter and darker, respectively, than middle-tone? Well, in these cases, you must tell the camera to adjust exposure accordingly. For example, to make an arctic fox appear as a middle-tone, the camera will underexpose by about 1.5-stops. To compensate for this, you must overexpose by the same amount. Similarly, to render a black panther a middle-tone, the camera will overexpose by about 1.5-stops. Closing down 1.5-stops (underexposing) will make your panther appear as it should—black, not gray.

Subjects that are darker than or brighter than (such as this heron) middle tone, require that you make some adjustments to your camera's meter reading. Nikon F5, 800mm lens, 1/800 sec. @ f/8, Fuji Provia 100F.

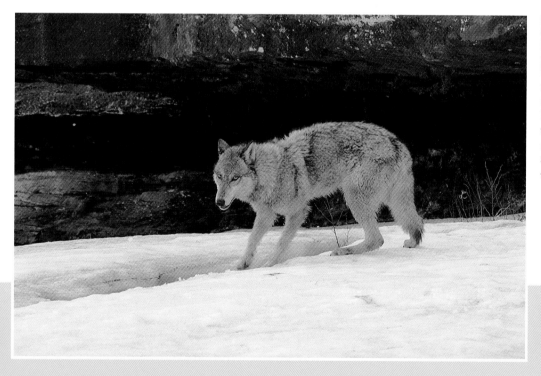

Scenes that include areas of extreme brightness, such as snow, or areas of extreme shadow can fool photographic reflected light meters into giving an inaccurate meter reading. Understanding how a light meter works will help you to make the necessary adjustments. Nikon D2H, 80–400mm VR lens set at 400mm, 1/100 sec. @ f/11.

Assessing the tonality of a subject

Once you've mastered that lens aperture and shutter speed combined determine the amount of light entering the camera, and that photographic light meters give an exposure value based on a mid-tone—18% gray—subject, exposure becomes much simpler. The real skill in calculating faithful exposures comes in being able to read tonality as a camera sees it.

All cameras see color in terms of a gray scale that ranges from pure, featureless black to pure, featureless white. In the middle is 18% gray—hence the term "middle-tone". Every color in the universe falls somewhere on this scale—knowing where, will allow you to set the right amount of exposure compensation. One way to gain experience in assessing tonality is to photograph some of your common subjects in black and white, and match them against the Gray scale (see above right). Another way is to use the color scale (see right), which I've developed over time. (Note that the figures are approximations and based on my own tests. I advise doing your own tests using your own light meter for accuracy).

Grey scale

Black	Mid-tone(18%) gray	White
−2 stops	±0	+2 stops

Color scale

	Color	Example subject	Exposure compensation (stops)
	Mid-tone green	Lawn Green field	±0
	Mid-tone red	Poppies	±0
	Mid-tone blue	Blue sky around midday	±0
	Yellow	Daffodil Dandelion	+1.3
	Flesh	Palm of the hand	+1
	White	Snow Swan	+2
	Dark Green	Conifer Evergreen tree	−1.3
	Light Blue	Blue sky around 9A.M.	+1
	Black	Raven	−2
	Dark brown	Wet earth	−1
	Mid-tone brown	Redwood tree	±0
	Gold	Sand	+1.5

Tip!

Assessing tonality
Carrying an 18% Gray Card, available from most photographic retail outlets, will help you assess the tonality of your subject, even when you can't get close to it. Simply compare the tone of the subject to that of the gray card and decide whether the subject is lighter than, darker than, or the same tone as the card.

| −2 | −1.5 | −1 | −.5 | +/−n | +.5 | +1 | +1.5 | +2 |

ISO and ISO equivalency

Every film has a speed rating, known as its International Standards Organisation (ISO) rating. Film speed refers to how quickly the emulsion in the film reacts to light. A slow film, such as ISO 50 or 100, needs more light before an image will form. The pay-off is that the light-sensitive silver crystals, commonly referred to as film grain, are much smaller, and therefore less visible in the final print. Faster films, such as ISO 400 and 800, need less light before an image will form. In low-light conditions, this gives you greater flexibility in setting aperture/shutter speed combinations. The downside, however, is an increase in grain, and a reduction in image quality.

A word on digital

The ISO of a digital sensor is called its ISO equivalency (ISO-E). The ISO-E can be set for individual frames, unlike film, whose ISO must be set for the entire roll. The same basic rules apply, in that a fast ISO-E will react to light more quickly than a slow ISO-E. However, DPSs don't suffer from graininess like films do. Instead, they create a phenomenon known as digital "noise." Digital noise becomes more apparent at faster ISO-E settings, and appears on images as random, unrelated pixels.

Even when needing to use fast shutter speeds to capture wildlife action, I prefer to keep ISO-E below 400 in order to maintain image quality.

Tip!

From experience, I never shoot at ISO-E ratings above 400 due to digital noise affecting image quality. In low-light conditions, consider using a faster lens. For example, switching from f/5.6 to f/2.8 will produce the same result in terms of exposure as altering the ISO-E from 400 to 1600.

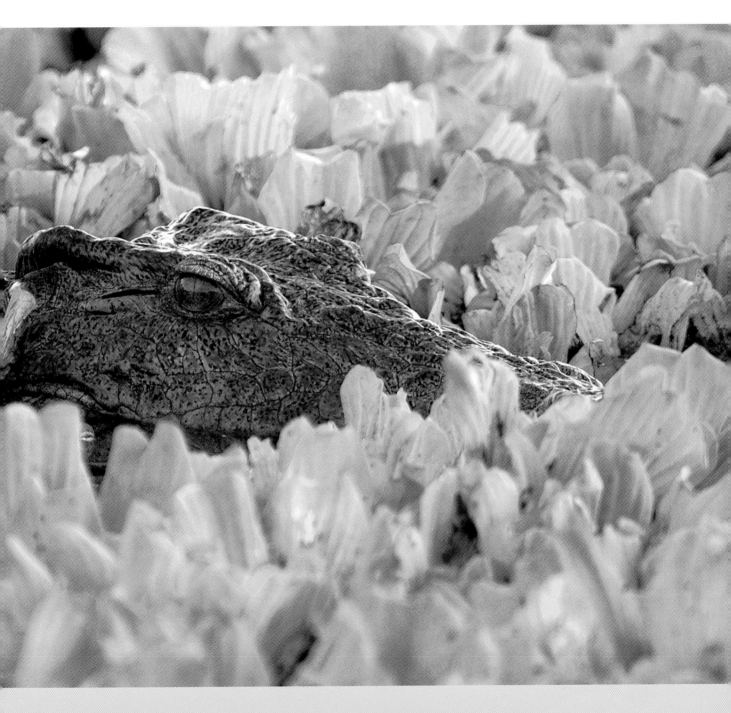

To maintain image quality when shooting with a digital camera, I very rarely use an ISO-E rating above 400, even in low-light conditions. Beyond ISO-E 400 I have noticed that digital noise becomes noticeable. Nikon D100, 800mm lens, 1/50 sec. @ f/5.6.

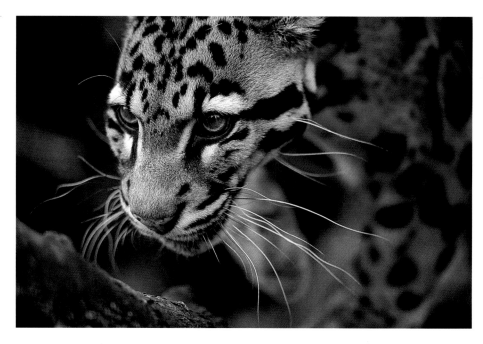

To isolate this captive clouded leopard from its unnatural surroundings, I used a large aperture, which renders the background completely blurred. Nikon F5, 80–400mm VR lens set at 400mm, 1/250 sec. @ f/5.6, Fuji Provia 100F.

Managing depth of field for creative effect

Technically, when you focus on a point in a scene, only that point will appear sharp in the final image. Everything in front and behind that point becomes increasingly out of focus the further away it is. However, our eyes are incapable of determining detail smaller than a certain size (about $1/10$ mm). For example, if you look at a 10 x 8 inch print made from a 35mm-format film, you will be unable to distinguish two adjacent points less than 0.03mm in size, and therefore they will appear sharp.

This distance is known as the "circle of confusion" and determines depth of field (the area of acceptable sharpness). You can control the extent of depth of field (deep or shallow) using the lens aperture. A small aperture (large f/number) will increase depth of field by reducing the size of the points that form the image outside of the focal plane. Conversely, a large aperture (small f/number) will reduce depth of field because the image-forming points get bigger with every increase in aperture.

Hyperfocal distance

Hyperfocal distance is the point of focus that gives the maximum depth of field for a given combination of lens aperture, focal length, and camera-to-subject distance. For example, if you focus the camera on infinity, depth of field will extend from somewhere in front of the point of focus (infinity)—known as the hyperfocal distance—to infinity. If the hyperfocal distance is,

say, 40 feet (12m) away, and you keep the lens focused on infinity, then your total depth of field is 40 feet to infinity. If you refocus the lens to the hyperfocal distance (40 feet in this example), depth of field will increase from half of the hyperfocal distance to infinity. So, your new depth of field will be 20 feet (6m) to infinity. This is the maximum depth of field possible in this example.

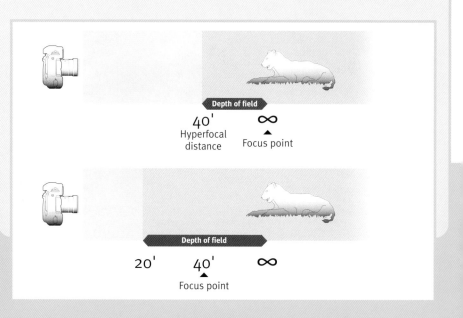

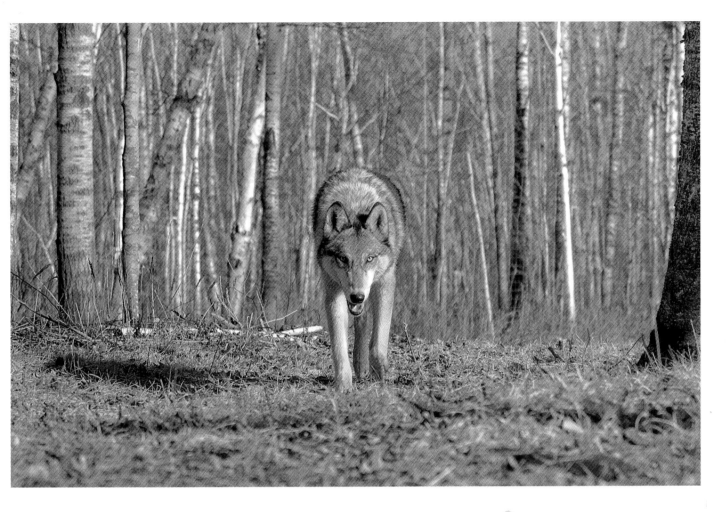

With this image I wanted to convey the wolf in terms of its environment, and so selected a small aperture to increase depth of field, making the background discernable. Nikon D2H, 24–120mm VR lens set at 120mm, 1/500 sec. @ f/8.

How much of the scene appears sharp will determine the visual presence of the photograph. For example, a shallow depth of field, where only the animal appears sharp, will help isolate the subject from the background by removing any pictorial distractions. On the other hand, rendering the whole scene sharp will give your subject a sense of place by including information about its environment.

 Tip!

You can find an on-line depth-of-field and hyperfocal distance calculator by logging on to any of the following web sites:

http://bertsirkin.brinkster.net

www.silverlight.co.uk/resources/ dof_calc.html

www.shuttercity.com/DOF.cfm

Shutter speed and the appearance of motion

Shutter speed determines how you visualize motion in your pictures. Freezing the action by setting fast shutter speeds will help capture fine detail and record precise information about the aesthetics of animals' actions.

A cheetah moves at a top speed of about 68 miles (110km) per hour—that's over 98 feet (30m) every second. If you set your shutter speed to 1/100 sec., by the time the shutter has opened and closed again, the cheetah will have traveled almost $^1/_3$ of a meter. So freezing the action of fast-moving animals requires an ultra-fast shutter speed. In this example, about 1/2000 sec. would do it.

Of course, photographs can also benefit from a little movement. To introduce some movement into your pictures, set a slower shutter speed. This will create blur that, managed properly, will give your images a strong visual energy.

Shutter speed is relative to the subject. Using the example of the cheetah, a shutter speed of 1/250 sec. would still be relatively slow compared to the speed of the action. However, the same shutter speed would be fast enough to freeze the motion of an eagle soaring.

A fast shutter speed has frozen the movement of this wolf as it runs along a river bank. Notice, too, how the splashes and tumult of water appear frozen in time. Nikon D2H, 24–120mm VR lens set at 120mm, 1/200 sec. @ f/11.

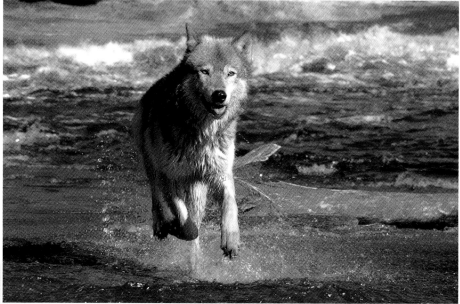

To capture this emotive image of a hippopotamus displaying hostility within its pod, I used a slow shutter speed to create a sense of movement. Nikon F5, 800mm lens, 1/25 sec. @ f/8, Fuji Provia 100F.

Camera panning

Camera panning is an excellent technique for giving your wildlife photographs a sense of motion. Used with a fast shutter speed, your subject will be frozen against a streaky background; with a slower shutter speed, both subject and background will have a level of blur that depicts motion.

The trick is to follow the movement of the animal with the camera from point A to point B. Stand with your feet slightly apart and ensure that you move the camera smoothly, avoiding any jerky movements.

It's best to predetermine the point at which you activate the shutter and continue to pan the camera for a few moments after the shutter has been released to avoid jolting the camera during exposure.

For best results, I recommend using AF in continuous-servo mode, allowing the AF to track the movement of the subject within the frame. Alternatively, use the predictive focus technique (see page 99).

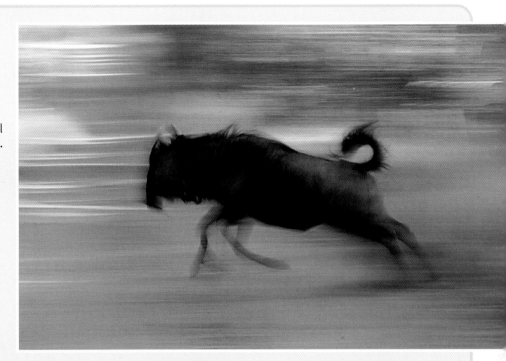

This is a classic wildlife image, captured using the camera-panning techniques described on the left. Notice how the background is streaked from the movement of the camera, right to left, as I follow the fleeing wildebeest. Nikon D2H, 80-400mm VR lens set at 80mm, 1/13 sec @ f/11.

Lens aperture and image quality

As well as affecting depth of field, lens aperture also affects optical rendering, which will influence the quality of the final image. The thickness of a lens changes between its center (thickest) and its edges (thinner).

At full aperture, almost the entire surface of the lens is used, causing the light rays passing through the thinnest parts of the lens to increase spherical aberration, resulting in a noticeable decrease in sharpness at the edges. To reduce spherical aberration—as well as coma (soft, pear-shaped image) and vignetting (soft, shaded edges)—you should close down the aperture by at least 1-stop from maximum. As you reduce the lens aperture, you increase the likelihood of diffraction and reduced image sharpness. Diffraction generally becomes apparent beyond f/16, and you would be wise to avoid apertures smaller than this if you want to maintain impeccable image quality.

Professional-quality lenses that are designed with aspherical lenses and special glass will give satisfactory results even at maximum aperture.

Artificial light

Because some animals are more active at night, there may be times when you need to use artificial light as your main light source. The obvious solution is to use a flash set-up—either a single unit or multiple units. The disadvantage of flash is that it can ruin a scene's natural look and, if mounted directly on the camera's hot shoe, will give flat, harsh lighting that is cold in color temperature. For this reason, it is better to use multiple flash units to light the scene, with one flash acting as the master unit and all others operating as slave units off the master. Using two or more units will also help to reduce distracting shadows, and increase contrast, adding depth.

Modern flash systems used in this way give excellent results, working from the camera's multi-segment metering system to provide accurate exposures. Adding a light orange or yellow filter over the flash will give the light a warm glow that is reminiscent of the light seen during the golden hours of dawn and dusk.

If you're using flash as part of a semi-permanent set-up, make sure you protect your equipment. Solid mounts will prevent lights from crashing to the ground in windy conditions, and a clear plastic bag will provide protection from rain and other moisture.

For set-ups that you plan to leave in place for several days, you may prefer to use older manual flash units, which are less expensive to replace should they become damaged or stolen. In this case, I would recommend operating the units using an external battery pack. You will also need to calculate exposure using a hand-held flash meter. It's worth running some tests to ensure that the system is working effectively.

Another option is to light the scene with a powerful flashlight. The flashlights used by game wardens in Africa have the power of four million candles, and are enough to provide adequate spotlighting on wildlife that is close by. Be aware that this type of lighting reacts with daylight film in the same way as a household bulb, which will give your pictures a strong orange cast, unless compensated for. The disadvantage is that it's low in power, which means you will need to use a slower shutter speed to ensure enough light falls on the film/DPS. As a result, image blur from movement or camera shake can be an issue.

> ## ⚠ Warning!
>
> **Artificial light and wildlife**
> Most wildlife is undisturbed by light from a flash unit. However, avoid using flash if the animal appears agitated. And refrain from shining a spotlight directly into animals' eyes, as it can cause discomfort and, with some animals, such as giraffes, permanent damage.

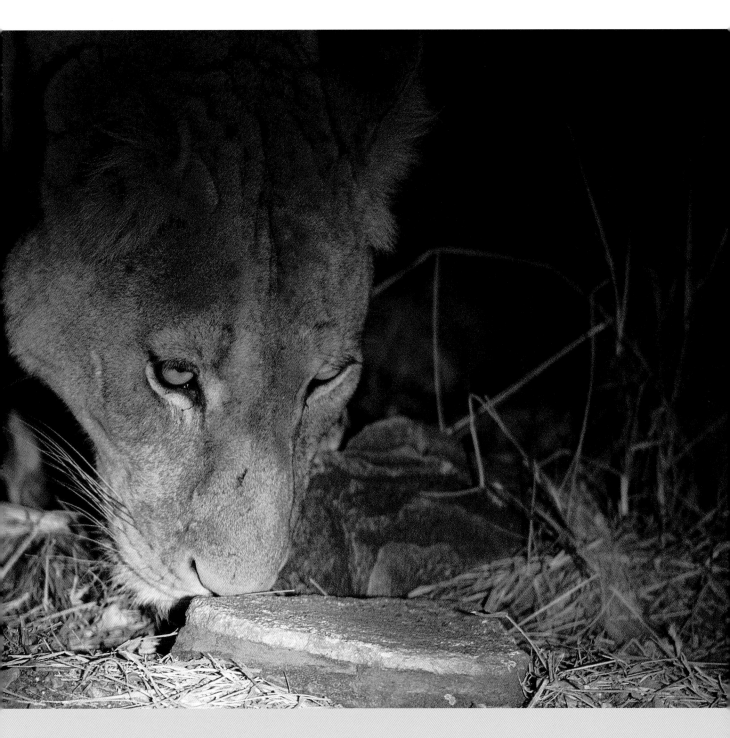

Taking pictures of wildlife at night is never easy. Here, I used a four million candlepower flashlight to illuminate the lioness. Notice how the sharp cut-off of light from the relatively low-powered source renders the background black. Nikon D100, 300mm, 1/125 sec. @ f/2.8.

Flash extenders

Most camera flash units are designed to work with lenses up to a maximum focal length of between 100–135mm, and have a limited flash range. Of course, many wildlife photographers shoot with lenses of 300mm focal length and more, and are often some distance from the subject.

Flash extenders give your existing flash unit extra "oomph." They are designed to operate with lenses of 300mm focal length and more, and work by concentrating the flash output using a precision Fresnel lens. This can give an additional 3-stops of light compared to using the unextended flash with a 50mm lens.

A word on digital

To avoid the cool color temperature of flash light using a digital camera, set the white balance on the camera to a warm setting of about 6000K (Kelvin). Following the pre-settings available on most digital cameras, this equates to "cloudy" (slightly warm) or "shade" (very warm).

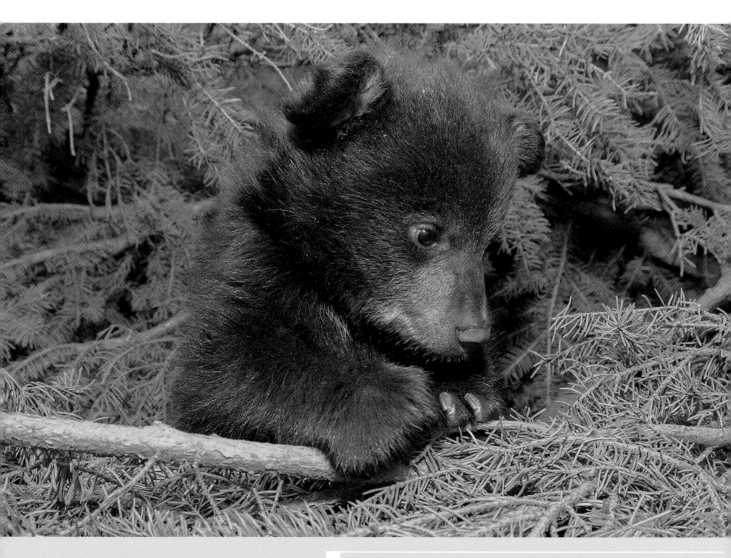

The light level for this shot of a black bear cub emerging from a thicket was so low that I had to use an external flash unit as the main light source. Nikon D2H, 24–120mm VR lens set at 62mm, 1/30 sec. @ f/8, Nikon SB800 flash.

Calculating flash exposure manually

Most modern flash units operate in conjunction with the camera to provide accurate exposures in the majority of shooting circumstances. However, if you ever need to calculate flash exposure manually, here's how.

Flash exposure is calculated on the flash-to-subject distance. This differs from natural light exposure calculations, which are based on camera-to-subject distance. If the flash is too far away from the subject, then your pictures will be underexposed.

The first step in calculating flash exposure is determining the range of your flash unit. You will need to know the guide number (GN), which is provided by the manufacturer, and refers to the amount of light generated by the flash unit at a given ISO/ISO-E rating. With the manufacturer's GN and the base ISO/ISO-E rating, you can then calculate the GN for different film/DPS speeds. This is most easily done by working in stops, using the f/stop series of numbers.

For instance, let's say your flash has a GN of 80 for ISO 100 film. To calculate the GN for, say, Fuji Velvia 50 film, first calculate the difference in stops in film speed. Fuji Velvia 50 is 1-stop slower than ISO 100 film. For the purpose of calculation, drop the zero from the original GN (80), giving you 8, and apply this to the f/stop scale: f/8. Now, open up one stop from f/8 (because of the slower film/DPS speed), and you have f/5.6. Multiply by 10 (to compensate for the zero dropped earlier in the calculation), and you get a GN of 56.

Now that you know the GN of the film/DPS you are using, you can calculate flash-to-subject distance using the following formula:

$$\text{Flash shooting distance (meters)} = \frac{\text{guide number (GN)}}{\text{f/stop (lens aperture)}}$$

Working with the example above, take your GN of 56, and let's say that your preferred lens aperture is f/16. Your flash shooting distance, therefore, will be 3.5 meters (56 divided by 16), If you want to shoot at f/8, rather then f/16, your flash shooting distance will be 7 meters (56 divided by 8). You can now determine where to position the flash relative to your preferred exposure settings.

If you're unable to move the flash unit closer or further away from the subject, and so must alter the lens aperture instead, exposure can be calculated using a slight variation of the formula.

$$\text{Lens aperture (f/stop)} = \frac{\text{guide number (GN)}}{\text{flash-to-subject distance}}$$

So, let's say you are five meters away from your subject. Your lens aperture would need to be set at f/11 (56 divided by 5.)

Tip!

When photographing wildlife using incandescent lighting (such as a spotlight), try switching to film balanced for tungsten lighting, or use a blue filter to produce a more natural color balance. Otherwise, your images will appear with a strong carrot-like orange glow.

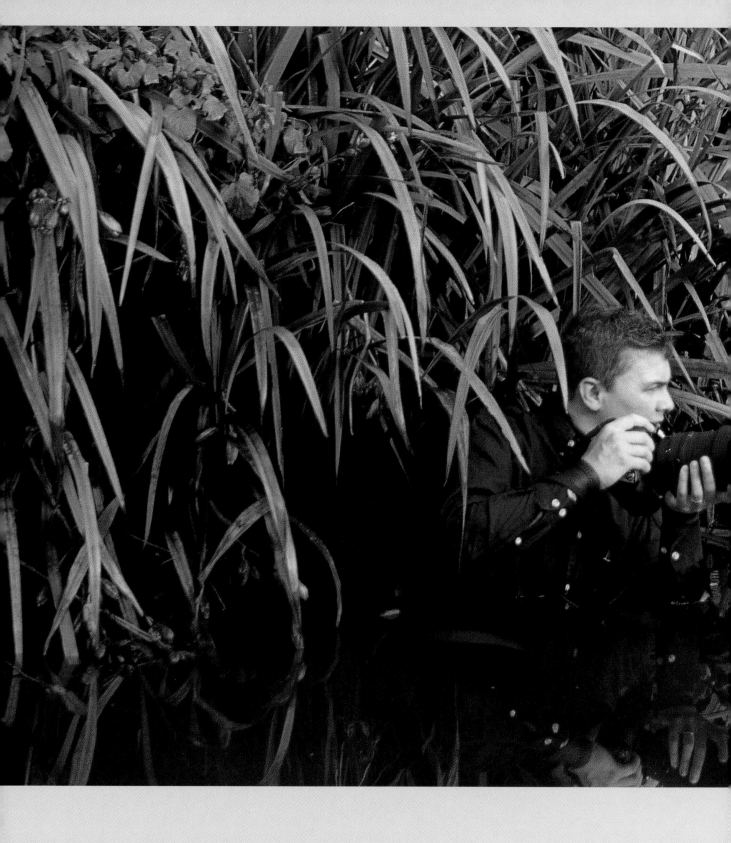

Understanding animal behavior

If you really want to learn how to take stunning wildlife images, then devote your spare time to learning about animal behavior. Great wildlife photography is about anticipating the moment and being ready for the action. If you wait for an animal to do something, chances are it will have done it and gone away long before you press the shutter. Most animals act far faster than we can react— they need to in order to survive. The key is to be ahead of the game, and that means knowing what to expect. It's a little like clay-pigeon shooting—you don't aim at the clay, you aim ahead of it.

There are many ways to learn about animal behavior. There are some excellent books on the subject (see Further reading, page 176), and the Internet is also a useful resource. Alternatively, build relationships with wildlife experts and/or biologists who operate in the field (see page 144). Their knowledge can be invaluable in getting the shot. Finally, there's nothing like first-hand experience, and personal field observation should be a part of your regular routine. Take frequent hikes in your local area, and look out for telltale signs, such as footprints, torn ground, and fresh droppings. Make sure you take along a good field guide to help you with identification, and a pair of binoculars for spotting.

Reading animals' body language is another factor in getting the shot. For example, did you know that a bird on a perch that flutters its wings and then defecates is about to fly away? Or that the position of an elephant's trunk can tell you how much danger you're in?

I always prefer being in the animals' environment rather than a human one. Here, I am chest-deep in a river, photographing several different waterfowl.

All animals communicate with body language, and knowing how to read it will help you anticipate, and get, great images. I managed this shot of a wolf pack's communal howl after two days of observation in the field and many months of theoretical study. Nikon D100, 800mm lens, 1/640 sec. @ f/5.6.

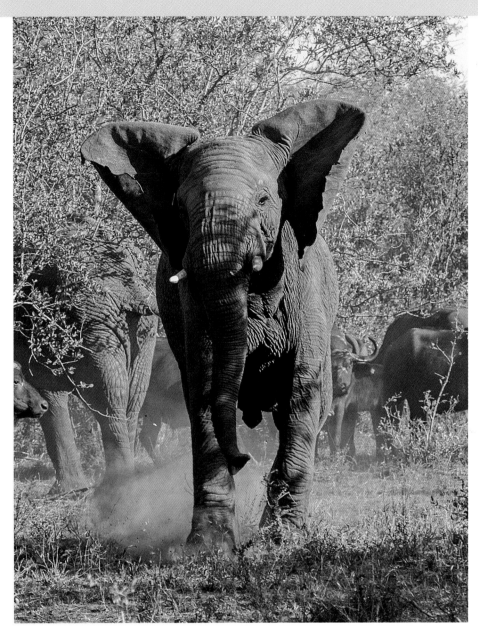

The position of this elephant's trunk told me it was time to get out of the way. Nikon D100, 24–120mm lens set at 120mm, 1/500 sec. @ f/5.6.

If its trunk is thrust forward and its ears are flapping, then you are being threatened. If its trunk is in a teapot-spout position, it will make a mock charge. And if its trunk is being held tightly against its body, well, you're in serious trouble. And what about a bear? When it's standing on its hind legs it is usually just getting a better view of its surroundings and sniffing for danger, but when it's quickly stamping its front paws on the ground, it's initiating a charge.

As well as saving your own hide, being able to read these signs, and those of all animals, is how professional wildlife photographers capture their great action shots. Admittedly, auto-focus and high-speed motor-winds help but, alone, they are not enough. All animals, including man, communicate with body language. Being able to interpret what they're saying will give you the chance to have your camera ready at the right place and time.

By watching this wolf for several hours I began to appreciate it's behavioral patterns, and was able to anticipate this shot of it shaking dust from its fur. Nikon D100, 80-400mm VR lens set at 98mm, 1/160 sec. @ f/16.

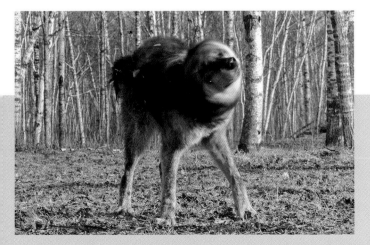

Tip!

An excellent book on the subject of animal behavior is *The Secret Language and Remarkable Behavior of Animals* by Janine M. Benyus (ISBN 1-57912-036-9). Written for the layperson, it is packed full of information to help wildlife photographers interpret animal body language.

Getting close—stalking

Stalking animals is an integral part of wildlife photography, and it's the only way you're going to get close enough to many species to photograph them. Your first consideration should be your equipment. SAS-style backpacks and big, heavy lenses are too conspicuous and unwieldy, so keep equipment down to the bare essentials. If the level of light allows, opt for the lighter and smaller slow lenses, such as a 300mm f/4, which is a fraction of the size and weight of the 1-stop faster f/2.8 version of the same focal length. Optical stabilization lenses (see page 24) will help when hand-holding the camera, and a monopod is a good compromise between no support and a heavy tripod.

The first thing to bear in mind when stalking an animal is to always keep downwind of it, even if it means making a long, laborious detour. Mammals, in particular, can smell odors several hundred meters away (a grizzly bear, for instance, can smell a wrapped chocolate bar in a pocket from two miles away!) So it's no use trying to hide behind a tree if your scent is acting like the proverbial foghorn. Masking your personal odor will help you get close. Avoid wearing anything scented, carrying food, and smoking. Ideally, if you have the opportunity, rub yourself with earth and the natural smells of the terrain.

When stalking an animal in the undergrowth, use trees and bushes for cover. Remember, though, that you still need to move noiselessly, avoiding the

To get frame-filling images of animals in the wild, such as this Bengal tiger, you'll need to learn how to track and stalk wildlife successfully—and safely! Nikon D100, 80-400mm VR lens set at 330mm, 1/400 sec. @ f/8

rustling of leaves and the snapping of twigs. Before approaching an animal, assess the various paths for the one most hidden but with the least resistance.

If the terrain is open, your subject will see you coming, so you must minimize its perception of the threat you pose. In my experience, crawling while showing no interest in the subject (looking away from the animal and not heading toward it in a straight line) is the most successful approach. Wearing clothing that blends in with the landscape, and a camouflage netting to cover your body, will also help.

Wearing clothing that blends in with the environment, or camouflaged netting (shown here), will help when stalking wildlife.

Successful stalking over open ground requires patience and, nine times out of 10, results in your subject scurrying for cover long before you've fired off a single frame. I once spent three hours on my belly covering just 328 feet (100 m) to photograph crocodiles in Africa. At the beginning of the stalk, there were 18 crocodiles along the river bank. As I edged closer, one by one they slipped into the water and sank out of sight. By the time I was close enough to take a shot, just one remained. Fortunately, that one gave me 10 minutes of productive shooting, making the whole experience worthwhile.

Stalking can be a disheartening and morale-draining exercise. Before you give up, think on this: some "professional" stalkers, such as lions, have a hit rate as low as one-in-20. If you manage the same level of success, then you're up there with the best of them.

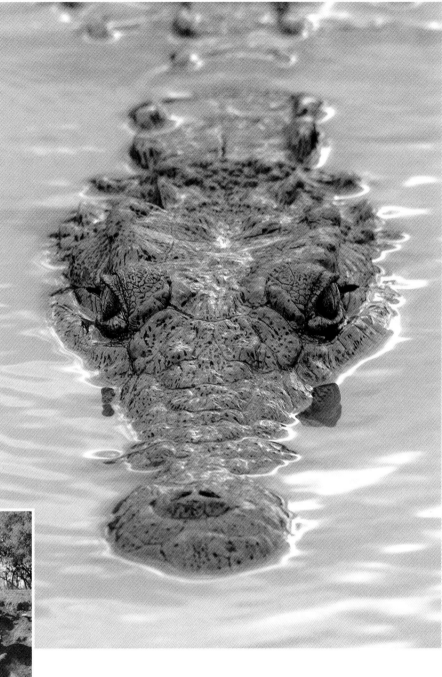

For this shot of a crocodile, I spent three painful hours covering just 328 feet over open ground to get close enough to the action. Nikon D100, 80–400mm VR lens set at 400mm, 1/250 sec. @ f/11.

Be prepared to fail when stalking wildlife— even the experts miss more than they catch. I managed to grab this shot of a buffalo herd as they stampeded after spotting my approach. Nikon D100, 24-120mm lens set at 120mm, 1/500 sec. @ f/5.6.

The circle of fear

All animals have a circle of fear (an area around them within which they feel safe). Once the circle is breached, they flee. The size of this area depends on available cover, possible escape routes, the season, and the animals' own "personality." For example, some birds, such as ducks, egrets, and spoonbills, are easy to approach, particularly if they are feeding. Herons, on the other hand, are more wary, and cranes have a circle of fear of about half a mile.

Many garden birds, while wary in summertime, come within touching distance in winter if bribed with a little food. A brown bear in Katmai National Park in Alaska may let you within a few feet of it during the summer salmon run, but will be far less accommodating immediately after hibernation in the spring.

Sometimes, you can use an animal's sense of smell to your advantage. For instance, should you locate a badger sett, spend three or four weeks simply taking food to the badgers, making sure to keep away from the entrance to the burrow itself. After a while, the badgers will associate your smell with the food, and your presence will be tolerated.

All animals have a "circle of fear" that, when penetrated, causes them to flee to a safer distance. How close you can get depends on the species. For birds such as the sandhill crane, it can be nearly half a mile! Nikon F90X, 300mm lens with 2x converter (600mm), 1/250 sec. @ f/8, Fuji Velvia 50.

One of the skills you need to be successful in wildlife photography is getting within an animal's circle of fear. Here, I am photographing a female puma with her cubs in North America.

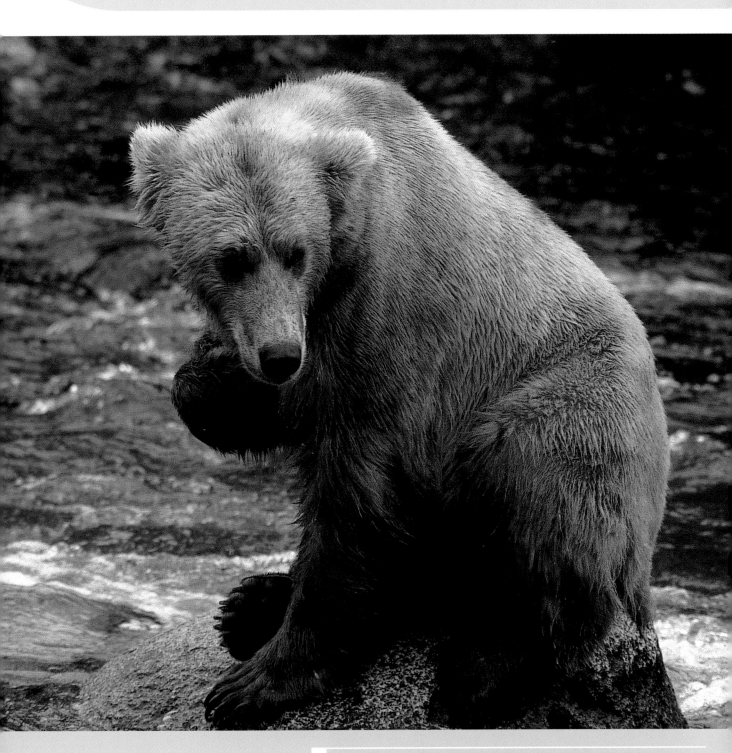

An animal's circle of fear varies, depending on the circumstances. Brown bears at Katmai National Park in Alaska can be approached safely to within 50 yards in July because of the abundance of food, namely salmon. At other times, though, they become far more territorial and you should keep your distance. Nikon F5, 300mm lens with 2x converter (600mm), 1/125 sec. @ f/8, Fuji Provia 100F.

"Fashion" in the field

Wear practical and water-resistant clothing that protects against the habitat you're working in. Military surplus stores are a great source of functional gear made of tough fabrics in colors that merge with the environment. Patterned camouflage isn't essential—just wear natural tones, such as green, brown, tan, and khaki.

Pockets should have zips, not Velcro, which is noisy, and you should avoid materials that make a noise when rubbed. As a general rule, natural fibers, such as cotton and linen, are preferable to man-made fibers, such as nylon and polyester.

Clothes should be worn in layers, so that you can add or remove items easily when necessary. In summer, avoid cotton underwear, which absorbs perspiration and takes ages to dry. In winter, wear high-quality polar fleeces to keep the elements out.

If you're going to be working in very wet environments, such as in rivers or wetland areas, then rubber boots provide the greatest protection. Otherwise, a pair of sturdy hiking boots lined with Gore-Tex or a similar material will keep your feet dry, without causing excessive perspiration. For safety, choose footwear with Vibram soles, which grip most surfaces, reducing the risk of falls. As for socks, you can't beat wool.

In very cold weather, wear a hat, which will keep your whole body warmer for longer. Gloves, too, make life outdoors more bearable in winter and on cold mornings. You may need to remove them when you actually begin shooting, but they'll stop your fingers from going numb during long waits in the field. You may want to finish off your outfit with a camouflage net, which you can get from military surplus stores. It will help to keep you hidden in the field, and can be used as a scarf when cold.

A wildlife photographer on an assignment could be mistaken for a soldier on maneuvers!

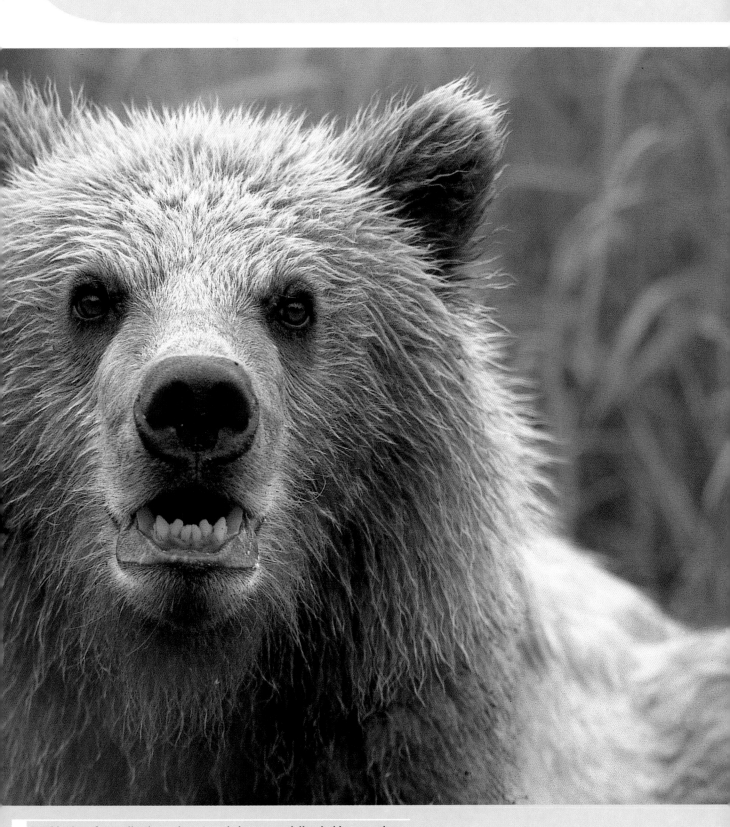

For this shot of a yearling brown bear, I needed some specialist clothing, namely a
pair of chest-high waders for traversing Brooks River in Alaska. Nikon F5, 300mm
lens, 1/125 sec. @ f/5.6, Fuji Provia 100F.

Working from blinds

A productive blind requires that you do your homework. First, you need to make sure that animals are present, so scout locations and look for signs, such as fresh tracks and droppings. Then assess the lighting conditions. In particular, consider where the sun rises and sets so that you position the blind at the best angle for photography.

Stationary blinds should be solid and covered in a light,waterproof canvas. As with your clothing, avoid man-made materials, which are noisy and prevent moisture from evaporating. It's likely that you'll be in the blind for the best part of a day, so make it big enough so that you can stretch out.

You now have two options. Either set it up some distance from where the final position will be, and gradually move it closer every few days, or set up a decoy blind in the final position a few weeks beforehand for the animals to get used to. This can be made from branches and tarpaulin. When you're ready to start shooting, replace the decoy with your real blind when the animals are not present.

It's best to arrive before your subject becomes active, and with a second person who, once you're in place, can leave, so that any watching animal will think the blind is empty. With some birds, such as raptors and crows, you may need to use more than one person to fool them.

When you're in the blind, set up your equipment as quietly as possible, and make sure any spare gear and accessories are easily accessible. Film should be removed from outer packaging, though it's best left in the plastic containers for safety. If you're shooting with a telephoto lens, keep a second body with a shorter focal length lens handy in case the animal wanders closer than you expect.

Take plenty of water and food (stored in a plastic bag to hide any smell), a blanket, binoculars, a field guide, and an empty container so you can relieve yourself without marking your "territory" outside, which may ward off animals. Finally, when you leave the blind, do so with the same care that you entered it.

Five things to do while waiting in a blind

For the most efficient and productive photography from a blind, you will need to be *in situ* for most of the day, and ready for action at any time. That means hanging around, doing little for hours on end. Here are five things to do to pass the time without compromising your photo-taking opportunities:

1. Study field guides to increase your knowledge of your subjects.

2. Study the surrounding area for "grab shots" (photographs taken on the fly, that are unplanned and not anticipated).

3. Practise with your camera so that operating the controls becomes second nature.

4. Plan how to react when a subject does appear—what exposure settings will you use, how will you compose the shot, what focus mode will you use?

5. Observe other wildlife and try to interpret their body language.

And here are some things to avoid...

1. Talking on your mobile phone.

2. Falling asleep!

A typical "dome" blind, available commercially from suppliers of outdoor equipment, and via the Internet.

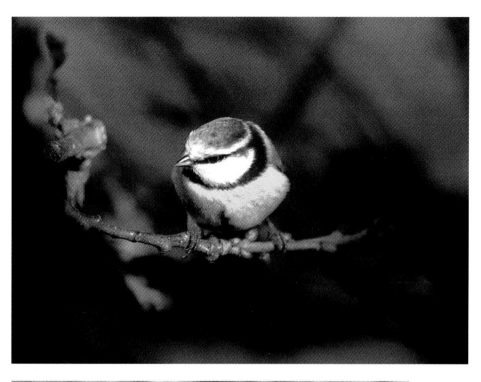

Working from a blind allows you to get much closer to wildlife than stalking in the open, making possible frame-filling images of even very small creatures. Nikon F5, 300mm lens with 2x converter (600mm), 1/125 sec. @ f/5.6, Fuji Provia 100F.

Mobile blinds

If you're photographing animals that are continually on the move, then a mobile blind is the best solution. The best designs are bottomless, have a rigid tubular structure that allows your camera to remain mounted when mobile, and have plenty of pockets for holding film and accessories so that you don't lose them along the way. Whenever possible, only move the blind when the animals are absent, and keep noise to a minimum. Used properly, mobile blinds are much less restrictive than stationary blinds, and let you cover large areas of ground with better results than you can expect from stalking.

When tracking animals that are constantly on the move over open ground, a mobile blind may be the answer. OK, you'll look a bit silly, but that's a small price to pay for getting the picture.

You need to take extra precautions with more intelligent birds. Some species of birds, such as hawks and crows, can count the number of people entering a blind. Nikon D100, 80-400mm VR lens set at 400mm, 1/320 sec. @ f/8.

Buried and elevated blinds

When photographing animals in open ground, you can use a buried blind. Dig a hole that is large enough for you to lie down in fully stretched. Cover with a natural colored, waterproof material, and secure with stakes or camping pegs. If it's raining, raise the cover slightly in the middle using a pole to allow rainwater to drain away.

You should enter and leave a buried blind with the same care and stealth that you would any other blind, and equipment should be protected from the dust and dirt that often gets blown about more at ground level. If you leave the blind for any length of time, warn passers-by that it's there with a sign or cordon.

To photograph animals in trees, such as nesting birds (see Wildlife photography and the law, page 7) and primates, you may need to erect an elevated blind. This is often a complicated and costly procedure, requiring the rental of scaffolding to create a collapsible tower. If you decide to go down this route, I would advise getting expert advice on how to erect the tower safely—both for you and for the public—and that when you're using it you also use a safety harness. For effectiveness, you need to use the same care as for any other blind, and you'll need a long telephoto lens (500mm or more), since the construction needs to be far enough away from the subject so as not to disturb it.

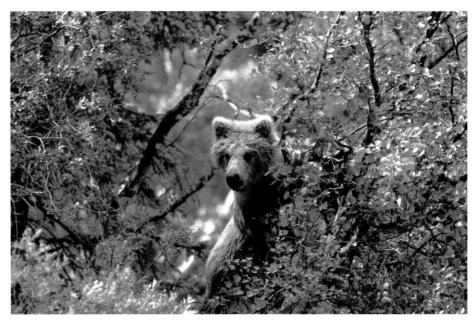

Getting at eye level with animals in trees or on high ground, such as birds, primates and, in this case, a yearling brown bear, may involve using an elevated blind, constructed from wooden or metal scaffolding. Nikon F90X, 800mm lens, 1/100 sec. @ f/5.6, Fuji Provia 100F.

1. Tarpaulin—raised to drain rainwater

2. Tent pegs

3. Beanbags

This diagram shows an example of the construction of a typical buried blind. This sort of wildlife photography takes some time to prepare.

Floating blinds

To photograph waterfowl that would otherwise be too distant to capture, you can use a floating blind. These are ideal for photographing courtship displays and nest-building in spring.

They're constructed by mounting a small framework on a buoyant base structure, then covering the lot with a camouflaged cloth, with holes cut in the sides for the camera lens. Cover the lens where it protrudes from the blind with camouflage netting. You then stand in the water under the blind. For safety, it should cover an area large enough to be stable, and you should always tread carefully as you move. In cold weather, wear a wet suit or dry suit to protect against hypothermia.

The inside of the blind should have plenty of pockets for accessories, spare film, and batteries. Store delicate equipment in a watertight container. To keep the camera steady, use either a tripod head mounted on the frame of the blind, or a beanbag. If you plan to be in the blind for a while, take food and water.

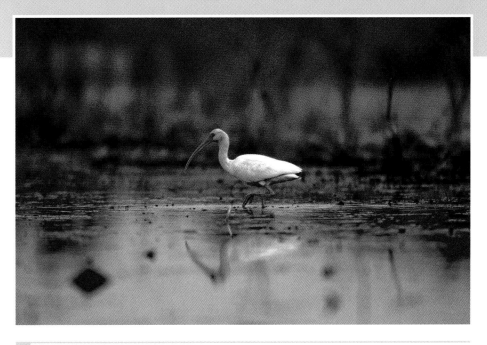

Floating blinds make approaching shy and elusive birds, such as this White ibis, possible. They also help to create a more aesthetic composition as you are at eye level with your subject. Nikon F90X, 300mm lens with 2x converter (600mm), 1/250 sec. @ f/5.6, Fuji Provia 100F.

1. Horseshoe shaped base made of wooden planking and filled with polystyrene.

2. A light, metal tubular framework supports the canvass cover.

3. Handle for manoeuvring the hide, and can also be used as an armrest.

4. Support for long lenses, such as a beanbag.

5. Watertight boxes are used for storing equipment, spare film and batteries.

6. A solid 'roof' protects the lens from rain.

7. Metal ring is used to tie the blind.

8. Storage pockets, sewn into the inside of the canvass cover for storing useful items.

9. Eyehole gives a view of activity around the hide.

Herons are notoriously shy birds, and approaching them on dry land can be difficult. A floating blind will enable you to get close enough for good photography. Nikon F90X, 300mm lens, 1/250 sec. @ f/2.8, Fuji Provia 100F.

This diagram shows the make-up and use of a typical floating blind.

Attracting animals to a blind

The easiest way to attract animals to a blind is with food. Laying out a few sunflower seeds, suet, or overripe fruit will quickly attract passing birds, particularly in the winter season when food is in short supply. If you use this tactic, it is imperative that you continue to feed the birds—and any animal you lure with food—throughout the winter, even after you've finished taking pictures, since they will become dependent on the food, and will continue to travel to the location in expectation of it.

Mammals are a little harder to attract, and you will need to learn the feeding habits of the species you hope to photograph. Badgers are particularly fond of peanut butter, for example, while salt licks provide an excellent lure for herbivores such as deer and bighorn sheep.

Attracting carnivores is more difficult still, and a chicken carcass can be left untouched while you're in the blind, only to be devoured as soon as you leave it. In this instance, patience is the key, and you will need to continue the feeding process until the animal becomes used to finding free meals near your blind. Be aware that most carnivores have a permanent territory that forms their hunting ground, and you will need to position your blind within this territory for it to be effective.

Most carnivores are territorial, which makes finding them easier once you know the extent of that territory. A little research will help make sure you're in the right place at the right time. Nikon D2H, 24–120mm VR lens set at 95mm, 1/800 sec. @ f/8.

Lures

During the breeding season, lures can be especially effective at attracting birds. You can use decoys on a pond or lake to attract members of the same species. However, acoustic lures should be avoided as they can upset the local ecosystem by disturbing birds with chicks, encourage neighboring male birds to become overly aggressive, and can even attract predators to the area.

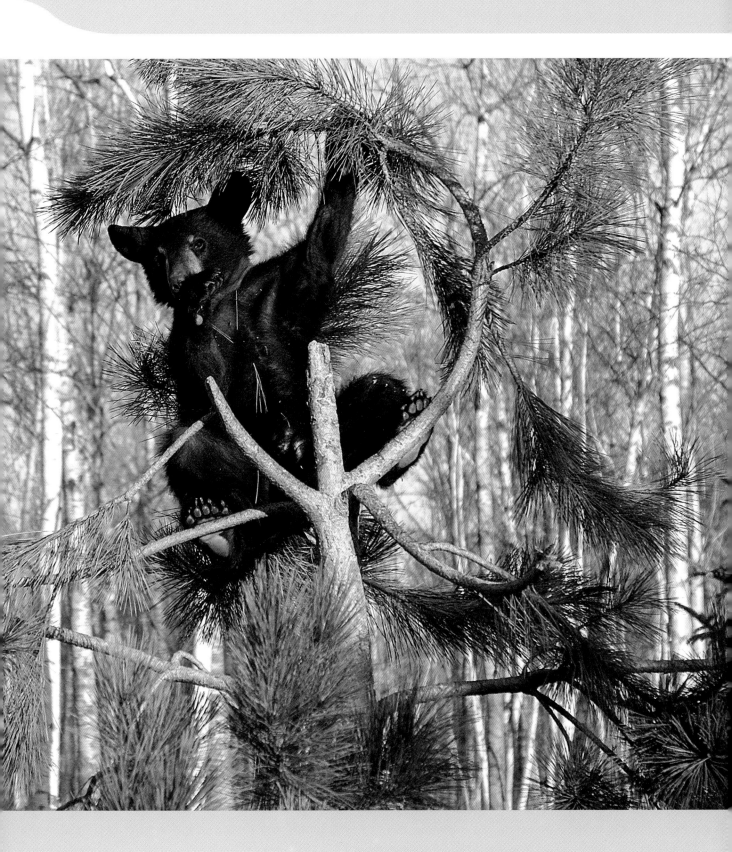

Professional profile

Chris Weston

"An assignment usually starts weeks or even months in advance of catching an airplane, and begins in my research office, reading through books, sifting through press clippings, studying maps, and trawling the Internet. The Internet has revolutionized my research to the point that I can't remember how I managed without it.

"A week or so before I travel I test and prepare the equipment I'll need. This will include the cameras, lenses, lighting, remote-control devices, and various general accessories, as well as any specialist gear I may require. Some gear, however, such as scaffolding for towers, I will pick up locally in order to save transporting it from the UK and incurring extortionate excess baggage fees.

"Once in the field, and whenever possible, I like to work with a biologist, particularly if I'm working in a location or with a subject I'm unfamiliar with. Having a specialist to help with fieldwork makes finding and approaching wildlife a far simpler process. More importantly, because of the style of photograph I like to produce, biologists help me to build a close rapport with individual animals, which means I can get closer safely (for both the animal and me) than I'd otherwise be able.

"This also allows me to abandon my super-telephoto lenses (500mm +) and use shorter focal length lenses, from wide-angle (12–28mm) to short/medium telephotos (80– 200mm,) instead. Although very long lenses are sometimes necessary, these shorter lenses give me a far more intimate perspective, which adds a greater dimension to my picture-making.

"I now shoot digital exclusively, preferring not just the immediacy of the image-capture process but also the additional flexibility that digital technology brings to wildlife photography. For me, digital photography has less to do with image manipulation, and more to do with having control over image quality in the camera. Never before has so much of the picture-making process been in the hands of the photographer."

Chris Weston's work can be viewed on his website: www.naturalphotographic.com

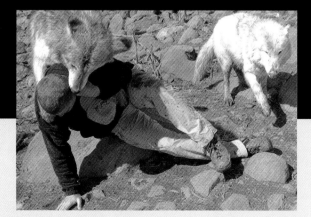

Mastering camera techniques

Animal portraits

Taking portrait images of animals is where many wildlife photographers begin. Certainly, some of the techniques needed for this style of photography are easier to learn than those required for successful action shots. Even so, there are some fundamental disciplines required that, if ignored, will result in poor pictures.

Your first decision is choice of frame format. A vertical format will emphasize the subject's features, while a horizontal format is more likely to accentuate the animal in its environment.

The most important parts of any animal that need to be sharp are its eyes (first) and its nose. However, because you'll often be shooting with a telephoto lens, depth of field is likely to be very narrow. You'll need a small aperture of between f/11 and f/16 for any creature with a long snout, such as a bear, wolf, rhinoceros,

hippopotamus, or lion. If it's impossible to get the necessary depth of field because of the lighting conditions, then always opt for the eyes. They are the first thing we look at in any portrait, wildlife or human, and they must be absolutely sharp or the photograph will fail.

Your other main consideration is lighting. Good portraits depend entirely on the right lighting conditions, however difficult this is for you to control. The best lighting for animal portraits falls from the side or slightly in front of the subject, in the early morning or late afternoon. If the animal is on a bright surface, such as the African savannah, snow, or sand, then the ground will reflect some light back onto the face, reducing harsh shadows.

Tip!

Fill-in flash
Consider using fill-in flash (at an angle of about 30–45° from the camera) to lighten the shadows caused by direct sunlight falling from the side. Make sure that the flash doesn't overpower the main light source when the subject is near, by dialling in minus flash exposure compensation. Maintaining a little contrast between the highlights and shadows will help to give your subject form.

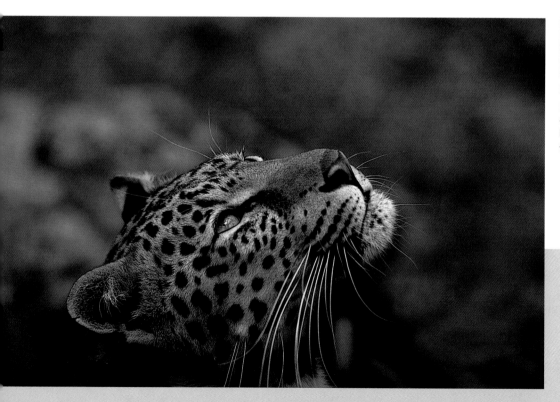

This image of an African leopard, taken in controlled conditions, is one of my most commercially successful shots. It has been used in adverts, on packaging, and even on the back of a violin! Nikon F5, 80–400mm VR lens set at 400mm, 1/125 sec. @ f/5.6, Fuji Provia 100F.

Animal portraits look best when the subject fills the picture frame. Cheetahs are one of Africa's most timid big cats, and can be quite approachable once they realize you are not a threat. Nikon D100, 105mm lens, 1/250 sec. @ f/5.6.

Technique tips

- Switching to a wide-angle lens will give your pictures a very different and appealing quality. Make sure it's safe to approach any animal before venturing within biting distance.

- Animal portraits look better when the subject isn't completely static. Try capturing a yawn, the licking of lips, a snarl, or the scratching of an ear. The more informative your image, the greater visual presence it will have.

Try to include additional information in your animal portraits. This picture of a bobcat is more compelling simply because the animal is yawning. It tells us something more than simply the species of animal. Nikon D2H, 24–120mm VR lens set at 90mm, 1/320 sec. @ f/8.

Use different focal length lenses to change perspective. Here, I used a 12mm wide-angle lens to capture an unusual view of a wild elephant. Nikon D2H, 12–24mm lens set at 12mm, 1/500 sec. @ f/11.

Fill-in flash techniques

Fill-in flash is a technique used to lift areas of shadow in a scene lit by natural light by using a burst of artificial light. It is particularly useful when photographing animals in direct sunlight. In hard-light conditions outdoors, the quality of light will cause dark shadows to form, particularly under the eyes, and around and under the nose. These shadows can be unflattering and obtrusive.

Also, if photographing a side-lit subject, the unlit side will contrast starkly with the lit side, and exposure will become a real challenge, if not impossible. Turning the subject so that its back is to the sun won't help much either, since, again, the face will be in shadow, and exposing for the shadow will render the brightly lit background washed out.

The basic technique has the flash unit on the unlit side of the subject. When the picture is taken, the flash will add light to the shadow areas, bringing out detail and making the tonal balance more even. The trick is to give just the right amount of light. Too little will be ineffectual, and too much will overpower the ambient light and detract from your composition. The effect you are looking for is one where the viewer is unaware of the flash at all. Most modern flash units work in conjunction with the camera's built-in computer to provide accurate exposures, and need little if any interference from the photographer.

In low-light conditions a fill-in flash can sometimes cause backgrounds to be underexposed, rendering them black. To avoid this, check if your camera or flash unit has a setting for slow-sync flash that utilizes a slower shutter speed. This will allow enough ambient light to illuminate the scene more naturally.

In all cases, avoid positioning the flash directly in front of the subject, as this will cause the animal equivalent of red eye. For best results, hold the flash at an angle of about 45° to your subject, using an appropriate flash cord to synchronize with the camera.

In scenes of strong contrast, use fill-in flash to lighten shadows and even-up the tonal range. Nikon D2H, 24–120mm VR lens set at 55mm, 1/320 sec. @ f/8, i-TTL Balanced Fill Flash (Nikon SB-800).

Tip!

When using a flash unit for an extended time in the field, consider operating it with an external battery pack to ensure power is maintained throughout the shoot. An external battery will also help to keep recycling times maximized, which can be important when photographing fast-action subjects.

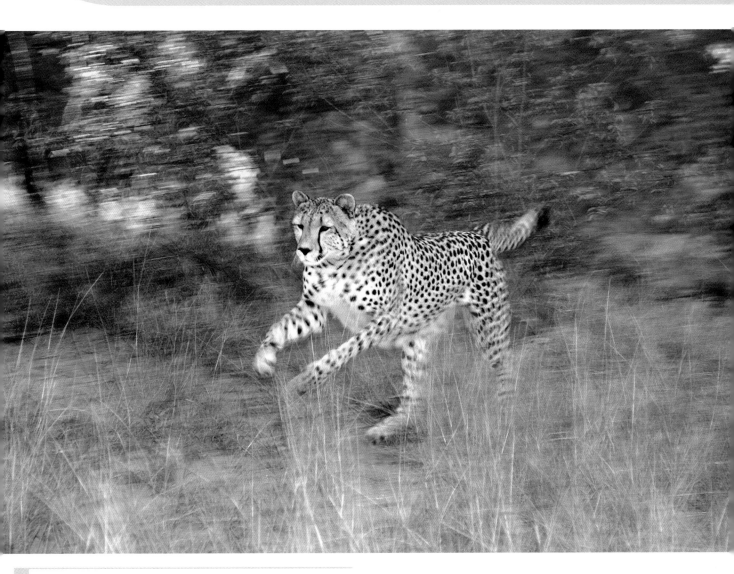

For this image of a running cheetah I used a quick burst of flash to help freeze the motion of the animal, illustrating another useful function of flash in wildlife photography.

Back lighting

Silhouettes make strong, graphic images. I underexposed this scene to lose all detail in the bird. Nikon D100, 800mm, 1/50 sec. @ f/5.6.

Back lighting has helped capture an atmospheric image of this newborn giraffe and its mother. Nikon D2H, 80–400mm VR lens set at 200mm, 1/750 sec. @ f/8.

Technique tips

- When metering exposure for back-lit subjects, switch to spot metering. This will provide a more accurate assessment of the light level for the effect you're trying to create.
- If you have to use multi-segment or average metering, and the animal fills less than two-thirds of the image space, use the exposure compensation function on your camera to adjust the exposure as necessary. Increase exposure for the golden halo effect, or reduce exposure for silhouettes. If you're unsure of the correct exposure setting, use the bracketing technique to reduce the risk of missing the shot.

A photograph of a back-lit animal can be wonderfully atmospheric, and is not as difficult to achieve as you might imagine. Your main enemy is going to be lens flare, caused by the light reflecting between the internal glass elements in the lens barrel. Flare can be avoided by using an appropriate lens hood or a professional quality lens, which has specially coated glass.

The best time of day for photographing back-lit wildlife is early morning or late afternoon, when the sun's low angle causes the atmosphere to diffuse the light, making contrast easier to deal with. Even so, it's how you expose the image that will determine the appearance of the shot. Exposing for the highlights, such as the area of sky behind your subject, will render the animal in silhouette, which creates a powerful graphic image. On the other hand, exposing for the shadows will create a beautiful golden halo of light around the edge of the subject.

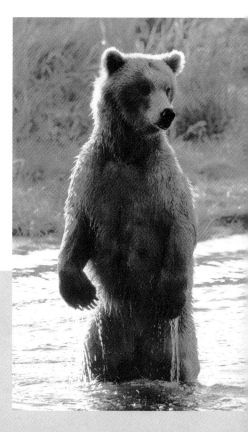

With controlled exposure, back lighting can be used to create a "halo" of beautiful light around your subject. Nikon F90X, 300mm lens, 1/100 sec. @ f/5.6.

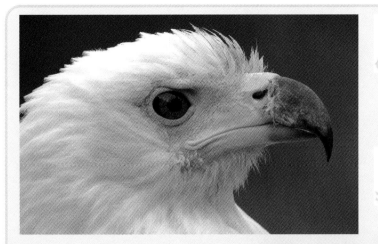

Of the three images, this one is exposed correctly. Nikon D100, 80–400mm VR lens set at 340mm, 1/90 sec. @ f/11.

This image is slightly overexposed. Nikon D100, 80–400mm VR lens set at 340mm, 1/60 sec. @ f/11.

Bracketing exposures

However hard you try, it's sometimes impossible to get exposure right. Many factors can influence it, including: very bright sunlight reflecting off shiny surfaces, such as water, sand, and glass; constantly changing light conditions like those on days where broken clouds fill the sky; and subtle variations in a subject's tonality. Plus, film manufacturers and processing laboratories operate to tolerance levels that could make a difference of up to $1/2$-stop in your exposures.

Because of these factors, you may want to bracket your exposures. Bracketing involves taking more than one photograph of the same scene at varying exposure values above and/or below your initial exposure setting. Typically, the variance should be about a $1/3$- to $1/2$-stop. On rare occasions you may want to go as far as +/- 1-stop.

Some cameras have an auto-bracketing function that allows you to set the parameters for bracketing. The camera then takes two or more shots automatically using the auto-wind to advance the film (or to replenish the DPS in digital cameras).

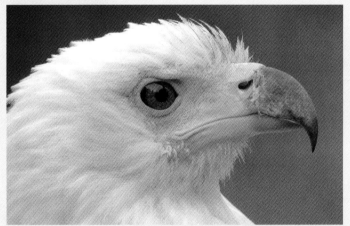

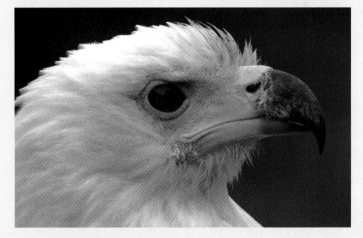

This image is slightly underexposed. Nikon D100, 80–400mm VR lens set at 340mm, 1/125 sec. @ f/11.

Motion photography

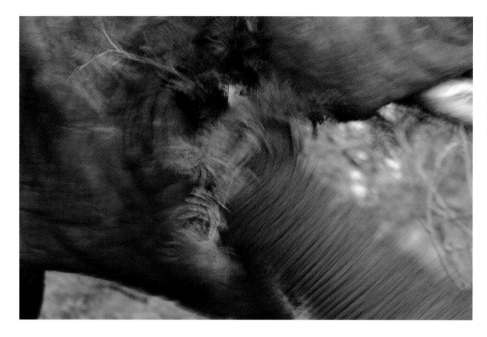

Blurring the appearance of motion can create images that have a more abstract quality, helping them to stand apart from our accepted views of wildlife. This picture of an elephant eating vegetation is a good example of how to make everyday occurrences appear more interesting. Nikon D2H, 80–400mm VR lens set at 250mm, 1/8 sec @ f/8.

Wildlife is rarely motionless, and capturing a sense of movement through image blur will create images full of visual energy that truly stand out. The technique requires good use of the viewfinder, and control over shutter speed and, to a lesser extent, lens aperture.

Set a slow shutter speed—somewhere between 1/20 and 1/125 sec. depending on how fast your subject is moving (the faster the animal, the faster the shutter speed)—and follow the animal's line of travel through the viewfinder. It's best not to crop too tightly in-camera, allowing the animal some room to "move" within the picture space. When you have a good composition, fire the shutter and continue to follow your subject with your camera for a few seconds. This will ensure that the camera doesn't come to a sudden stop and jerk while the shutter is open.

Depending on the shutter speed, the level of visible movement, which is depicted by image blur, will vary from slight (faster shutter speed) to quite pronounced (slower shutter speed.)

For this emotive image of a black-winged stilt, I switched to a slow shutter speed to give the image a sense of motion. Nikon D100, 800mm lens, 1/15 sec. @ f/5.6.

Technique tips

- Use lens aperture to vary the quality of the background. A wide aperture will make the streaks of movement merge together, while a smaller aperture will give a more pronounced result.
- If the intensity of light is too bright to attain a slow shutter speed, use a neutral density filter to reduce the level of light entering the lens.

Using motion blur for this image has helped to accentuate the movement of the wolf passing through the rock "tunnel." Nikon D2H, 24–120mm VR lens set at 110mm, 1/25 sec. @ f/8.

Although the movement of the vulture in this image is frozen by shutter speed, the streaked background gives the appearance of motion. Nikon D2H, 24–120mm VR lens set at 120mm, 1/320 sec. @ f/5.6.

Action photography

Making great photographs of animals in action is one of the most rewarding areas of wildlife photography. The thrill of the chase, the joy of watching young at play, and the fascination of animals interacting, make for pictures full of passion. For the best results, you'll need a camera with AF and enough light to set a fast shutter speed.

There are essentially two types of animal action: predictable and unpredictable. Predictable action, such as an animal traversing an often-used path, is relatively easy to photograph, because you can anticipate the shot and have the camera in position, ready and waiting. In these instances, first observe what the animals are doing. Then set your camera to manual focus and pre-focus on a point you know the animals will pass through. Set a shutter speed of no less than 1/250 sec. and, if possible, a lens aperture of about f/11—this will give you sufficient depth of field in case the focus is slightly out. After that, you just have to wait for the right moment, where animal expression, light, and composition all fall into place.

Taking pictures of animals in action is one of the most rewarding, if difficult to perfect, areas of photography. Nikon D2H, 24–120mm VR lens set at 70mm, 1/400 sec. @ f/11.

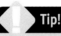

Tip!

While most modern cameras come equipped with AF capability, it is worth noting that not all AF systems are created equal. The systems incorporated in professional-specification cameras, such as Nikon's D2H, vary significantly to those used in consumer-grade cameras, such as the Nikon D70.

Typically, the difference is in speed and responsiveness, and this can have an impact on the success of your shoot. If fast-action wildlife photography is your passion, then consider investing in one of the professional camera models.

The same can be said of some AF lenses. All my Nikon lenses are AF, but some are more efficient than others. For example, I have a 300mm AF-S lens that is both fast and silent in operation. However, the 80–400 VR lens is pedestrian and noisy by comparison, and requires skilled handling for successful fast-action work.

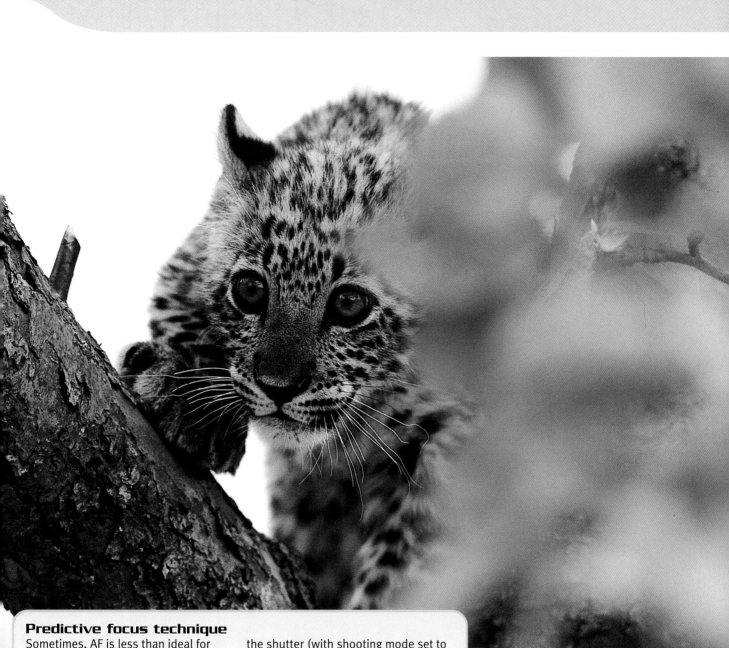

Predictive focus technique

Sometimes, AF is less than ideal for action photography. An alternative technique is predictive focus, which you can use when you know the path an animal will take.

First set your camera to manual focus mode, then focus on a point along the line of travel where you will take the picture. Then, frame the subject in the viewfinder and follow its progress by panning, see page 65. Just before the animal reaches the pre-determined focus point, activate

the shutter (with shooting mode set to continuous), and keep the camera exposing images until just after it passes. As long as you have at least one exposure when the animal passes the point of focus, you will have one sharp image for the album.

This technique does take some practise, but it's worth persevering with as it's a useful skill to have in your armory when the need arises.

Because I could predict the line of travel of this three-month old Persian leopard cub, I used the predictive focus technique. Nikon F5, 300mm lens, 1/125 sec. @ f/2.8.

Unpredictable action is more difficult to capture because you have no idea where to focus the camera. Switch your camera to continuous AF, where the focus tracks the animal from one AF sensor to the next, as it moves around the picture space. You'll need to select your origination AF sensor and get your subject in focus. Then it's a question of working the viewfinder to follow the action while letting the camera keep the subject sharp.

Two things will help: firstly, don't crop too tightly in-camera; secondly, zoom out or switch to a shorter focal length to give the animal space to move within the image frame. Also, you're more likely to achieve the shot if your camera is supported on a monopod or hand-held with an optical stabilization lens as opposed to being supported on a tripod.

Again, a fast shutter speed and medium lens aperture will help. If light levels allow, I recommend an exposure setting of about 1/250 sec. at f/11, or 1/500 sec. at f/8. For particularly fast-moving animals, you may need to shoot at speeds above 1/1000 sec. For action photography, shutter speed takes priority over lens aperture, so if you have to compromise, open up the aperture before sacrificing shutter speed.

A fast-frame advance will also help, but be wary of simply holding down the shutter until the film runs out or your CF card fills up. Top professional cameras shoot at about 8–10 frames per second, and can whiz through a roll of 35mm film in about four seconds. By the time you've changed films, the action will almost certainly be over.

With digital cameras, burst rate is a greater challenge. Except for very expensive professional models, most digital SLR cameras have a burst rate of just a few frames before the camera locks up and downloads the captured images to the storage device. And you can guarantee that the best shot will be the one that happens just after the camera locks.

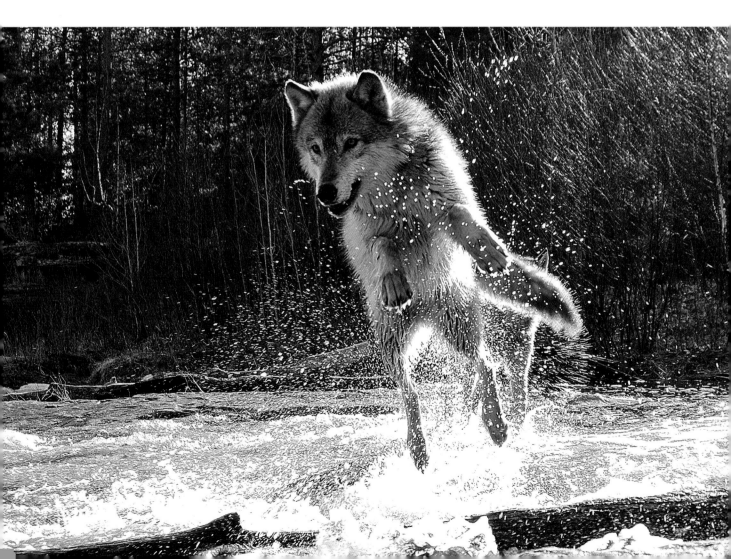

Successfully capturing wildlife action means working the viewfinder. Use it to observe events as they play out in front of you as much as a guide to framing and composition. Nikon D2H, 80–400mm VR lens set at 150mm, 1/500 sec. @ f/11.

Technique tips

Good action shots take practice. If you don't have any wildlife to hand, choose another fast-moving subject, such as a cat or dog, a soccer game, or even a young child playing. Alternatively, visit a safari park or wildlife sanctuary. Don't worry too much about composition—just try to take consistently sharp images.

If light levels don't allow the shutter speed/lens aperture combination you need, then consider up-rating, or "pushing," your film, or altering the ISO-E setting on digital cameras, to a faster speed. Most ISO 50 and 100 films can be up-rated by 1-stop without any noticeable loss in quality—this is particularly true of "professional" films such as Fuji Velvia and Fuji Provia F. Alternatively, Fuji Provia 400F is a very fine-grained, fast film that produces good results in low-light conditions. While some digital cameras suffer increased noise at faster ISO-E settings, most produce very good results with low noise levels up to 400 ISO-E.

Up-rating (pushing) film

The purpose of up-rating, or pushing, film is to gain additional stops of light when light levels are too low to attain the shutter speed/lens aperture combination you need. It is done by altering the nominal ISO rating of a film by manually changing the ISO setting on the camera. (You will need to switch off any automatic DX coding function on the camera to do this.)

When you up-rate a film, you are effectively telling the camera to act as if the film is more sensitive to light than it actually is. For example, you may take an ISO 100 film and rate it at ISO 200—1-stop faster than the base rating. When the camera takes a meter reading, it will assume the revised (faster) ISO rating, and give an exposure value accordingly.

Some films react better to being up-rated than others. In some cases, "professional" films, such as Fuji Provia 100F and Fuji Velvia, give better results when pushed 1-stop than a different film of the equivalent ISO rating. Whatever film type you are using, however, I recommend up-rating by no more than 2-stops, and preferably only 1-stop.

Up-rating film must be applied to the entire strip, and you must advise your processing laboratory of the change, otherwise you'll end up with a set of underexposed images.

To capture this shot of a wolf in mid-air was possible because I had the camera set up in anticipation of the action. Being ready, and having the camera ready, are key to creating great action images like this one. Nikon D2H, 24–120mm VR lens set at 50mm, 1/320 sec. @ f/8.

Photographing from a vehicle

Cars can make excellent temporary photo-blinds, particularly in places where animals have become familiar with their presence, such as in many National Parks. Like with all blinds, it's better to arrive before your subject, and I would advise covering the windows with camouflage netting, secured with strong adhesive tape, to obscure any movement inside the vehicle, which will make an animal nervous and more likely to flee.

The color of the car is largely unimportant, but do turn off the engine to limit noise and reduce vibrations. Once stationary, limit your own movement inside the vehicle, as this can give away your presence to some of the more intelligent creatures.

To support your camera, you can buy special mounts that attach to the side of the vehicle. However, experience has taught me that these gadgets tend to magnify camera movement and vibration. A better solution is to use a beanbag resting on the door through an open window. A beanbag gives you greater flexibility of movement, and dampens any vibrations.

Vehicles make great mobile blinds, particularly in areas where wildlife has become used to their presence, such as in many national parks.

Technique tips

- If using a beanbag, secure it to the vehicle so that it doesn't fall out. If you have to retrieve it, you'll disturb your subject and more than likely lose any further photo opportunities with that animal.
- In some parts of the world, cars are better replaced with more natural forms of transport. For example, the best way to photograph tigers in India is from the back of an elephant.

 Tip!

When working regularly from a vehicle, it's worth making up some kit holders to hang from the dashboard or over the seats to make accessing essential gear quick and simple. With several pockets, you can easily stow spare lenses, film or memory cards, cables, filters, and other gadgets.

Once accustomed to the sight of vehicles, animals are often less wary of your presence than if you were out on foot. Nikon D100, 800mm lens, 1/640 sec. @ f/5.6.

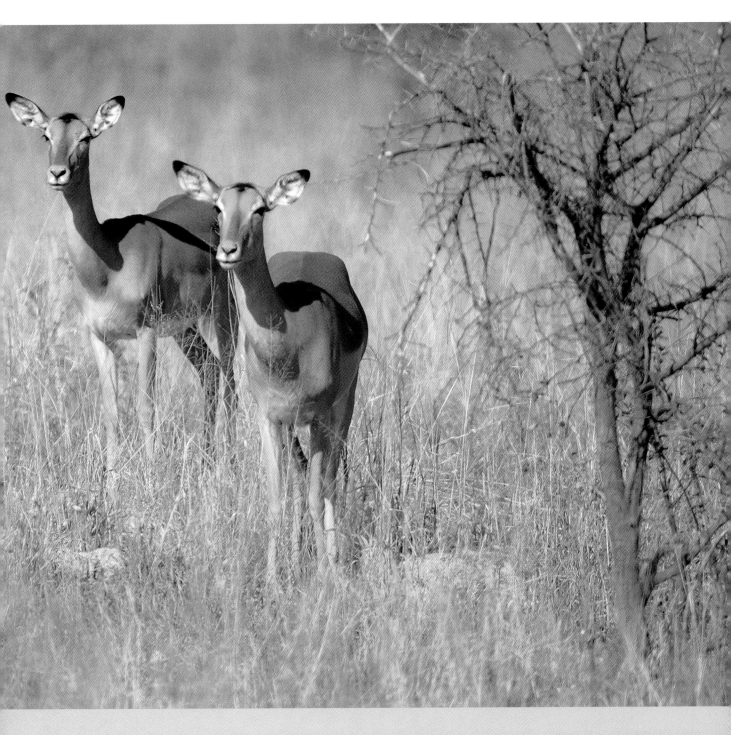

Photographing birds in flight

One of the principle difficulties of photographing birds in flight arises because of the relative size of your subject in the viewfinder. Small birds, such as tits and songbirds, can be all but impossible to follow without a super-telephoto lens (500mm or longer), since they can change direction extremely quickly. In these instances, along with a long lens, wide-area AF with multiple AF detection sensors will give you a fighting chance.

Larger birds, such as raptors, cranes, and herons, are easier to photograph simply because they fill a larger portion of the image frame. Even so, you'll be at an advantage if you can predict the flight path. Waiting for the breeding season will pay dividends since birds flying to and from their nest tend to follow the same route.

If you find that working with AF gives unpredictable results, you can use the predictive focus technique with the camera set to manual focus. Set the camera on a tripod and focus on a point that you know the bird will pass through. As the subject approaches, fire the shutter just before it reaches the pre-focus point. To give yourself some leeway, use a smaller aperture (about f/11) to gain a deeper zone of acceptable sharpness. (Remember that, the longer the focal length of the lens used, the more depth of field reduces. If you're using a lens greater than 400mm, you may need to stop down as far as f/16).

Usually, you'll be photographing birds in flight from below, which doesn't always give the most aesthetic compositions, although you can create some effective silhouettes this way. Ideally, you should try to find a raised viewpoint that puts you closer to eyelevel. Working from an elevated blind will help. Alternatively, shoot from a hillside nearby. If you have to photograph from the ground, then wait until you have a day with a dense blue sky, which will give a reasonable contrast range.

Technique tips

- Photographing birds flying over a bright surface, such as water or sand, will help illuminate areas of shadow when photographing from below.
- Following a bird in flight is easier when hand-holding the camera. An optical stabilization lens will help reduce the risk of camera shake blurring the final image.

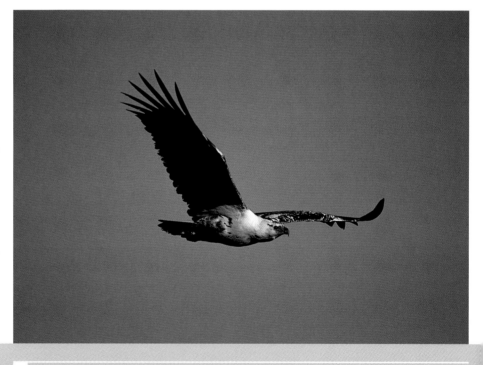

To get a more appealing perspective on this African fish eagle, I erected an elevated blind along a well-used flight path. Nikon F5, 800mm lens, 1/500 sec. @ f/8, Fuji Provia 100F.

Simple flight photography

The easiest way to begin taking pictures of birds in flight is to photograph them as they fly away from a perch, such as a tree branch or fence post. This gives you a little time to compose the image and focus on the subject while it's stationary.

Step 1 Set the camera to AF in continuous-servo mode, and set the shooting mode to continuous. Use a fast shutter speed of about 1/500 sec. if possible.

Step 2 Focus the camera on the bird while it's perched, and frame it so it's in either the top right or top left corner of the frame (depending on the direction of flight). This will ensure that when the bird leaves the perch it will drop into the frame rather than out of it (see below).

Step 3 Through the viewfinder, watch for the telltale signs that indicate imminent flight. For example, if a bird ruffles its feathers and defecates, then it's about to fly away.

Step 4 As the bird is about to fly, press the shutter and pan the camera in the direction of flight. The AF should track the movement of the bird to keep the image sharp.

Anticipating a bird flying away from a perch is simple when you can recognize some behavioral traits.

A typical sign is defecating and the ruffling of feathers...

...before the bird takes to flight. All three images: Nikon D2H, 300mm lens with 2x converter (600mm), 1/640 sec. @ f/8.

This illustration outlines the line of travel after a bird leaves its perch. Being able to predict the flight path makes photographing birds in flight a simpler task.

Photographing birds at the nest

First, I want to advise that you avoid photographing birds at their nest until you are very experienced in camera technique, and are knowledgeable about habitats and the environment. Nesting is a particularly vulnerable time for birds, and the slightest provocation can see parent birds abandoning unhatched eggs or their young. In some countries, photographing many species of bird at the nest requires a license, a system that protects threatened species from the sometimes over-eager attention of inexperienced photographers.

Once you begin photographing birds at their nest, start off by making careful observations from a distance, using a powerful pair of binoculars. Watch to see how often the adults fly to and from the nest with food for the fledgling birds, and from which direction they approach. If they sit continually on the nest, then the eggs are yet to hatch, and you should withdraw until a later time.

If the nest is in the open, you have few photographic complications to worry about. Your main obstacle will be any foliage or branches obscuring your view. However tempted you may be, under no circumstances should you remove branches or foliage. They are protecting the nest from predators. If you can find an unobscured view, just be patient and wait for the best light and right composition.

Closed nests—those in hollowed-out trees (woodpeckers), dug into the ground (puffins), in boxes (tits), or disguised in tall grass (bitterns)—provide a greater challenge. Observation needs to begin early so that you're ready when the chicks start to peek out of the entrance hole.

It's possible to build nest sites that have a transparent side, through which you can photograph the birds in the nest. However, these pictures lack originality.

In some areas of the world, photographing birds at their nest is simply a matter of turning up and remaining patient. This image of a puffin was taken on Skomer Island, off the coast of Wales, where puffins are easily approached and unbothered by human presence. Nikon F90X, 400mm lens, 1/300 sec. @ f/5.6, Fuji Velvia.

Once you identify a closed nest, you should make any approach unobtrusive and with stealth. It's then a question of biding your time until the right moment. Nikon D2H, 300mm lens with 2x converter (600mm), 1/200 sec. @ f/14.

Technique tip

- A less obtrusive way of photographing birds at the nest is to use a remote-controlled camera (see page 114). The camera should be set up while the birds are away. Once in place it will be ignored. With a remote-control device, you can sit up to 656 ft(200 m) distant and snap away happily, knowing that you are not causing distress.

Close observation of birds' habits during the nesting season is essential to ensure the safety and security of your subject. I spent several days observing this Cape Griffon vulture before beginning photography.

Photographing action sequences

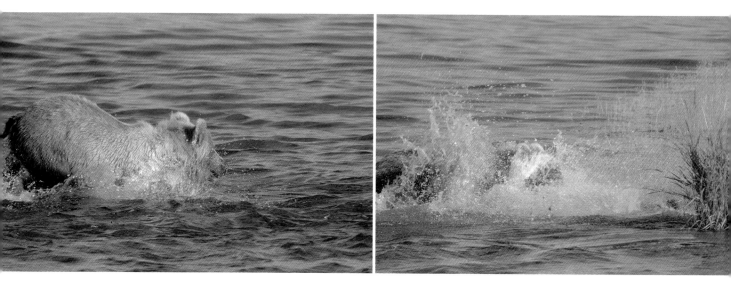

If a picture speaks a thousand words, then a good sequence of images merits a whole book. Sequences are the photographer's tool for revealing nature's secrets—how animals behave, move, hunt, play, and interact. A meaningful series of images is best achieved when you have some idea of the story you're trying to tell. Before you head out with your camera, study the behavioral patterns of your subject species, and try to construct a storyboard of the events you want to capture.

For example, on an assignment to photograph Brown bears in Alaska's Katmai National Park, I was aware of the different salmon-fishing techniques adopted by various bears. I knew that adolescent bears, who had yet to make it far enough up the hierarchical ladder to snatch the prime fishing spots, would chase the salmon through the shallow waters. I wanted to capture a sequence that showed the whole event, from first splash to kill, and so used my knowledge to plan the shots ahead of time.

I used a shot-by-shot technique that involved watching the action as it played out in the viewfinder, and firing the shutter only when the right composition appeared in the frame. It means having to work the viewfinder, and paying careful attention to what's going on in front of you. The advantage of this technique is that you are less likely to run out of film before the action is over. (Even so, it is better to keep a spare loaded camera to hand so that you don't miss any shots while reloading). For continuity, I kept exposure values consistent throughout my picture-taking.

A variation on the shot-by-shot technique, which can be used with a "fixed" subject, such as a bird building a nest, involves using an intervalometer. This is a mechanical or electronic device that controls the timing between shots, ranging from a few seconds to several hours. Some high-specification digital cameras have this accessory built-in. The camera needs to be well mounted on a sturdy support, and protected from the elements.

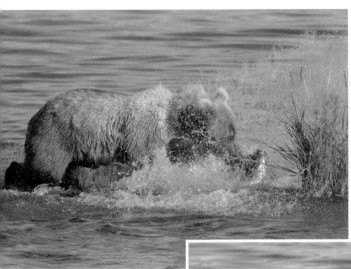

Taking a successful sequence of images requires practise and persistence. I used my knowledge of bear behavior and worked the viewfinder to capture this rare moment of a yearling brown bear successfully catching a prime salmon along Brooks River in Alaska. Nikon D100, 800mm lens, 1/320 sec. @ f/8.

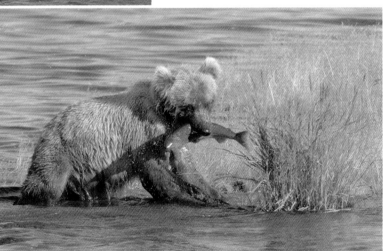

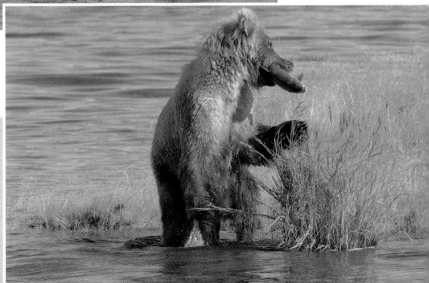

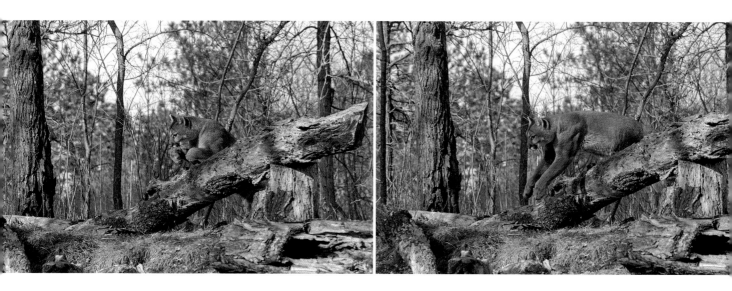

Another method for capturing a sequence of images is to fire the shots in a single burst. This technique is often used to reveal the breakdown of movement as it occurs. Occasionally, it is employed when it's impossible to know exactly when to fire the shutter for the right composition—somewhere in your 36 frames, you hope that one or two will have hit the mark.

When using the burst technique, you must keep a close eye on the frame count. A professional SLR will eat through a 36-exposure roll in about four seconds. If it's possible to slow down the frames per second (fps) rate, then shooting at 3fps will increase this range to 12 seconds, and will probably provide a more expressive sequence of images.

Technique tips

- When using the burst technique, make sure that any auto-bracketing function is switched off. Otherwise, only one in every three pictures will be correctly exposed.
- Use the camera panning technique (see page 65).

An alternative method to the shot-by-shot technique used for the sequence on pages 108–109 is simply to keep the shutter firing in continuous shooting mode. This technique is ideal for capturing a series of images that detail aspects of animal behavior. Nikon D2H, 24–120mm VR lens set at 120mm, 1/640 sec. @ f/7.1

Tip!

If you're reaching the end of a roll of film, or your memory card is almost full, consider replacing the film or downloading images before you start photographing a sequence of images.

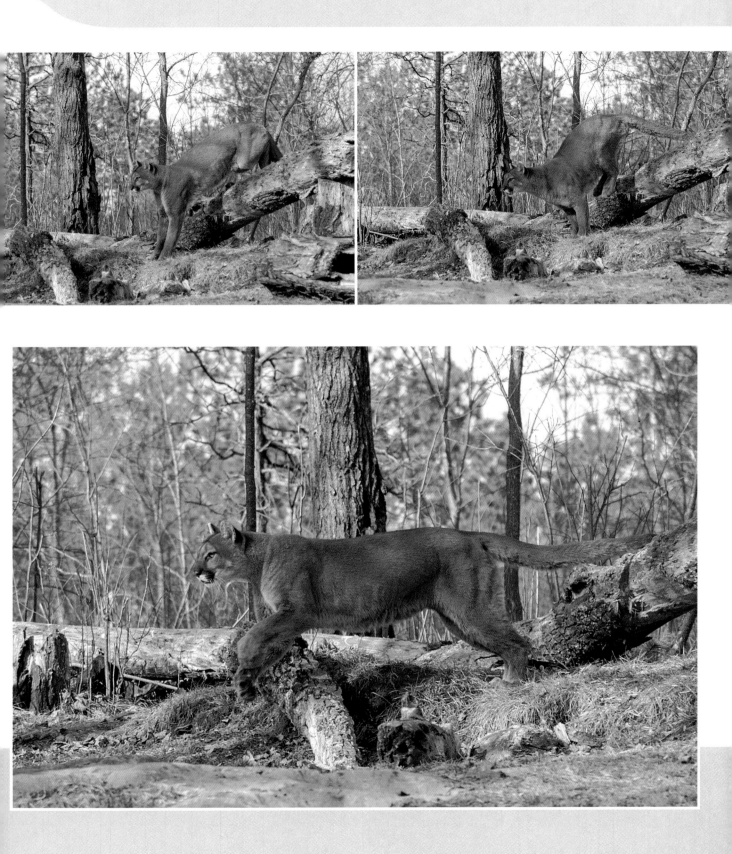

Aerial photography

Photographing from the air gives wildlife images a novel perspective, revealing a side of nature that few people get to see. Of the various forms of aerial transport available, the two most flexible for photography are the micro-light aircraft and the balloon.

Balloons have the advantage of flying at slower speeds, giving you a little more time to compose the shot. They are also quiet, which means they are less likely to scare wildlife into running for cover. On the downside, their direction is less easily controlled, and you may well find yourself flying in the opposite direction to where the action is.

Compared to balloons, micro-lights are fast and noisy, but they can, at least, follow the action, keeping up with a herd of migrating wildebeests, or following a stampede of elephants.

In both cases you'll almost certainly have to hand-hold your camera. To help reduce image blur caused by camera shake and vibration from the aircraft, use optically stabilized lenses, or select a fast shutter speed (depth of field becomes almost irrelevant being so far above the ground).

To compensate for the forward movement of the aircraft, particularly in the case of micro-lights, you may need to pan the camera backwards. The sense of motion this creates often gives images taken from the air a strong visual energy.

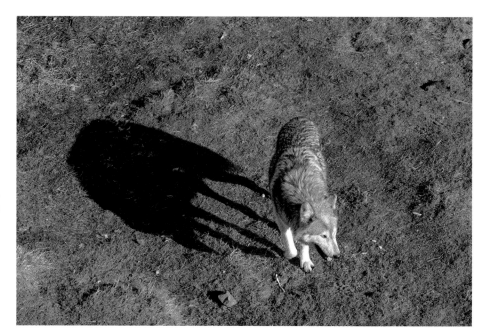

Technique tips

- Make sure your camera equipment is secured, to prevent it from dropping overboard.
- Opt for a zoom lens—it will give you greater compositional flexibility, and avoid the need to change lenses mid-flight, which can be problematic. A digital camera with a large-capacity memory card will also save time mid-air.

I have used an aerial perspective to emphasize the shadow cast by the late afternoon sun falling from the side of the wolf. Wildlife rarely looks attractive when photographed from above, and a successful image needs to have more of a message than a simple portrait shot. Here, I'm trying to convey an image of the wolf as a larger-than-life predator. Nikon D100, 80–400mm VR lens set at 98mm, 1/320 sec. @ f/8.

 Tip!

Photographing an animal from above requires that images have strong compositional properties to avoid simply looking unnatural. See page 124 for more tips on camera angle and perspective.

This image of a herd of charging elephants was photographed from a micro light aircraft above the Greater Kruger National Park in South Africa. The "natural panning" caused by the moving aircraft enhances the sense of speed depicted in the image. Nikon D100, 24–120mm lens set at 105mm, 1/40 sec. @ f/5.6

Remote-controlled cameras and camera traps

Remote-controlled cameras

Remote-control photography is a good way of photographing shy or vulnerable species. When the animal is not present, set up the camera in an appropriate position—it helps to have scouted the area beforehand—then retreat to a blind. Some remote set-ups have a video link that allows you to view the scene through the viewfinder from up to 650 feet(200 m) away using a monitor connected via a cable or independent transmitter. Otherwise, you'll need to use a pair of binoculars to check on the action and estimate the right moment to fire the shutter.

Of the two types of system available, infrared is the least expensive but it is also the least flexible. It has a limited range (about 100 feet/30 meters), and you can lose control of the shutter if a leaf, branch, or other obstacle blocks the line of sight between the transmitter and receiver. A radio-controlled set-up overcomes both these limitations. It has a range of about 650 feet (200 m). You can alter the camera's position remotely, thereby reducing the risk of camera failure. This technology does come at a price.

A remote-control cord used to fire the shutter without touching the shutter release button helps to avoid camera shake when using a camera mounted on a tripod.

Using an infrared device increases the distance from which the shutter can be triggered remotely. Typically, they work from 33–100 ft (10–30 m).

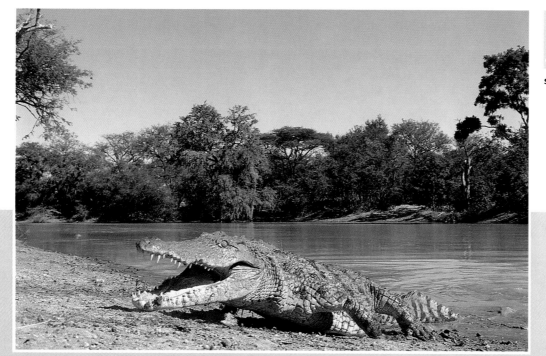

Not wanting to get too close to this wild crocodile, I triggered the shutter remotely.
Nikon D2H, 24–120mm VR lens set at 24mm, 1/320 sec. @ f/8.

Simple camera traps

With a camera trap, the animal fires the shutter. The camera is set up where there is known animal activity, such as along a well-trodden path or close to the entrance of an active den. A transmitter and separate receiver are then placed opposite each other along the line the animal will travel. When the subject passes through, it breaks the invisible beam and fires the shutter.

The advantage of this type of system is that the camera, suitably protected, can be left in place for as long as it has unexposed film or space on the memory card, and the photographer can be elsewhere. For this reason it's a system that works particularly well for nocturnal creatures, such as some leopards and badgers.

The downside is that the photographer has no control over composition, and the technique can take some experimenting with to master. It's advisable to use a digital camera so that the results from a period of shooting can be viewed immediately, and any necessary adjustments made on the spot.

Another problem with camera traps is that other animals in the area, and not the one you're after, will trigger the shutter, and you will find your film/DPS filled with shots of animals you were neither expecting or wanting.

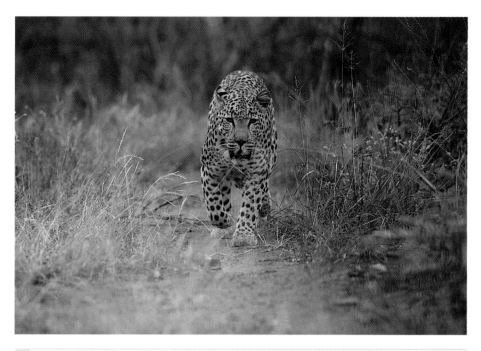

Having identified this often-used track in the bush, I set up the remote camera trap and let the leopard take its own picture. This technique often requires a degree of trial and error to perfect. Nikon F5, 800mm lens, 1/125 sec. @ f/8, Fuji Provia 100F.

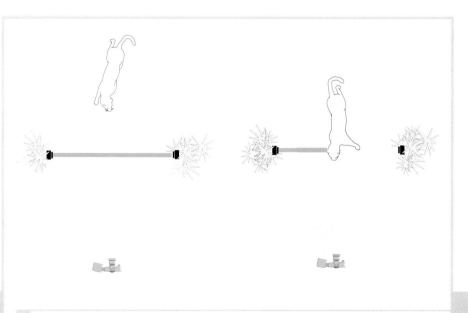

This illustration shows the camera trap in operation. A transmitter on the left sends an infrared beam of light to a receiver on the right. When the leopard cuts the beam a signal is sent to the camera and the shutter is triggered.

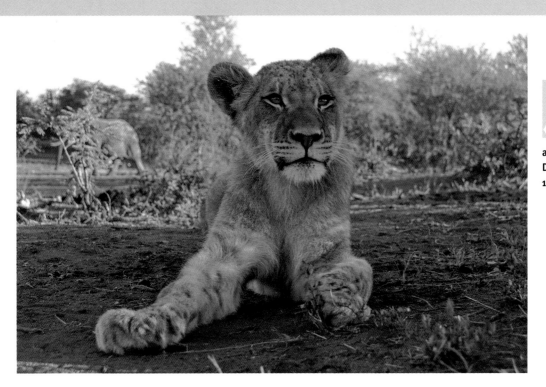

Getting this close to a wild lion on foot is inadvisable. A camera mounted on a remote vehicle is a far safer option, and achieves an unusual perspective. Nikon D100, 24–120mm lens set at 42mm, 1/640 sec. @ f/5.6.

Remote-controlled vehicles

Remote-controlled vehicles enable you to get the camera close to distant or non-approachable subjects. Any model vehicle should be purpose-made for the equipment it's going to carry, and "toy" models should be avoided as they are rarely stable enough for the job. Seek the advice of a model-builder who can help you design a rugged, well-balanced vehicle. The wheelbase needs to be large enough to avoid the set-up tipping over, and four or six wheels will make sure the machine doesn't become stuck. The camera can be mounted on a motorized universal joint that enables movement in all directions, and camera tilt can be controlled using a gyroscope.

Technique tips

- Soundproofing a remote camera will make it more effective. Wrap it in a blanket or similar, or build a purpose-made soundproof box to fit around it.
- In camera-hostile environments, protect your equipment from shocks, dust, dirt, and humidity with foam and adhesive tape. Protect it from water by placing it in a waterproof housing.

This illustration shows the technique used for photographing the lion cub remotely with a wide-angle lens.

Getting eye level with a Mallard duck using a floating blind. Nikon F90X, 200mm lens, 1/60 sec. @ f/2.

As well as ground vehicles, it's possible to design radio-controlled boats that can be used for photographing waterfowl and other types of bird on or near water. Some packaged models will work reasonably well, although a purpose-built structure will provide a more stable and secure vehicle for your expensive camera gear. The remote system and drive motor can be placed below the waterline to increase stability, with the camera mounted above, covered in camouflage material or a decoy. Before letting the boat loose with your camera gear on-board, test the whole structure with a weight equal to that of the equipment you'll be using.

Although less dangerous than a lion, terrapins are almost impossible to get close to. I used a remote controlled "goose" to get close enough to achieve a frame-filling image of this small, shy creature. Nikon F90X, 200mm lens, 1/250 sec. @ f/2, Fuji Velvia.

1. Camera

2. Decoy (white-fronted goose)

3. Miniature boat model

4. Receiver with antenna

5. Steering servomotor

6. Battery

7. Electric motor

8. Operation servomotor

9. Speed control

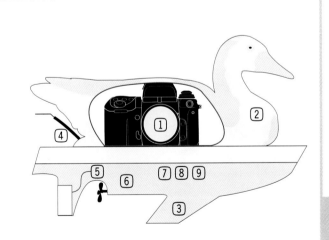

My "goosecam," made from a specially adapted radio-controlled boat and a decoy.

Professional profile

Art Wolfe, USA

"I am constantly working to record nature in different ways, and that challenge is, in part, what keeps me out there, photographing. Of all the visual arts, photography is uniquely suited to capturing nature at its finest, and my collection of wildlife images presents four distinct photographic perspectives.

"When I first began taking pictures of animals, I concentrated primarily on classic wildlife portraiture, going to great lengths to get as close to my subjects as was safe for both parties involved. My ultimate goal was to 'freeze' the instant of contact between photographer and animal. This is particularly effective when attempting to convey the spirit of the moment or the subject. Rather than letting the viewer remain detached, they are faced with an image that evokes an emotional response.

"After a time, my photographic perspective took an abstract turn. I have long been an admirer of artist M.C. Escher's beguiling use of negative and positive spaces, and capturing natural patterns on film soon became a favorite theme of mine. As in the series of portrait images, environment has almost no role in these photographs. Instead, it is the two-dimensional nature of the image that causes each element to be commensurate with the next, while the surrounding negative space warrants equal attention.

"The third direction my craft took was in capturing animal behavior. Much can be learned of the behavioral patterns of wildlife by studying movement, and finding a way to record motion in a still image presents a unique challenge. Further still, creating a successful artistic outcome with a portrait of movement is an even more difficult task to achieve, and I have played with this aspect of filming for many years, developing long exposure techniques to highlight the power and grace of my subjects.

"The last and defining perspective is, for me, key to the evolution of my work—capturing wildlife in its natural environment. Almost for the first time, I began stepping back from my subjects, creating within my images a greater sense of place. The photograph shown here of two mountain goats is indicative of this approach to wildlife photography. By using a wide-angle lens to gain an increased perspective of the subjects, they hold centre stage in the image while maintaining the viewers' appreciation of the surrounding habitat.

"These beautiful wild creatures, photographed browsing the wild-flowered meadows of Logan Pass, deep within Montana's Glacier National Park, are classic emblems of the open country of the Northern Rockies. Protected for decades, they have lost their natural fear of mankind and so, consequently, photographers and tourists alike can approach, or be approached, without fear or harm. In taking the picture, I utilized both a polarizing and a 2-stop graduated neutral density filter, which brought the entire exposure into alignment and gave the overall scene a vibrant composition. So that every blade of grass and flower petal is as sharp as the distant ridge, I set a small aperture (f/22) that helped maximize depth of field."

Art Wolfe's work can be viewed on his Web site— www.artwolfe.com.

Wolfe Inc.

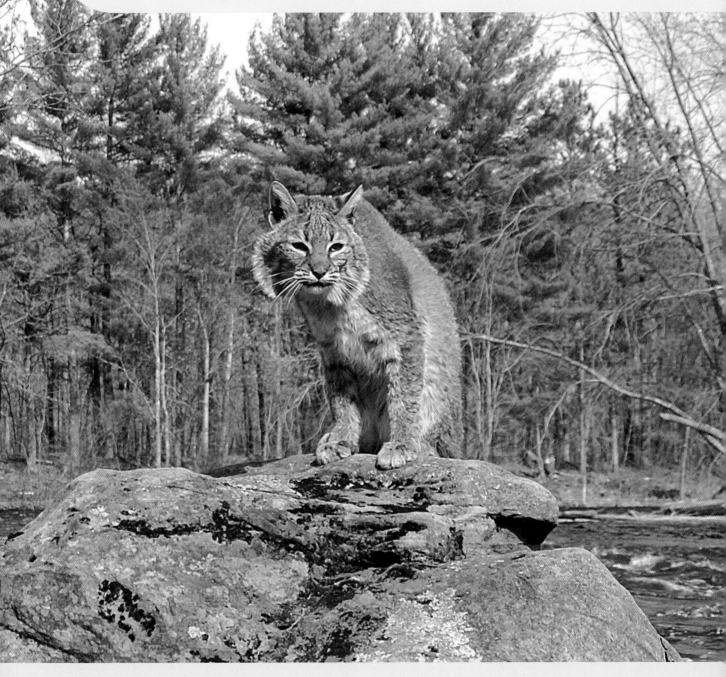

Defining the picture space

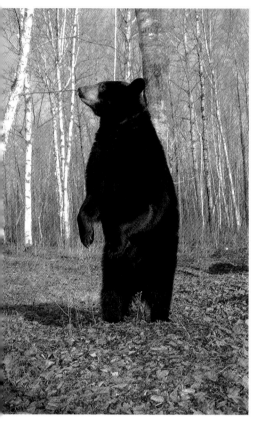

When you compose a picture, think of the viewfinder as a blank sheet of paper. The first decision to make is which frame format to use—horizontal or vertical. A horizontal format emphasizes space, and is useful when you want your subject to be seen in its environment. A vertical format accentuates height, and can be used to draw attention to an animal's features or behavior.

The picture space must be considered as a whole, and any pictorial elements within the frame should either interact with each other or be excluded through skillful photographic technique. Consider how people view the world around them. For example, in the West we read from left to right and from top to bottom. We tend to look at images in the same way.

A useful technique to improve image composition is to divide the frame into nine sections with imaginary lines at $1/3$ intervals horizontally and vertically across it (some cameras have a viewing screen with these lines in place). When you view the whole scene, consider each portion of the picture space in turn, and assess the relevance of any visible objects. Start in the top left square and end at the bottom right. Then, find a way of linking those objects that have a place in the picture, and removing those that are irrelevant.

I shot this picture in the vertical format to emphasize the bear's height. Nikon D2H, 24–120mm VR lens set at 34mm, 1/500 sec. @ f/8.

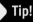

Tip!

Viewfinder coverage
Few cameras have viewfinder coverage of 100%. When composing an image, remember to take into account any additional area around the picture frame that is unseen through the viewfinder.

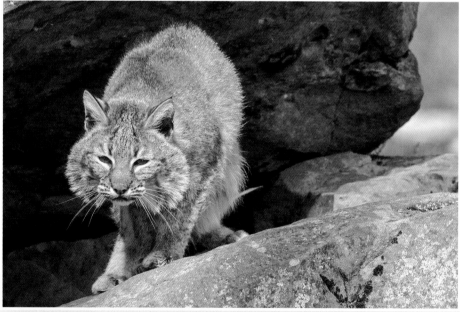

A horizontal format will give a greater emphasis to space, creating a sense of place around your subject. This is further enhanced in this image of a bobcat by the asymmetrical placement of the subject. Nikon D2H, 300mm lens, 1/250 sec. @ f/11.

Perspective and spatial relationships

When defining perspective, you must evaluate the size of the subject in the picture frame, and its relationship with the other pictorial elements. For example, to alter the size of the main subject you can either move closer to make it bigger, or further away to make it smaller, or you can change lenses to a different focal length. Whichever option you choose, the results will be quite different, and it's important to your image-making that you understand why.

A lens with a magnification power of one (50mm in 35mm format terms) produces an image that closely resembles that seen by the human eye. By doubling the focal length of the lens to 100mm, you double the size of the subject in the frame. Switching to a 200mm lens will quadruple it, and so on. The effect is an optical reduction in the distance between you and the subject.

However, increasing the magnification factor is not the same as altering the size of the subject by changing your distance from it. Altering the physical distance between you and your subject (as opposed to the optical distance) by moving closer or further away, changes the spatial relationship between the subject and its surroundings, expanding the space when using a wide-angle lens, and compressing it with a telephoto lens.

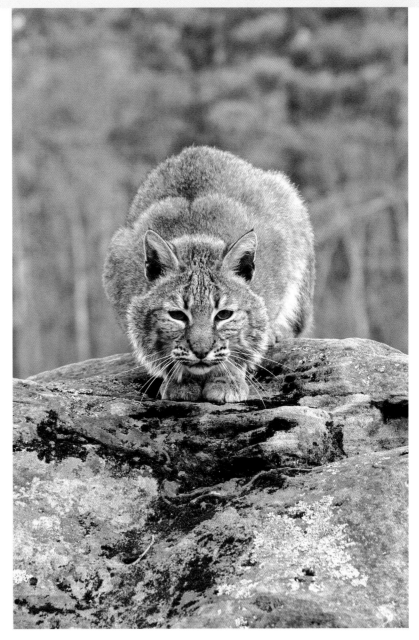

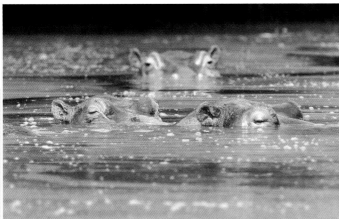

Spatial relationships are altered by changing camera-to-subject distance, or by switching focal lengths. In this image, I have minimized the appearance of space, placing the emphasis on the cat, by using a long focal length lens. Nikon D2H, 24–120mm VR lens set at 120mm, 1/180 sec. @ f/8.

When composing this image, I imagined the viewfinder to be divided into nine squares. Using a zoom lens I cropped out all the unnecessary pictorial elements, and composed the three hippopotamuses in a shape that links them within the scene. Nikon D2H, 300mm lens with 2x converter (600mm), 1/180 sec. @ f/11.

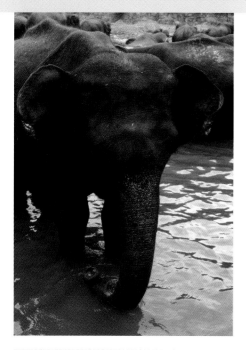

Camera angle and perspective

The angle at which we photograph an animal depicts our relationship with it. When you photograph a subject from above, there is an inference of superiority and control, while the opposite occurs when you photograph a subject from below: the animal appears to have power over you. When photographed at eyelevel, the visual impact is one of equality, with neither subject nor photographer having the upper hand.

Whichever angle you choose will reveal your empathy with the subject. Rarely do pictures taken from above look pleasing because they show a relationship with wildlife that many of us are uncomfortable with. For example, if you compare photographs of polar bears taken from the tundra buggies in Churchill, Manitoba, Canada, with images taken from ground level, the latter are far more appealing and photographically more compelling.

A better angle is to photograph at eyelevel with your subject. The resulting images are often far more intimate and illustrate a relationship between the viewer and the subject that is rarer and more unusual. This, in itself, makes your photographs more powerful. Beware, however, because this technique usually means getting down and dirty!

Photographing down on this elephant portrays a relationship between animal and photographer that, generally, we feel uncomfortable with. Nikon F90X, 80–400mm VR lens set at 400mm, 1/100 sec. @ f/5.6.

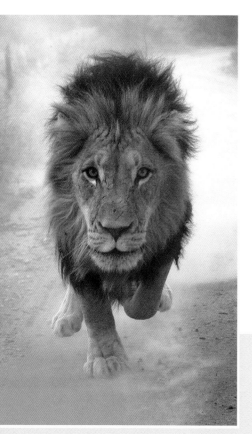

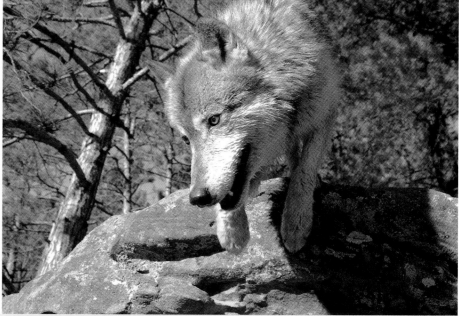

At eyelevel, our relationship with the subject is that of an equal, which gives the image a natural balance and reveals a more intimate viewing experience. Nikon D2H, 24–120mm VR lens set at 70mm, 1/750 sec. @ f/5.6.

By changing the camera angle to below the level of the subject, you again change the relationship between photographer and subject to one where the animal is the dominant presence. Nikon D2H, 24–120mm VR lens set at 32mm, 1/500 sec. @ f/8.

I have cropped in tightly on this subject, and used a gap in the foliage to form a natural frame around the bobcat's eye. Nikon D2H, 24–120mm VR lens set at 120mm, 1/60 sec. @ f/16.

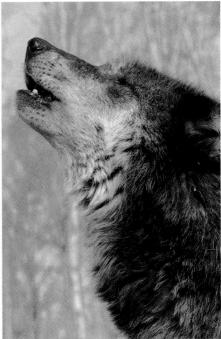

To isolate the behavioral aspects, I cropped in tightly with a telephoto lens, and used minimal depth of field. Nikon D2H, 24–120mm VR lens set at 120mm, 1/320 sec. @ f/11.

Framing

Placing a frame around a picture helps to emphasize it, and the same thing happens when an animal is framed within the picture space.

Frames help to isolate a subject from its surroundings, and guide the viewer's attention towards it. They also provide a natural border to an image, which holds the viewers' gaze within the picture space.

Natural frames occur regularly in nature: the arc of a branch, foliage on bushes, and even the legs of other animals. Look out for these natural frames, and use them to focus attention on your subject.

Isolating the subject

Isolating the subject from distracting elements can be achieved by managing image size, subject positioning (see page 126,) and depth of field. A long telephoto lens will crop unwanted space from around an animal, creating a frame-filling image. If the subject is very far away, then good use of depth of field can blur foreground and background clutter, leaving your subject the focus of attention. Placing the subject in the center of the frame—as per the rule of thirds—will also ensure that it takes the limelight within the picture.

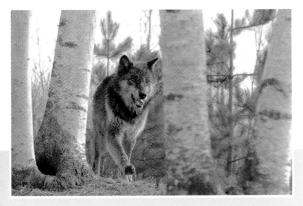

I used the tree trunks to frame the wolf. The trees also lend this image a sense of place that is missing in the more abstract picture of the bobcat's eye, above. Nikon D2H, 24–120mm VR lens set at 120mm, 1/350 sec. @ f/8.

An alternative method of isolating a subject is to place it centrally within the picture space. Nikon F90X, 300mm lens, 1/250 sec. @ f/4. Fuji Provia 100F.

Subject positioning

Where in the frame the main subject is positioned will affect the message the photograph communicates. There are two choices—centered or off-center. One of the best-known compositional techniques is the rule of thirds. The principle behind this rule is to divide the picture frame up into thirds, both horizontally and vertically. The focal point of the image should fall at a point where the lines intersect. The asymmetric design this creates produces tensions and relationships between the pictorial elements, producing a dynamic and visually energetic picture. Conversely, placing your subject centrally engages and holds your attention for a more intimate visual relationship.

With this image of a bobcat, I have used the tried-and-trusted compositional tool known as the rule of thirds. Nikon D2H, 24–120mm VR lens set at 35mm, 1/1000 sec. @ f/8.

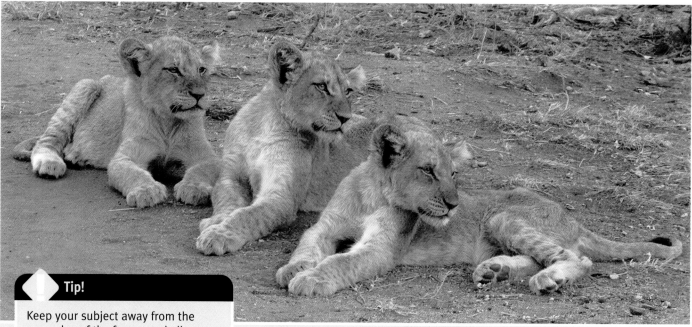

Tip!

Keep your subject away from the very edge of the frame, and allow some "breathing" space around it. If the subject is too close to the edge, the picture will appear unbalanced and awkward.

The asymmetry created by having three lion cubs in the picture space causes the scene to have a more dynamic feel, compared with the balanced image of the ostrich, opposite. Nikon D100, 80–400mm VR lens set at 105mm, 1/60 sec. @ f/11.

Symmetry and asymmetry will dictate the visual weight of your pictures. A balanced (symmetrical) picture tends to create a sense of tranquility and/or stability, while an unbalanced (asymmetrical) image tends to be more dynamic. For example, compare the images of the ostrich and the lion cubs, and note how their differing compositions affect your emotional response to them. In the ostrich image, a symmetrical composition gives the picture a natural balance that in turn makes the viewer feel balanced—our preferred natural state. On the other hand, the lion cubs image creates a visual tension that leaves the viewer with a feeling of imbalance, which makes the image more dynamic and, in many ways, more compelling.

By placing the subject centrally within the picture space, the visual weight of the scene emphasizes the subject rather than the environment the subject is in. This creates a more intimate relationship between the subject and the viewer. Nikon D100, 80–400mm VR lens set at 400m, 1/640 sec. @ f/5.6.

In this image, the position of the ostrich is balanced by the inclusion of the tree on the right. The symmetrical composition creates a static image when compared to the pictures of the lion cubs (left).

When the subject is a dangerous animal, the added tension makes the photograph even more compelling. Nikon F5, 80–400mm VR lens set at 300mm, 1/250 sec. @ f/8, Fuji Provia 100F.

Communicating with color

Color is one of the most powerful communication tools outside of language itself, and we use it frequently in everyday life. For example, when you see a red traffic light, you stop. When it turns green, you go. This messaging system is also apparent in nature. Poison-dart frogs, for example, use bright, highly visible colors to warn off predators, while the color of a robin's breast deepens when it is time to find a mate.

Color also helps dictate whether we feel warm or cold. Red, orange and yellow can make us feel warm, while stark, hard blues can make us shiver. The real power of color in photography comes when you mix colors in the image space. For example, colors that are complementary (red and green; blue and orange; yellow and violet), generate tension when they are put together. Red and green, in particular, create visual energy and a real sense of depth, because their respective wavelengths are different, and when we see them adjacent to each other our focus has to shift back and forth to view them.

The intensity of color also conveys information and evokes an emotional response from us. Strong, bold colors, such as deep red, yellow, and blue, are dynamic and sensational in appearance: they draw our attention to them. Red, for example, is often used in publishing because it is eye-catching. Pastel colors,

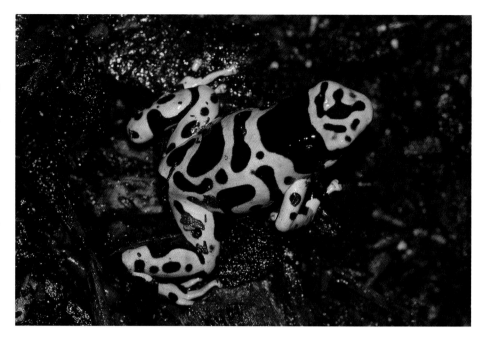

on the other hand, have a calming effect, having a quieter impact on our senses.

Mixing color within the image space creates a visual intensity and adds interest to a photograph. However, don't ignore the possibilities of creating images with uniformity of color. Single tones or monochromes remove the compelling impact of multiple, competing colors, and emphasize other design elements, such as shape, texture, and pattern.

The color wheel
The color wheel illustrates some of the most important color relationships. The colors you use within the picture space will create particular emotional responses.

Color can also be the subject of the picture, as is the case with this extreme close-up of a butterfly's wing.

Poison dart frogs use color to warn off predators. Communication by color is prevalent in both the human world and within nature as a whole, and can be exploited by color photographers to pass on subliminal messages to the picture viewer.

The primary colors (red, yellow, and blue) have a visual intensity that can make a bold statement when used in isolation within the picture space. Here, the intense blue draws your attention and captivates your gaze on the important pictorial element within the scene—the bird. Nikon D2H, 80–400mm VR lens set at 400mm, 1/200 sec. @ f/8.

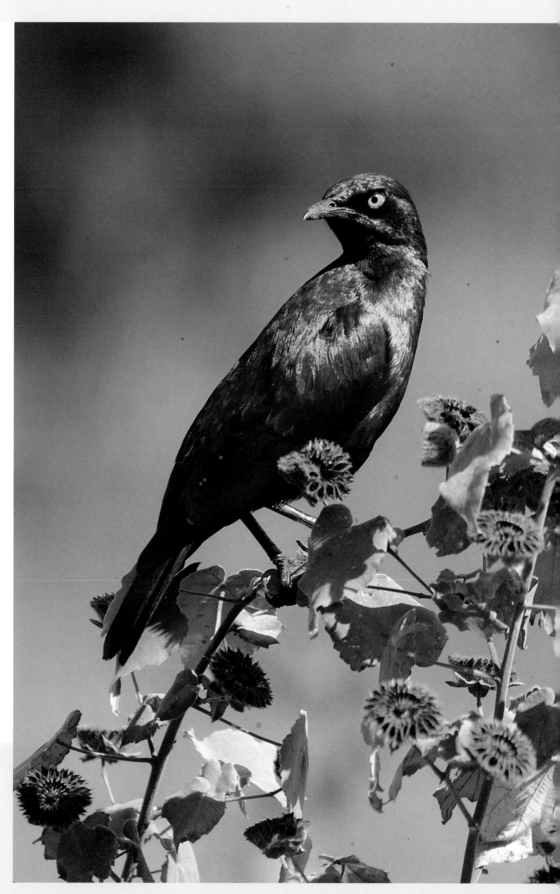

Professional profile

Paul Harcourt Davies, UK

"In the field, it is all too easy to get bogged down in the fiddly aspects of equipment when taking pictures at close quarters. Over the years I have tried to evolve methods that can be used quickly and reliably up to about 4x magnification. After that, it is a question of the 'studio,' which might just as easily be outdoors as in.

"These days, my prime interests lie in the aspects of design inherent in nature, and being freed from complexity helps me focus, literally, on capturing patterns in small animals, as well as plants and flowers. To this end I use a macro flash (either homemade or a commercial Nikon SB29s unit), with a Sigma, and a few other macro lenses. I may also use equipment such as a multiplier and various rings for reversing and coupling lenses.

"The system I am currently using employs a digital SLR body (either a Nikon D100 or Sigma SD10), with a macro flash attached. It is highly portable and very effective, though it requires a good deal of patience and a subtle hand. Focusing is by moving forward and backward gently with the whole unit until the subject comes into sharp focus.

"Since I have to struggle to squeeze every bit of depth of field out of a situation—I am not one of those folk who think shallow focus (even out of focus) means 'art'—I demand the utmost from any lens I use, and spend a lot of time moving the camera until what appears in the viewfinder looks right to me.

"Some years ago I made a 'macroscope' from an old microscope stand, which is portable and immensely solid, so an effective studio can be set up easily whenever and wherever I want. That now means Italy, where I am lucky enough to live. The region is rich in traditionally farmed land, and the imagination it inspires and the potential for great photography are wonderful. It is easy to bring specimens home to an outside table (housed in an old pigsty!) for an hour or so before releasing them. To get a horsefly to pose while you focus on the reflections in its eyes would otherwise prove impossible."

Paul Harcourt Davies's work can be seen on his Web site—www.hiddenworlds.co.uk.

Letting your images speak

Photography is a means of translating personal vision into graphic reality. While many successful pictures are created on the fly, the most inspirational photographs and productive shoots happen when the photographer has the clarity of vision to determine the style of image he or she wants to create.

In essence, the role of photography is to communicate and to evoke an emotional response. Your choice of subject, sense of timing, and how you compose the images determine the messages they will relay.

Once again, your ability to control how the scene appears in the final image is tied to how capable you are at operating the camera. Lens choice, exposure settings and combinations, subject placement and framing, and exactly when you press the shutter release, all influence the visual impact of your images.

This section outlines some key opportunities to consider when defining your photographic message.

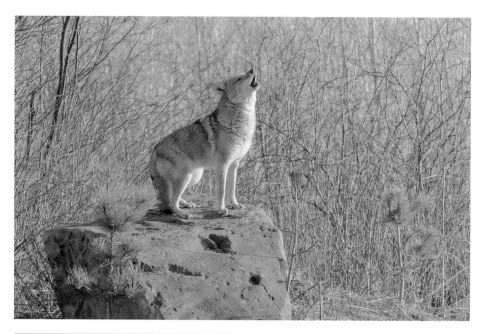

A sense of place: a coyote howls to its pack from a prominent position in woodlands in North America. Nikon D100, 80–400mm VR lens set at 145mm, 1/500 sec. @ f/8.

A sense of place

Wildlife images need not all be frame-filling close-ups of the animal itself. Placing the subject in context with its environment will create an atmospheric sense of place. By including the surrounding scenery, the image relays information about where that animal lives, and the type of terrain it must conquer in order to survive. Using wide-angle lenses will help to accentuate space, and a small aperture will increase depth of field so that foreground and background details are rendered sharp.

A sense of place: a Black-backed jackal camouflaged in the tall grass of Kruger National Park, South Africa. Nikon D100, 800mm lens, 1/640 sec. @ f/5.6.

Animal interaction

No animal lives entirely alone, without any interaction with others of its own species. Even solitary creatures, such as brown bears and leopards, must breed and raise young. Other species, such as wolves, gorillas, and orang-utans, thrive in groups.

How animals interact makes for fascinating wildlife photography. The photo opportunities are endless: a mother with her cubs, monkeys cleaning each other, cubs at play, and so on. Animal interaction is best captured using the techniques described for action photography (see page 98) and taking sequences (see page 108).

Animal interaction: two spring cubs tussle over a broken tree branch as part of their early education in how to be a bear. Nikon F90X, 300mm lens with 2x converter (600mm), 1/500 sec. @ f/5.6, Fuji Provia 100F.

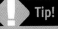 **Tip!**

Focal length
Use wide-angle lenses to help portray a sense of place, and switch to a telephoto lens when photographing emotive portraits. A zoom lens will help save time when you're working with an unpredictable subject.

Emotion

Emotion is not exclusive to humans. Whether all animals have emotions is open to conjecture, but many of the subjects you may photograph, particularly primates, will display emotion openly. Bears and members of the Canidae family (coyotes, dogs, foxes, jackals, and wolves) are also very expressive. Use the techniques described for animal portraits (see page 90) to capture emotive images.

Emotion: a vulnerable black bear cub cowers in the hollow of a tree, away from predatory danger. Nikon D2H, 24–120mm VR lens set at 70mm, 1/90 sec. @ f/7.1.

Emotion: a lone wolf stalks across icy ground in search of food during the winter months. Nikon D100, 80–400mm VR lens set at 400mm, 1/125 sec. @ f/8.

Cute and cuddly

Capturing well-composed images of cute youngsters and cuddly creatures (perhaps the most commercial of photographic styles) will always result in successful photographs. Not all wildlife falls into this category—few people find a crocodile cute or cuddly, for instance. Bear cubs, giant pandas, young elephants, and dolphins, on the other hand, all have the "Aaaah..." factor. For the best results, crop in close to capture facial expressions.

Cute and cuddly: a young bear cub pokes its out head from behind the protection of its mother. Nikon D2H, 24–120mm VR lens set at 100mm, 1/320 sec. @ f/8.

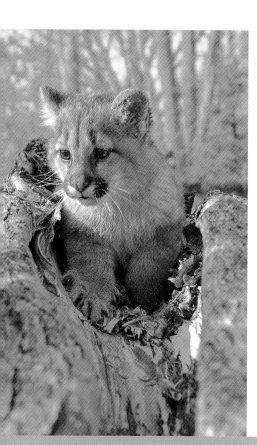

Humor

People like to smile and laugh, and a humorous picture is always a crowd-pleaser. Keep an eye open for interesting facial expressions, or juxtapositions of subject and circumstance. Often, you need to be quick-fingered to grab these fleeting moments, so it's worth keeping your camera to hand and ready to shoot. Some wildlife is predisposed to humor. Hippopotamuses, for example, are aesthetically comical creatures, and primates regularly pull stunts that amuse us.

Humor: a Black bear plays hide and seek in woodlands. Nikon D2H, 24–120mm VR lens set at 90mm, 1/300 sec. @ f/8.

Cute and cuddly: a puma kitten thinks about using a dead tree trunk as a slide during playtime. Nikon D2H, 24–120mm VR lens set at 58mm, 1/350 sec. @ f/7.1.

Humor: a face only a mother could love. A young hippopotamus in South Africa is oblivious to the clinging water lettuce adorning its forehead. Nikon D100, 800mm lens, 1/60 sec. @ f/5.6.

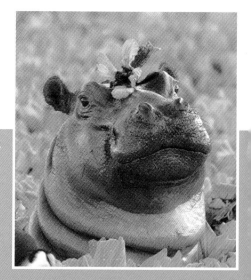

Animal behavior: an otter frolics in a river, enjoying a few moments of play between feeds. Nikon D100, 80–400mm VR lens set at 100mm, 1/160 sec. @ f/4.8.

Animal behavior

How and why animals do what they do always provides the photographer with a reason to press the shutter release. In fact, photography has been instrumental in our understanding of many of the behavioral traits of wildlife. Photographing animal behavior takes patience—I once spent an entire day watching a pod of sleeping hippopotamuses, waiting for them to display the behavior patterns I had gone to photograph. A basic knowledge of a species' biology, and good camera technique are the keys to success. Review the techniques described for capturing action photography on page 98, and consider spending time in the field with a biologist or researcher (see page 144).

Animal behavior: climbing trees is a natural instinct for bears. This youngster gets to grips with the technique. Nikon D2H, 24–120mm VR lens set at 42mm, 1/400 sec. @ f/11.

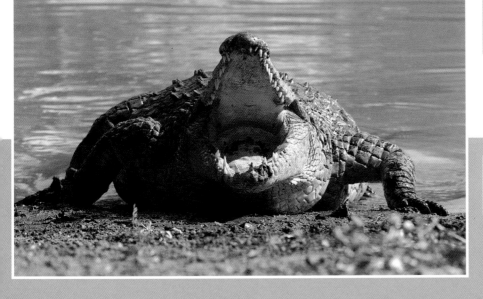

Animal behavior. crocodiles often bask in the sun with their mouths wide open to speed up the process of warming their bodies. Nikon D2H, 80–400mm VR lens set at 175mm, 1/400 sec. @ f/11.

Professional profile

Jim Brandenburg, USA

"You have no need to travel to far-distant, exotic locations to capture stunning images of wildlife," says world-renowned photographer Jim Brandenburg. And he should know—his most successful commercial image was taken 300 yards from his own back yard in northern Minnesota. The boreal forests in Minnesota also became the landscape for his best-selling book, *Chased by the Light*.

Chased by the Light was a project that evolved out of Jim's love of wolves. Wanting a break from the politics and pressures of paid assignments, he set out on a self-imposed challenge that he describes as a "photographic mountain that had never before been climbed." That challenge was to take just a single image each day for the 90 days between the fall equinox and the winter solstice.

It was a project that combined the attributes of ecology, emotion, and vision, and one that tested Jim's discipline and resolve to their limits. "In many ways, being confronted by a familiar palette, taking only a single frame a day, and making it work pictorially, is far more difficult than delivering a whole set of images for *National Geographic*," he says.

"Some of the photographs that resulted from my experiences—chance encounters with wolves, white-tailed deer, and quick mink on the shorelines—would not have been published had I been my usual self-critic. They are noteworthy to me, nonetheless, in that I somehow was led at the right instant to the spot where these animals presented themselves to me, and was able to record that moment with one exposure. The excitement surrounding those moments was palpable. All my woods skills of stalking and reading sign came into play."

The project sat in a drawer in Jim's home for two years before it was enticed out by John Echave, senior editor of *National Geographic*. It then appeared in the November 1997 issue of the magazine before being published in book form in 1998. There were so many requests for prints that Jim opened a small gallery in Ely, Minnesota, which proved to be a turning point in his photographic career.

Jim measures the success of the project not simply in commercial terms, however. For him, it was not an exercise aimed at impressing other photographers with his work—it was all about winning the heart and mind of the common person. And he is proud that the message got through.

Today, Jim Brandenburg's time is spent shooting specifically for the gallery, and the new challenge is to make images with staying power. He has converted to digital, using Canon equipment, and is a firm believer that this new technology helps bring an image to life. His advice to anyone starting out in wildlife photography is to, "Be like a predator—be nimble, open-minded, and react to opportunity."

Jim Brandenburg's work can be seen on his Web site—www.jimbrandenburg.com.

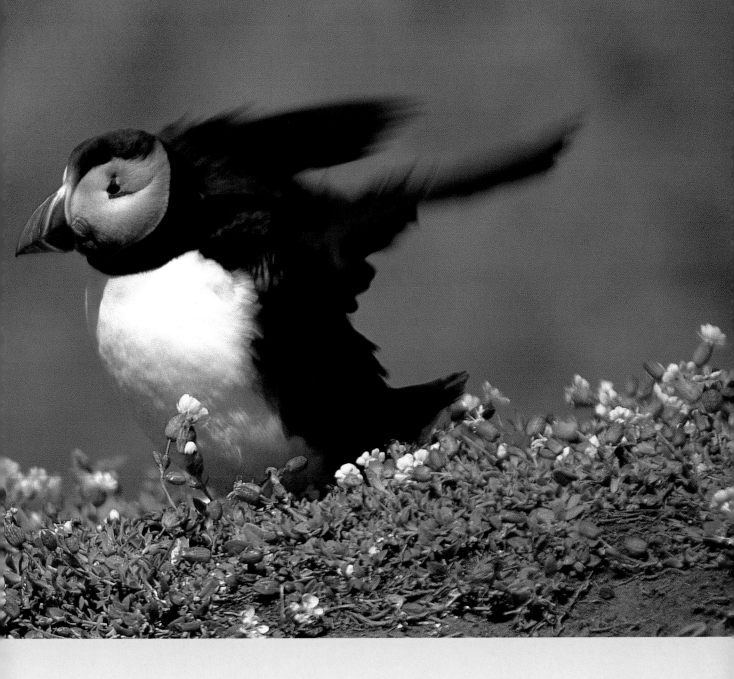

Preparing for harsh conditions

Wildlife photography has taken me to some of the world's most inhospitable regions. Here I am heading out on an ice climb in New Zealand.

It is unfortunate for the wildlife photographer that the world's most beautiful and wild places are also its least hospitable. The practicalities of photography in camera-hostile regions are challenging, even to the experienced professional, though not so insurmountable that they should put you off trying.

Successful wildlife photography means doing your research. This image of Brown bears catching salmon at Brooks River Falls in Katmai National Park in Alaska can only be taken during a brief period at the beginning of summer, when the salmon are returning to spawn. Once the salmon run is over, the bears disappear back into the woods. Nikon F5, 300mm lens with 2x converter (600mm), 1/250 sec. @ f/8, Fuji Provia 100F.

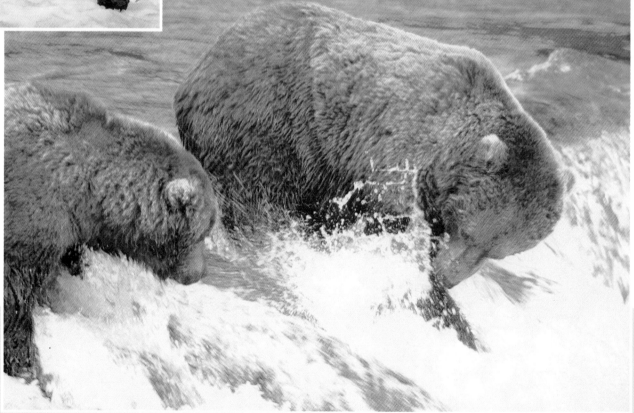

Travel preparation

Good preparation will make the task of photography easier, and the success of your shoot more likely. Before you leave, spend some time researching your destination. Consult travel guides, tourist information offices, government and non-government wildlife organisations, maps, press clippings, and, of course, the Internet, to plan your trip and ascertain the most productive areas for photography.

Time of year should also be a consideration, as it will determine weather and environmental conditions that will affect your success. For example, there is no point traveling to Brooks River, Alaska, in March to photograph Brown bears hunting for salmon, since the salmon don't arrive until late June. Similarly, arrive on Skomer Island, off the coast of Wales,

in September, to photograph puffins, and you'll be too late—they left in the summer. Of course, when planning trips that are season-dependent, remember that the seasons in the southern hemisphere are opposite to those in the north.

You will also need to prepare your equipment for local conditions. Tropical rainforests are damp, humid places that will soak your gear and film in moisture. In Africa, the dust of the savannahs will cause havoc with cameras and DPSs. And the intense cold of the polar regions will blank out liquid-crystal displays, drain batteries, and freeze film so that it snaps in the hand. If you're unprepared for these and similar eventualities, your photographic trip of a lifetime may be over before it's even begun.

Tip!

If you own a substantial amount of expensive equipment, then it's worth having it insured with a reputable company that deals specifically with camera equipment. If you leave it as a non-specified item on your home-and-contents insurance policy, you may find yourself out of pocket if the worst happens. You can find the contact details of insurers in advertisements in photographic magazines, but be sure to read the small print.

During the summer, Skomer Island, off the coast of Wales, is teeming with Puffins. By September, they're gone again. Knowledge like this will help you get the most out of the time you spend in the field. Nikon F90X, 300mm lens, 1/500 sec. @ f/5.6, Fuji Velvia.

Working with biologists and researchers

Perfecting camera technique and shooting skills is an ongoing job for the wildlife photographer, but gaining a rudimentary understanding of basic biology will also help get you shots that other enthusiasts will miss. However, it is impossible to acquire the same in-depth knowledge that a specialist biologist or researcher has.

When photographing in remote and inhospitable locations, help from an expert can often make the difference between a successful trip and a disaster. While you are handling technical equipment issues and camera set-ups, the specialist can be advising on the best approaches, indicating behavior patterns, and identifying the most appropriate times and places to capture spectacular images.

A successful working relationship requires mutual respect and trust. Take notice of the advice given, and explain your photographic requirements in as much detail as possible. Bear in mind that a biologist's skills are scientific, not artistic, and he or she will not necessarily anticipate the parameters of good composition without some help from you.

Establishing areas of responsibility is also necessary for a successful field trip. Who, for example, will decide on a back-up plan if plan A falls through, or be in charge of acquiring additional equipment if required? What are the travel arrangements, and whose job is it to make them?

Once in the field, you must let the specialist know how you work, so that they can respect your photographic space. Equally, you must be prepared to walk away if they tell you to, and accept that their reading of the situation is better than your own.

I find the specialist knowledge of biologists and researchers to be invaluable in the field. Here I am working with a falconer, photographing a Harris hawk. The bird is fitted with a radio transmitter, and we are using telemetry to locate it.

A year in the field

One of the great things about wildlife photography is that you'll never run out of subjects. I can spend days at a single waterhole in Africa, and years photographing my favorite species. There is always a new perspective to capture, different techniques to try, and mysteries to unravel. The table below is a sample annual itinerary. There is little science behind it, other than knowing when conditions are at their most conducive for productive wildlife photography. The subjects are... well, subjective, and merely represent *some* of my favorites. I reproduce it here simply to give you some idea of the photographic opportunities around the world. And, you never know, one day I may see you there.

January	Winter in the north, summer in the south, but I'd head to Yellowstone National Park in Montana, USA, to begin the year with my favorite wildlife subject—wolves.
February	Summer is the only time to visit Antarctica, and so I'd head as far south as you can go for king penguins, seabird colonies, elephant and fur seals, and, maybe, the odd orca.
March	Time to head for sunnier climes, so it's off to Florida for some of the most spectacular bird photography in North America.
April	Sticking with the sunshine, April is the ideal time to photograph dolphins off the coast of Central America. Head to Honduras for some breathtaking imagery on the ocean.
May	The Okavango Delta, in the heart of Botswana, is considered by many photographers to be the ultimate wildlife destination: quintessential Africa at its best.
June	Now to Skomer Island, off the coast of Pembrokeshire in Wales, to photograph one of the world's largest colonies of puffins. Plan an overnight stay to avoid the day crowds.
July	I'd head much further north, to Katmai National Park in Alaska, in time for the salmon run and to catch Brown bears idly fishing along the Brooks River Falls.
August	Long-haul back to Africa to capture the big cats in South Africa's Kruger National Park.
September	Staying in Africa I'd head a little further north to the Masai Mara reserve in Kenya in time to catch the awe-inspiring migration of wildebeest, zebra, and Thomson gazelle.
October	I'd head for the world's largest freshwater wetlands, the Pantanal region in Brazil, where wildlife abounds and is inquisitive of human activity.
November	Now to Donna Nook on the east coast of England, to photograph one of the most accessible breeding colonies of gray (Atlantic) seals in the country.
December	I'd finish the year in Alaska, along the Chilkat River in Haines for the annual conference of bald eagles. More than 3000 birds congregate along the banks for their last easy meal before winter really sets in.

Tropical rainforests

Principal regions: Central America, South America, central Africa, South-East Asia, and northern Australia.

Tropical rainforests are teeming with wildlife, but are one of the hardest environments to photograph in successfully. Wildlife is difficult to spot, and moves adroitly when you see it. The dense cover of the rainforest canopy allows little light to reach the forest floor, making long exposures or flash essential. And the humidity will leave your equipment looking like it's been used for underwater photography.

For prolonged spells you should consider using only professional-specification cameras that are designed to withstand harsh environments and are resistant to impact and humidity. Unchecked, humidity will cause microscopic fungus to grow on the inside of lenses, on camera electronics, and on film emulsion. At the end of each day's shooting, or during any period of prolonged inactivity, equipment should be stored in a dry box, with plenty of moisture-absorbent silica gel. Also, try to expose lenses to sunlight whenever possible—fungus grows best in the dark, and 10 minutes of sunlight will kill off mildew spores. Finally, it is essential to clean all equipment daily to remove traces of moisture and keep cameras in working condition.

When out of the camera, film should be kept in the plastic container it comes packaged in, which will help keep moisture at bay. You should also store film in a cool bag, like those used for keeping drinks and food cool, so that it is protected from extreme variations in temperature. Similarly, memory cards, such as Compact Flash, should be stored in plastic wallets when not in use.

A raincover will help protect your expensive camera equipment in rainforests.

Achieving great wildlife images in tropical rainforest environments is fraught with numerous difficulties. A lack of light, well-hidden, shy creatures, and humidity—as well as an abundance of rain—make the task of the wildlife photographer a challenging one.

Temperate forests

Principal regions: North America, southern central America, Europe, East Asia, and south-east Australia.

Over the years, temperate forests have altered, due primarily to human interference. Primary temperate forests now exist only in isolation, and can be found in Poland, Siberia, and Tasmania. Secondary temperate forests are far more prevalent, and form the natural habitat of many bird and insect species, as well as predatory mammals, including bears, wolves, lynx, and foxes, that feed on the numerous prey species to be found, such as squirrels.

Unlike tropical rainforests, temperate forests experience the changing seasons. Fortunately, photography is possible year-round, and each season brings with it its own colors (soft pastels in spring; green in summer; yellow, red, and gold in fall; and white in winter), and its own activities (nesting in spring; growing in summer; food-gathering in fall; and hibernating in winter).

Light intensity also changes with the seasons. In winter, when foliage is sparse, light falls freely on the forest floor. In summer, however, when a thick blanket of leaves soaks up the sun's rays, light levels are intermittent, and assessing accurate exposure settings can be a real challenge.

Equipment isn't exposed to the same ravages as it is in a tropical rainforest and, although professional equipment can cope better with constant outdoor use, most consumer-grade cameras are equally up to the task, provided they are kept safe from particularly inclement weather. In very wet conditions, protect your camera with a waterproof cover. At the height of winter, when temperatures are freezing, cover any exposed metal surfaces with cloth-backed tape to make touching them less unpleasant.

Brown bears are prevalent throughout the temperate forests of Europe and North America. Nikon D2H, 24–120mm VR lens set at 60mm, 1/400 sec. @ f/8.

Nowhere near as populous as they once were, wild wolves find their home in the temperate forests of North America and Europe. Of course, where you find predators, you will find their prey, such as deer and many small mammals. Nikon D100, 80–400mm VR lens set at 400mm, 1/750 sec. @ f/8.

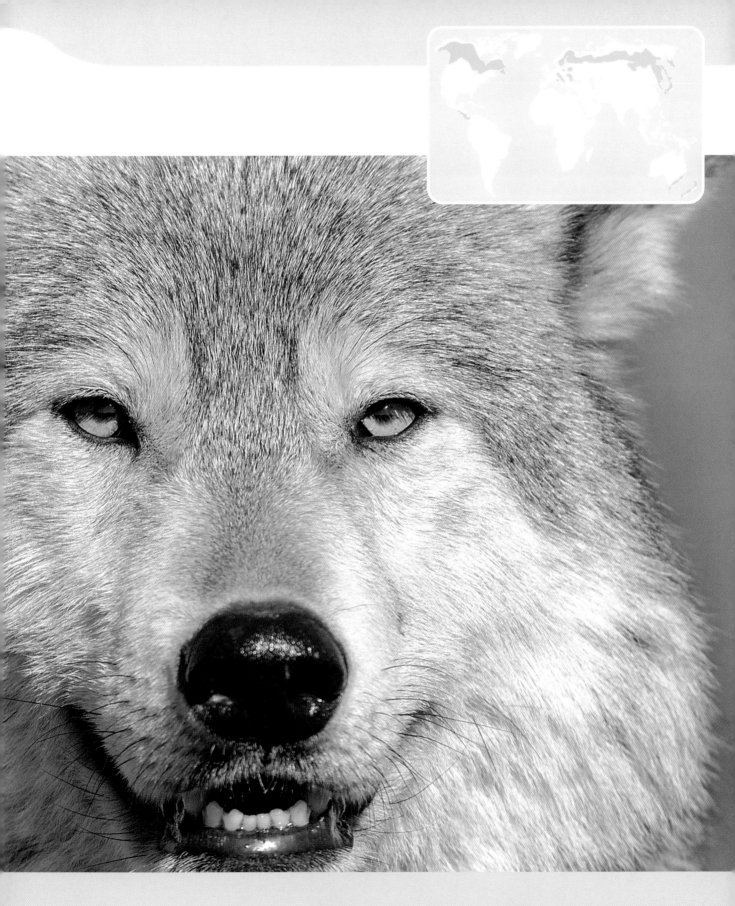

Savannahs

Principal regions: central-eastern South America, west Africa, central and southern Africa, East Africa, east Asia, and south-west Australia.

The region where the wildlife photographer is most likely to encounter the savannah is Africa. Here, in areas such as the Serengeti in Tanzania, and Masai Mara in Kenya, mammals, insects, and bird species proliferate.

Activity in the savannah is governed by the season (rainy or dry), with animals migrating in search of water. Each year, in the Serengeti and Masai Mara parks, zebra, wildebeest, and gazelle march a cyclic route that covers some 1,800 miles (2,900 km). The zebras initiate the "great migration," following the rains south from Kenya through to Tanzania, eating the tips of high grasses. Wildebeest follow them, munching on the lower parts of the stalks left behind by the zebras. The gazelles follow on next, feasting on the new shoots. And, wherever the creatures of the plains go, predators are sure to follow. Lions, cheetahs, and leopards kill off the weak and, in doing so, maintain the ecological balance of the region.

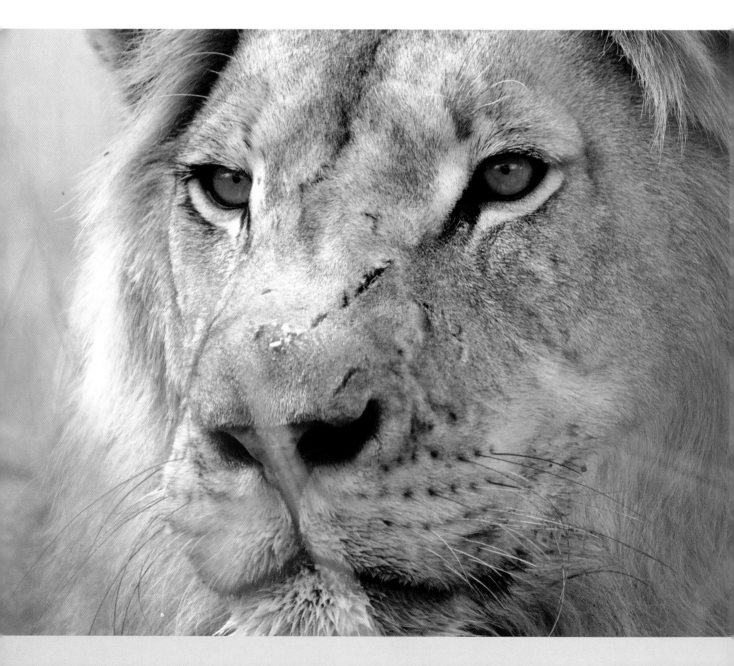

The cheetah makes its home in the savannahs of Africa. Nikon D2H, 80–400mm VR lens set at 400mm, 1/125 sec. @ f/5.6.

Good light is an essential ingredient for wildlife photography in the savannah. Here, you are faced with the opposite problems to those encountered in forests. Clear skies and the absence of giant vegetation make harsh lighting a certainty during the middle of the day. The best time to photograph is early in the morning, when the light is warm and diffused. Generally, this means getting up before daybreak and beginning to shoot at about 7a.m. You will then have a good two hours before the sun gets too harsh.

Photographic equipment will be severely tested, with violent jolts from your vehicle, and dust kicked up by wind and movement (of animals, vehicles, and yourself). Use a specially designed camera bag with foam padding. Professional cameras will offer some protection against dust as most of the joins are sealed against penetration by dust. Consumer models, however, will need added protection in the form of plastic tape to keep dust out.

Consider using an ultraviolet filter to keep the front element of your lens clean. If the filter becomes too heavily caked in dirt and dust, it's far cheaper to replace than the lens itself.

When shooting, try covering your camera with a thin plastic bag to minimize dust contamination. And when changing lenses on a digital camera, do so inside a plastic bag to keep dust from entering the camera body and adhering to the DPS.

At the end of each day, clean all your equipment with a blower brush (you can use an aerosol spray on non-delicate parts), and replace disposable protective covers. Memory cards and film should be stored in a cool bag and kept in plastic containers when not in the camera.

The savannahs of Africa are home to many wild species—some large, some so small you'll probably never see them. Of all the animals you're likely to spot in Africa, the lion is, perhaps, the most majestic. Nikon D100, 800mm lens, 1/180 sec. @ f/5.6.

Deserts

Principal regions: western South America, south-west North America, North Africa, south-east Africa, Middle East, central Asia, and west and central Australia.

Desert regions, such as the Sahara in North Africa, the Kalahari in South Africa, the Mojave in California, and the Gobi in Mongolia, are particularly difficult places for wildlife photographers. Not only is the environment harsh, but much of the wildlife (fennec foxes, jerboas, kangaroo rats, and many species of insect and reptile) is invisible, spending most of the day hidden below ground or under rocks, away from the searing heat.

Daybreak is the best time to photograph wildlife in the desert. At this time, many species of mammal are heading back to their dens after a night of hunting, and insects and spiders are easier to approach. The surface temperature of the sand has yet to reach its peak, which makes the environment more comfortable for everyone, including you, and heat haze won't be apparent, making sharp imagery more possible.

Camera equipment should be kept out of the direct rays of the sun. When traveling, store photographic gear in a well-ventilated icebox, stowed in a shady place. When photographing, try to keep your camera and lenses shielded from the sun by covering them with a white cloth, reflector, or umbrella. Make sure that lenses, in particular, are kept cool, as excessive heat can melt some of the glues used to hold them together.

Avoid sand and dust getting to your cameras, too. Professional equipment that is resistant to penetration is preferable to consumer-grade gear, but all equipment, no matter what make, should be covered when traveling or during windy conditions, and cleaned regularly throughout the day.

Contrary to popular belief, deserts are home to an abundance of wildlife. You simply have to look harder to find it. Here, two ostriches traverse the landscape in search of water.

> **Tip!**
>
> **The early bird ...**
> In the desert, an early start will pay dividends for your wildlife photography. You will find predators returning to their dens after a night of hunting, while insects and reptiles are lethargic until their bodies warm, making them more approachable.

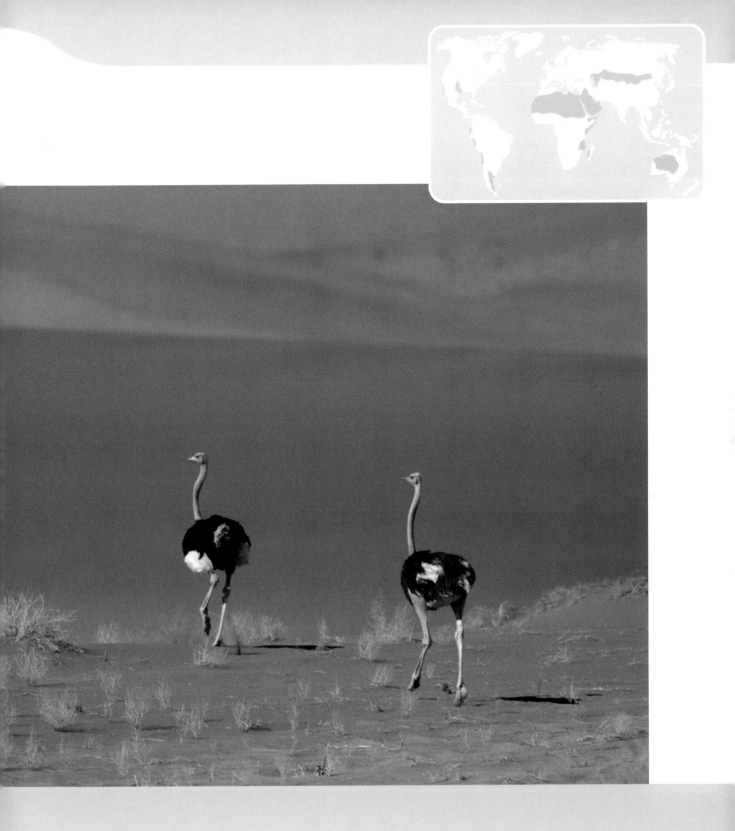

Wetlands

Principal regions: coastal North and South America, coastal northern Europe, coastal northern Asia, Africa, the Pacific Islands, Indonesia, coastal Australia, and New Zealand.

For those interested in photographing birds, insects, amphibians, and reptiles, wetlands are a proverbial paradise. Wetland regions are prevalent on every continent, and are rich in wildlife. Avian fauna, in particular, is incredibly diverse, and as well as small reptiles and amphibians (green frog, fire salamander, palmated newt, and common toads), the intrepid photographer in the right area will also find alligators. The Okefenokee wetland in southern Georgia, USA, for example, are home to about 250 species of birds, and remains the last bastion of the American alligator (more than 12,000 live here).

Daybreak and sunset are the best times for photography, when the light is rich but not garish, and the wildlife is most active. For the photographer, too, the cooler hours are more comfortable, out of the heat of the midday sun, and away from the biting insects that become more active as the temperature rises. While photography is possible throughout the year, the highlights revolve around migration and birth patterns in spring and fall.

Water is the obvious concern for photographic equipment. When traveling on water in a canoe, kayak, or other form of boat, store all your gear in a watertight bag. If photographing in the water, the safest solution is to use one of the purpose-made underwater housings that allow you to safely submerge the camera. Although expensive, they have the advantage that you can take underwater or semi-submerged shots. These housings are best used in conjunction with a digital camera using a large capacity memory card, otherwise you'll need to dismantle the entire housing every time you need to change the card.

An ultraviolet filter will help to keep water off the front element of the lens, and any stray droplets can be wiped clear with a lint-free cloth. Keep memory cards and film in plastic containers.

Wetlands are the perfect habitat for many wading birds, such as this heron feeding among water lettuces. As well as birds, expect to see small mammals, reptiles, and amphibians. In certain areas you may also find some much larger reptiles, such as alligators. Nikon D100, 800mm lens, 1/100 sec. @ f/5.6.

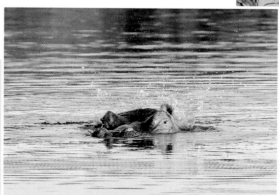

Hippopotami can be found throughout the wetland regions of southern Africa. Nikon D2H, 300mm lens with 2X teleconverter (600mm), 1/250 sec. @ f/8.

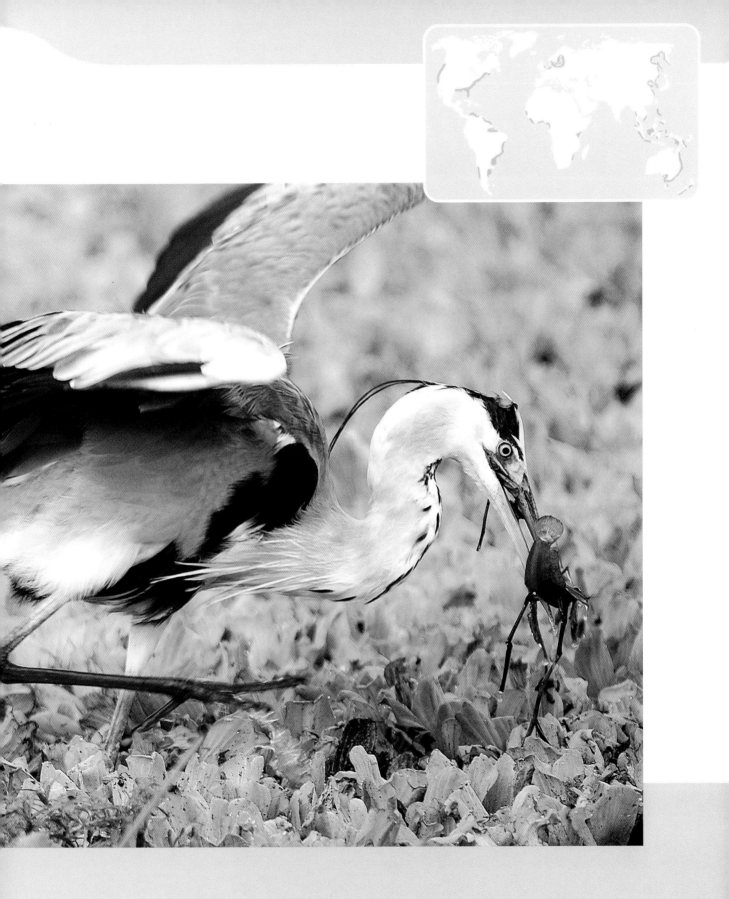

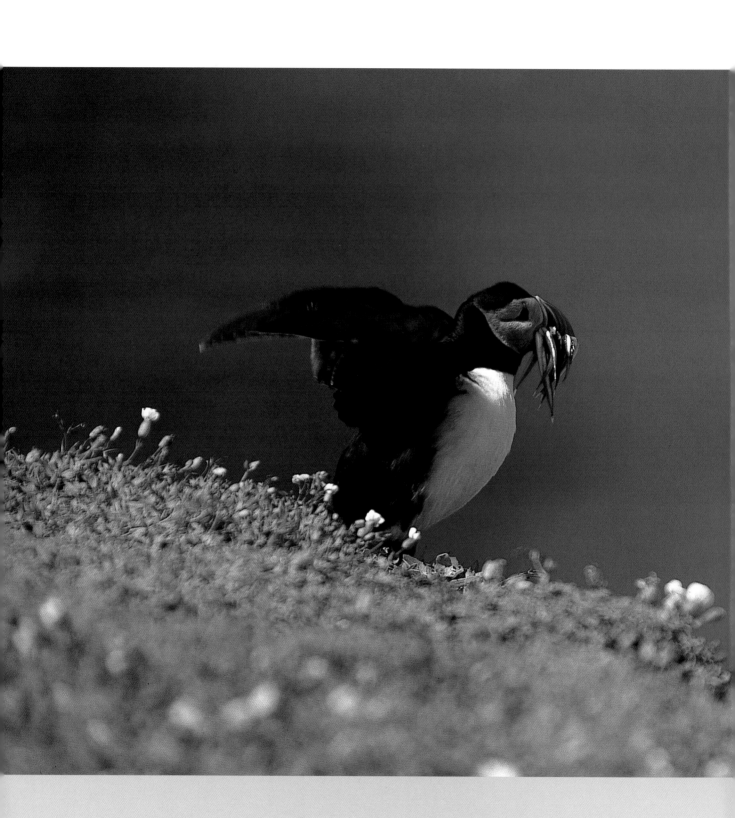

The coast and islands

Coastal regions and outlying islands provide a great variety of subjects, ranging from the creatures that reside in the seas and oceans, to those that live on land and exploit the water for food. An imaginative wildlife photographer can spend hours in a single location, at any time of the year, and never be lost for something to do. If you're photographing bird life, spring and fall migrations are the most active time.

The rich colors of the coastline give wildlife images some amazing backgrounds, and I will often underexpose a shot by -$^1/_3$- to -$^1/_2$-stop purposefully in order to saturate bold colors. Exposure needs careful consideration, since water and sand are both highly reflective surfaces that can fool a camera's light meter.

Corrosive salt and spray from the sea can be particularly hazardous to camera gear. All lenses should be fitted with an ultraviolet filter to protect the front element. Cover any exposed joints with plastic tape and, in windy or stormy weather, place the camera in a strong, waterproof plastic bag. When changing lenses, only do so in a protected environment, such as inside your camera bag, where you are shielded against sand and spray.

Similarly, protect the camera when changing film. Sand in the film chamber can cause scratches on the whole strip of negatives or transparencies, and can also damage the shutter curtain, which should also be protected from salt and seawater. A better option is to use a digital camera with a large-capacity memory card.

During any break in shooting, clean equipment thoroughly, and take extra care when cleaning the glass element of the lens. Use a blower brush to remove particles of sand or salt before wiping the lens surface with a cleaning cloth.

Coastal regions can provide the wildlife photographer with myriad subjects, and a kaleidoscope of colors. Sea birds, such as this puffin, heading back to the nest with a bill full of sand eels, are an obvious subject. Nikon F90X, 300mm lens with 2x converter (600mm), 1/500 sec. @ f/5.6, Fuji Velvia.

Tip!

Pooling around

As well as the obvious coastal subjects, such as sea birds and seals, take a walk along the beach and check out the rock pools that form microcosms of our seas and oceans. Take your time and you'll find loads of subjects just waiting for your camera to snap them. For best results, use a polarizing filter to remove unwanted reflections from the water's surface.

The polar regions

Wildlife photographers reserve a special affinity for the North and South Poles, which are considered to be the last true wilderness areas. During the short summer (the only practical time for photography), the ice caps at both poles melt slightly, forcing animals out to the coast and peninsulas. Few animals can survive in the desperately harsh conditions that exist here, but those that do are hugely photogenic: polar bears and arctic foxes in the north, and penguins and Antarctic seals in the south.

The extreme conditions in the polar regions cause havoc with camera equipment. Professional-specification gear is essential to cope with the wide variances in temperature, and even this must be prepared with expert knowledge if it is to last the entire shoot. To ensure lubricants won't freeze, causing problems with focussing, the manufacturer's own technicians should service lenses. Below -20°C (-4° F,) zoom lenses should be avoided as they contain more of this lubricant than prime lenses, and so are more liable to failure. High-end electronic cameras should be fitted with lithium-type AA batteries, which are more resistant to cold than other types. Alternatively, the camera can be powered via a cable attached to a power pack kept within your clothing. For real extremes, below -30°C (-22°F), a mechanical camera properly prepared is a better option.

Be careful when transferring the camera between (relatively) warm indoor locations (tents or igloos) and the cold outdoors. Ideally, you should allow the temperature of the two environments to equilibrate before exposing equipment, otherwise frost will form quickly. Outside, your breath will also cause frost to form, and your skin can adhere quickly to cold metal parts, which is an unpleasant experience.

Film also suffers in this environment. Frozen film becomes brittle and breaks easily, and is sharp enough to gouge a clean cut in flesh.

Often, in very cold climates, manual cameras will continue to work long after more sophisticated electronic models have given up.

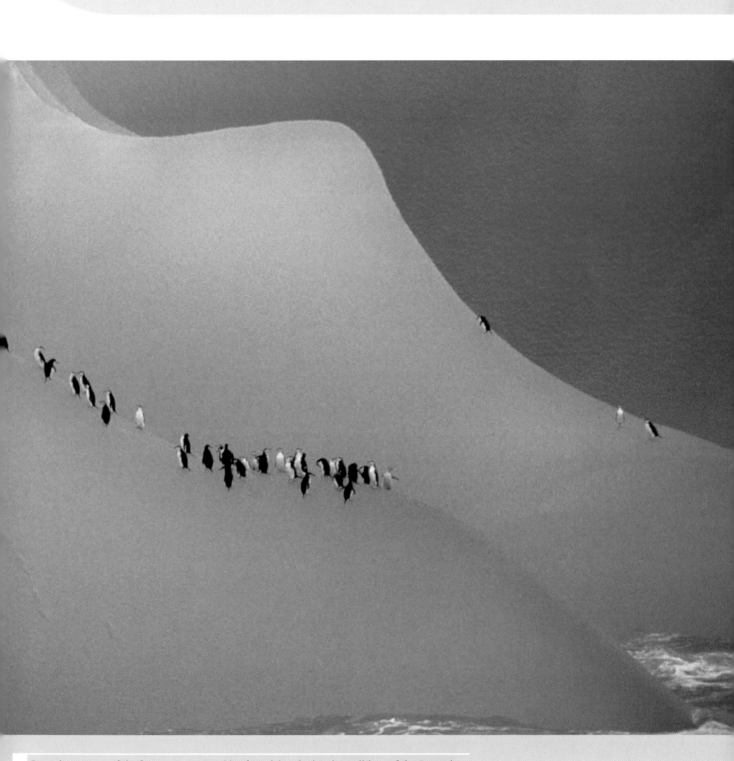

Penguins are one of the few creatures capable of surviving the harsh conditions of the Antarctic. Only accessible for a very short period during the brief summer season, the Antarctic and Arctic regions are considered a Mecca by wildlife photographers in search pf pristine wilderness.

Processing film

While it is possible to process your own film, given modern processing techniques most photographers find it is often quicker and less expensive to use an external laboratory to do it for them. I would advise building up a rapport with a local, professional lab. The better they get to know you and your work, the better the results are likely to be.

Viewing slides

To view your slides, use a quality light box and a precision loupe. The light box should be fitted with the correct light tubes (5000K daylight color-corrected,) and be manufactured to produce the industry standard level of light intensity. Boxes come in varying sizes, from quite small (about the size of a sheet of Letter/A4 paper), to immense tables several feet long. While the latter may be overkill, if you're serious about your photography and don't see yourself switching to digital capture in the near furture, then I'd recommend opting for a larger model to allow yourself plenty of working space.

A loupe is the tool used for inspecting slides. Again, there are various models available to suit all budgets. As with most things photographic, buy the best quality you can afford. Most picture editors use a 4x magnification loupe, so what's good enough for them should be good enough for you, although higher magnification models are available. Make sure you select one that allows you to focus the optics for your eyesight for best results.

Editing your images

One of the hardest things you'll ever do as a wildlife photographer is edit your own images. For the photographer, each image is personal, and editing is a subjective task. For a picture editor, on the other hand, who cares nothing for the lengths you traveled or the hardships you endured to capture a particular shot, the editing process is purely objective—the image either makes the mark, or it doesn't. It's a simple as that.

The first edit should be a technical one. Is the image sharp and well-exposed? Are the colors vibrant (unless you were aiming for the subdued, pastel look?) Beyond technical considerations, images can earn marks for artistic merit. Study the composition. Is the subject too close to the edge of the frame, or does the scene have too much clutter that detracts from the visual presence of the image? Creativity is also a key element in the success of an image. There are quite literally millions of wildlife images on the market today—how does your picture differ from the competition?

Any images that don't make the grade should be discarded from your library, but don't abandon them completely. The best way to improve your photography is to learn from your own work. Look at each image and consider how you might have taken the shot differently to improve it.

To keep track of all my images, I use a computer-based asset-management system based around the software application Portfolio by a company called Extensis.

Asset management

Asset management is the fancy term for how your store and retrieve your images. This may be as simple as a manual card file that works in conjunction with your filing cabinets. However, in the digital age, for professional photographers, this usually means a computer-driven system.

There are a number of packages available on the market for managing and filing electronic images and, since everyone will have their own preferences, I'm going to avoid recommending any specific application. However, I will illustrate how I currently manage my own image library (see opposite).

 Tip!

With the exception of Kodak Kodachrome film, color film processes are less stable than black-and-white ones, and the average life span of an E6 transparency or color negative is only about 20 years. How you store your film can have a significant affect on the longevity of the image.

Film should be stored in a cool, dry environment. Avoid using wooden cabinets made of particle board as the glues used in the manufacture can be harmful to emulsion. Ideally, place transparencies in plastic, glassless mounts in archival transparent pages, and hang them in a metal filing cabinet.

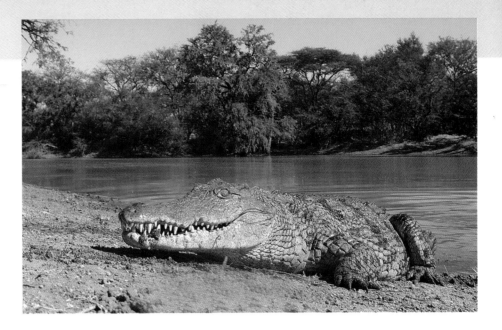

This image of a wild crocodile was photographed with the camera operated remotely from a Mac laptop. The digital file was recorded directly onto the Mac's HDD. Nikon D2H, 24–120mm VR lens set at 24mm, 1/320 sec. @ f/8.

The digital workflow

1. Once I've taken a series of images, I'll download them direct from the camera (or from an external disk if I have saved them in the field) to my Apple Mac. All the files are saved to my Master (RAW) Folder held on an external hard-disk drive (HDD) that is connected via FireWire to the Mac.

2. Once the files are on the hard drive, I review the RAW images in the Nikon Capture 4 program. I store any imperfect images in the dustbin. With the "keep", files I make any minor adjustments to shooting parameters then save them as 16-bit TIFF files in my Master (TIFF) Folder, also on the external HDD.

3. Once I have a TIFF file, I will then finish any processing using Adobe Photoshop. I am no expert in Photoshop and my processing is limited to adjusting Levels and Saturation, removing blemishes caused by specks of dirt and dust, and cropping. (See page 164).

4. If the image is to be placed with my agency, then I will resize it using Genuine Fractals to create an image file of about 50MB. This is a stipulation of my particular agency, and is by no means an industry standard. Any other files will only be resized at the specific request of a client.

5. Having completed processing and resizing, I then overwrite the TIFF file in the Master (TIFF) Folder.

6. When I want to review or sort the final images I use Extensis Portfolio, which is specially designed for managing digital photographic files. I also use this application to append image titles, keywords, and captions.

7. The final stage in the process is to back up the HDD to DVD.

When working in the field, I download all my images to a laptop computer and back up the files to a portable storage device.

> **Tip!**
>
> Digital images should be stored on an external hard-disk drive, connected to your computer via FireWire or USB2 cable, and backed up to CD-Rom, DVD, or tape. The advantage of storing digital files in this way is that they are protected from soft media becoming obsolete. Also, if you decide to change your computer, you can simply plug the external drive into the new machine without any need for file transfers or disruption to workflow. An image-cataloguing software program will make retrieving images from the hard drive quick and simple.

My digital darkroom

1. Apple Macintosh Computer
 (G4 processor, 512mb RAM)

2. Internal HDD running Nikon Capture 4, Adobe Photoshop, Genuine Fractals, and Extensis Portfolio

3. External HDD connected via FireWire

4. External DVD-RW drive connected via FireWire

5. Film Scanner connected via USB 2

6. Flatbed Scanner connected via USB

7. Color printer 11 x 17 in. (A3) capability connected via USB 2

Basic image-processing techniques

As I mentioned earlier, I am not an expert in using image-processing software, and I'm certain there are far more capabilities to this software than I'm aware of. Although this book concentrates on the in-camera elements of creating great images, a little knowledge of post-camera processing can go a long way.

There are numerous image-processing programs on the market, but I'm going to talk about Adobe Photoshop because it is the industry-leader and the one I use myself.

Adjusting contrast
I use Levels to ensure the image has a full tonal range, from pure black to pure white. This process is known as re-mapping.

To make adjustments in levels, first open up the Levels dialog box by going to the Image menu and selecting Adjustments then Levels.

Film Scanner

Printer

Flatbed Scanner

DVD Writer

External Hard Drive

Software

This illustration shows the equipment that makes up my current digital darkroom. Although computer technology is changing all the time, equipment needn't be upgraded regularly if you plan ahead and design a system that will meet both your current and future needs.

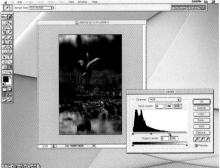

This series of three images shows the process of re-mapping using the Levels function in Adobe Photoshop.

Image re-mapping

To adjust the highlights, drag the white slider (the one on the right) until it corresponds with the point of the histogram where the graph begins to rise (right of center). As you do so, you will see the image brighten. You can then adjust the shadows by dragging the black slider (the one on the left) until it corresponds with the rising point of the histogram to the left of center. Note that the image darkens.

This process effectively sets the darkest area of the picture to black and the brightest part to white, thereby increasing the tonal range.

You can also alter the level of the mid-tones without dramatically affecting the highlights and shadows by using the gray slider (the one in the middle). This will alter the overall contrast of the image, and is worth experimenting with until you find the desired effect.

Using the eyedroppers in Levels

Rather than using the sliders to map the variances in tone and contrast, you can use the black, white, and gray eyedropper tools instead.

First, open up the Levels dialogue box as described before. Then, click on the black eyedropper (the one on the left). You'll notice the cursor changes to an eye dropper symbol. Click on the area of the image that you want to correspond to pure black (the image will darken). Next, select the white eyedropper (the one on the right), and click on the area of the image that you want to correspond to pure white. Once again, you'll notice that the image brightens, but that the overall result is more vibrant. Finally, you need to set the mid-tone point, particularly if you notice an overwhelming color cast. You set the mid-tone point by selecting the gray eyedropper (the middle one), and clicking on an area of the image that should be a middle-tone color.

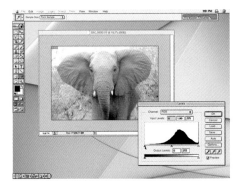

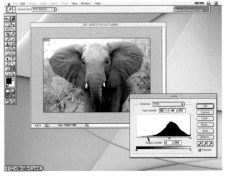

An alternative to using the slider bar to re-map tones is to use the eyedropper tools. This is a far more selective approach.

Tip!

When using the eye dropper tools, enlarge the picture to a size where you can select individual pixels easily. This will increase the accuracy of the re-mapping process.

Tip!

When using the white eye dropper, avoid selecting reflected highlights, such as the reflections from water, as they hold no detail and will produce an inaccurate white point.

Adjusting color saturation

I have found that digital images straight from the camera often lack the vibrancy of color visible in the original scene. Whereas in film photography you can switch to a more saturated film, such as Fuji Velvia or Kodak VS, you have fewer options with a digital camera. Therefore, saturation must be adjusted post-camera rather than in-camera. You can make slightly flat pictures more colorful by adjusting the level of saturation by about 15–20. Go to the Image menu and select Adjustments then Hue/Saturation.

To increase colour saturation, use the Hue/Saturation function. Be careful not to overdo it, however, as too much saturation can lead to unnatural-looking images.

Removing dirt and dust marks

DPSs are prone to dirt and dust that accumulate on the low pass filter in front of the sensor. They appear as large dark splodges on your pictures, and can ruin an otherwise excellent image. It's possible to remove marks using the Cloning tool.

First, enlarge the image using the Zoom tool until you can see the marks clearly. Click on the Rubber Stamp (Clone) icon and select a size large enough to cover the mark, if possible, and a style of tool.

From experience, I advise using one of the hard-edged options.

Then select an area of the image to clone from, usually adjacent to the mark, by pressing the Alt key (the cursor becomes a Rubber Stamp symbol when you do this), and click the mouse simultaneously. Position the reference circle over the dust mark and click. You'll notice that the dust mark disappears, with each original pixel value being replaced with the value of the cloned pixels.

Tip!

Cloning areas with high detail
Cloning areas of single tone is relatively simple, but using the Clone tool effectively on areas that contain detail is more complicated. To make the job easier, enlarge the image until you can distinguish individual pixels, and clone one pixel at a time. This is very time-consuming, and is one reason I keep my DPS free from dirt and dust with regular cleaning.

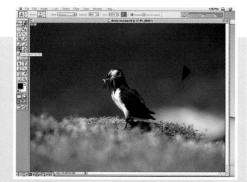

Here, I removed dust marks and scratches by using the Clone tool.

It's sometimes impossible to get the perfect composition in-camera. Using the Crop tool can help to tighten up the image space, and create a more aesthetic photograph.

Cropping for better composition

You can change the story your pictures tell by altering the picture composition using the Crop tool. Cropping can also be used to remove distracting background features, or to simply "tighten up" the image space.

To crop an image, select the Crop tool, click the mouse on your picture, and drag the cursor to enclose the area you want to keep. When you've finished, the area outside the boundary lines darkens.

Once you've selected the area to crop around, adjust the parameters of the crop to the precise size using the top, bottom, and side points. When you're happy with the new composition, action the crop by going to the Image menu and selecting Crop, pressing the tick button on the toolbar, or simply pressing the Return key.

Tip!

Cropping an image deletes pixels and, if you crop too much, you may reduce the quality of the image to below an acceptable level. To avoid this, increase the size of the image before cropping to make up for the loss of pixels.

Self-assignments

Self-assignments can be a source of inspiration and motivation to any wildlife photographer, professional or amateur. They are also a useful means of adding to your library of stock images and, if good enough, can lead to publication.

1. Start out by creating a theme for your project, based around a particular species, behavior, habitat, or photographic technique. "How animals fly" and "A year in the life of a wolf pack," for instance, are two themes that will give your assignment a structure that you can work and plan around.

2. Make your theme motivational. A well-defined assignment should push the boundaries of your knowledge of either the subject or of a particular camera or photographic technique.

3. Once you have established your theme, research your subject thoroughly. Use the techniques described in this book to identify the best location and time of year for photography, how to approach the subject, and any behavioral patterns to look out for.

4. Hone your photographic skills, particularly if your assignment means using equipment or techniques you are unfamiliar with. If you need to use expensive equipment that you don't own, consider hiring it rather than purchasing it.

5. Book some time off work, or agree on some time away from your family, and organize your shooting days in advance. Make a Plan A then a Plan B to cover contingencies, such as inclement weather.

6. Before you go out in the field, visualize some of the images you want to make, and think through the photographic process to achieve them.

7. Once in the field, as well as taking standard shots, experiment with different techniques and ideas. For example, use slow shutter speeds when photographing fast-moving animals (see page 56), or try combining artificial and ambient light (see page 92). Experimental photography has a fairly low success rate, but the few images that make the grade are worth the effort, and it's a great way of expanding and improving your camera skills.

8. Keep a list of the images you need to complete your assignment, and tick them off as you make them.

9. Once you have processed the images, edit them (see page 162), and put them in order. Like a good story, your assignment should have a beginning, middle, and an end. Try thinking of each picture as a paragraph in a story you're trying to tell.

10. Once you've completed your assignment, consider sending it to a magazine with an outline of the project. If the work is good enough, they may be interested in publishing it.

Self-assignments are an excellent source of inspiration. A few years ago I decided to embark on a project focussing on the wetlands of the Okefenokee National Wildlife Refuge in Georgia, USA. The project resulted in several articles being published, including this one in the Wildfowl & Wetlands Trust members' magazine.

In the land of the trembling earth

In the far south of the North American state of Georgia lies one of the continent's most fascinating natural areas – the **Great Okefenokee Swamp**. For over fifty years part of this rare and beautiful wetland has been preserved as a National Wildlife Refuge. Natural history photographer **Chris Weston** uncovers the seasons in this 'land of trembling earth'.

The Okefenokee is a vast bog lying inside a saucer-shaped depression that was once part of the ocean floor. Its name derives from a European interpretation of the American Indian words meaning 'land of the trembling earth'. Peat deposits up to fifteen feet thick cover much of the swamp floor and are so unstable in places that one can cause trees and bushes to tremble by stamping on the surface. The decaying vegetation has another unusual effect on the swamp: the slow-moving waters of the Okefenokee are tea-coloured due to the high levels of tannic acid.

For over thirty-five years, after the last of the American Indian tribes had been driven from its refuge, the Okefenokee suffered at the hands of developers. First came the Suwannee Canal Company which, in 1891, purchased most of the swamp from the state of Georgia. Their intent was to drain the land for logging and to grow crops. They spent three years digging the Suwannee Canal eleven and a half miles into the swamp before realising that, far from draining the land, they were letting more water in than out. The company went bankrupt and the land was sold to the Hebard Cypress Company in 1899. Twenty-eight years of logging followed, until, by 1927, nearly half a billion board feet of timber had been removed and the Okefenokee lay bare of trees.

Relief came in 1937 with the establishment of the Okefenokee National Wildlife Refuge through the efforts of the Okefenokee Preservation Society. The aim was to restore and preserve the swamp for wildlife. Their efforts have been well rewarded. Today, under the administration of the US Fish & Wildlife Service, nearly 400,000 acres of the swamp are protected and the refuge is home to an abundance of flora and fauna, including 234 species of birds and over 12,000 alligators.

The swamp is far from being one continuous habitat. Islands, lakes, cypress forests, areas of scrub and shrubs, and open wet prairies form a mosaic of habitats in which wildlife thrives. Lakes and prairies are created after long droughts when fire burns out vegetation and the uppermost layers of peat. At times, to maintain habitats for wildlife populations, refuge staff and volunteers use fire as a management tool, carrying out prescribed burns.

Islands, lakes, cypress forests, areas of scrub and shrubs, and open, wet 'prairies' form a mosaic of habitats in which wildlife thrives

Other work is undertaken to preserve the natural qualities of the swamp, providing habitats for wildlife and recreational opportunities for visitors. Research goes on into everything from bacteria to Black Bears, by means of population censuses or surveys of vegetation and water levels. Forests are regenerated and thinned to help create openings, always with an emphasis on management of endangered species, such as Red-cockaded Woodpecker, Indigo Snake and other inhabitants of the long-leaf pine community.

The Okefenokee year begins in spring. March sees the overwintering Ducks, Tree Swallows, robins, flycatchers, Greater Sandhill Cranes and Cedar Waxwings depart for northern nesting grounds, as martins, warblers and kingfishers arrive. In the prairies the resident Lesser Sandhill Cranes begin their courtship rituals and wildflowers begin to bloom, including the Golden Club, otherwise known as the 'Neverwet' because of its water-repelling properties, and bladderworts. By April, Great Blue Heron, White Ibis and Great and Snowy Egret colonies are active and Sandhill Crane chicks are beginning to hatch. High up in bulky nests ospreys are feeding their young.

April also sees the beginning of the mating season for the alligators. Territorial warnings and the distinctive bellowing calls of mating males fill the air. The quiet, slow-moving waters of the Okefenokee are a perfect environment for courtship and mating, and the reason why this ancient and magnificent reptile has thrived here. Once listed as 'endangered', the American Alligator's status has been downgraded to 'threatened', a result that is one of the success stories of the conservation work going on in the refuge.

One of Okefenokee's more unusual plants now comes into bloom. The insect-eating Pitcher Plant lures its prey into a sticky trap at the bottom of a pitcher-shaped leaf. The plant is very sensitive to disturbances in its environment and commercial exploitation of the species is now regulated in the state of Georgia.

In May, Florida Soft-shell Turtles are busy laying eggs, while Raccoons are just

*Opposite: **Okefenokee wetlands**. Top: **A Great Blue Heron** performs a courtship dance. Bottom: **Lurking in the margins** — an alligator keeps watch. All photographs by Chris Weston.*

as readily digging them up to eat. In the forests and woodlands Red-cockaded Woodpeckers start their nesting season. Here, too, the result of another environmental success story emerges. In the early 20th century, unrestrained hunting of Virginia Deer nearly drove this graceful animal to extinction. Thanks to restocking programmes and new hunting regulations, the deer have returned in great numbers.

By summer, as young herons and egrets leave their nests to join their parents by the water's edge, new sounds now fill the natural amphitheatre. Several species of frog can be heard croaking during the evenings and, in August, young alligators are clacking for their mothers. Out on the water, White Water-lilies and Sweet Bay flowers are in bloom.

The climate of the Okefenokee is less affected by seasonal variations than other parts of the United States, but by autumn the traditional autumn colours become prevalent. Cypress needles turn golden brown and Sweetgum leaves glow with a reddish hue. Autumn migration now begins with many warblers moving through the swamp, as well as the occasional Bald Eagle. American Robins and Greater Sandhill Cranes start arriving for the coming winter.

Into winter and the alligators are less active and cease feeding, encouraging River Otters out into the lakes and boat trails. This playful mammal has found refuge from its main predator, man, in the sanctuary of the Okefenokee. Elsewhere in North America, as the owner of one of the most valuable pelts in the animal world, the otter has been less fortunate and is now a rare sight.

Waterfowl and waders are now commonplace in the prairies. Ring-necked Ducks, Wood Ducks, American Coots, Green-winged Teal, Hooded Mergansers and large numbers of cranes, ibises, egrets and herons feed in the shallow water margins. As winter progresses, ospreys once again start to nest, their aerial courtship displays, together with those of Red-tailed Hawks, embroidering the skies above the swamp. Another year has come full circle in the rich swampland of the Okefenokee.

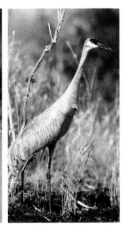

The conservation work undertaken to restore and maintain the Okefenokee refuge's wetlands has created one of the most beautiful and well-preserved freshwater areas in North America. However, titanium-bearing ore deposits in land close to the Okefenokee Swamp have attracted mining interests and come as a reminder that such places are under constant threat from the human need to develop natural resources. Mining activities close to the swamp may have geological consequences harmful to the integrity of the water table. Local conservationists, having temporarily halted an application to extract the ore, will face further battles to ensure that the Okefenokee Swamp and its spectacular wetland wildlife will survive for future generations to enjoy.

*Opposite top: **A turtle makes its wary way out of the water**. Opposite middle: **A River Otter** peeps out from among the lily-pads. Opposite bottom: **Black Vultures** observe the goings-on from their swampland perch. Top left: **White Ibis**. Top right: **An elegant Sandhill Crane** stalks in the tall grass of Okefenokee Swamp. All photographs by Chris Weston.*

Okefenokee National Wildlife Refuge lies on the border of Georgia and Florida in southern USA. The refuge has three access points and facilities include a visitor centre, museum, lectures, guided boat tours, boat hire, boardwalks and a viewing tower. A guide service is available and a five-day pass for the refuge costs $5. The refuge also offers accommodation in furnished cabins and has a camping ground. Further information can be obtained from the Refuge Manager, US Fish & Wildlife Service, Okefenokee National Wildlife Refuge, Route 2, Box 3330, Folkston, GA 31537, USA.

Glossary

Aberration
In optics, a defect in the image caused by a failure of a lens system to form a perfect image.

Aperture
The hole in the lens that allows light to pass through and expose on the film/DPS when the shutter is open. The hole is variable in size, which is measured in f-stops.

Back up
To make and store second or further copies of computer files to protect against loss, corruption, or damage of the originals.

Bracketing
Taking a series of different exposures of a single scene. This is especially useful in a difficult metering situation. Some cameras can do this automatically for you.

Brightness
1 A quality of visual perception that varies with the amount, or intensity, of light that a given element appears to send out.
2 The brilliance of a color, related to hue or color saturation—for example, bright pink as opposed to pale pink.

Buffer
A memory component in an output device, such as a digital camera, that temporarily stores data, which it then feeds to the device at a rate allowing the data to be turned into, for example, an image.

Camera shake
Where the camera hasn't been held steady during the exposure, causing the image to streak or look out of focus.

Catch light
A small highlight.

Color temperature
The measure of color quality of a source of light, expressed in degrees Kelvin.

Color cast
A tint or hint of a color that evenly covers an image.

Contrast
Of ambient light: the brightness range found in a scene. In other words, the difference between the highest and lowest luminance values.

Crop
1 To use part of an image for the purpose of, for example, improving composition or fitting an image to the available space.
2 To restrict a scan to the required part of an image.

Density
The measure of darkness, blackening, or "strength" of an image in terms of its ability to stop light. Its opacity.

Depth
1 The sharpness of an image—loosely synonymous with depth of field.
2 A subjective assessment of the richness of the black areas of an image.

Depth of field
The measure of the zone or distance over which any object in front of a lens will appear acceptably sharp. It lies both in front of and behind the plane of best focus, and is affected by three factors: lens aperture, lens focal length, and image magnification.

DPS
Digital photo sensor. An electronic imaging sensor in a digital camera that takes the place of film.

EV
Exposure Value. A measure of camera exposure. For any given EV, there is a combination of shutter and aperture settings that gives the same exposure.

Exposure
The total amount of the light reaching the light-sensitive film in a conventional camera, or the sensor in a digital camera. It is determined by the effective aperture of the lens and the duration of the exposure to the light.

f-stops
Settings of the lens diaphragm that determine the amount of light transmitted by a lens. Each f-stop is equal to the focal length of the lens divided by the diameter of the entrance pupil.

Fill-in
1 To illuminate shadows cast by the main light by using another light source or reflector to bounce light from the main source into the shadows.
2 A light used to brighten or illuminate shadows cast by the main light.

Filter
An optical accessory used to remove a certain waveband of light and transmit others.

FireWire
The standard providing for rapid communication between computers and devices, such as digital cameras.

Flash
1 To provide illumination using a very brief burst of light.
2 The equipment used to provide a brief burst, or flash, of light.

Focal length
For a simple lens, the distance between the center of the lens and the sharp image of an object at infinity projected by it.

Focus
1 Making an image look sharp by bringing the film or projection plane into coincidence with the focal plane of an optical system.
2 The rear principal focal point.
3 The point or area on which, for example, a viewer's attention is fixed, or compositional elements visually converge.

Format
1 The shape and dimensions of an image as defined by the shape and dimensions of the film gate of the camera in use.
2 The orientation of an image. For example, in landscape format the image is oriented with its long axis running horizontally, while in portrait format the image has its long axis running vertically.

Frame
1 A screen's worth of information.
2 An image in a sequence replicating movement.

Grayscale
The measure of the number of distinct steps between black and white that can be recorded or reproduced by a system. A grayscale of two steps permits the recording or reproduction of just black or white. For normal reproduction, a grayscale of at least 256 steps, including black and white, is required.

Histogram
A statistical, graphical representation showing the relative numbers of variables over a range of values.

Kelvin
A unit of temperature that is relative to absolute zero, used to express color temperature.

Light box
A viewing device for transparencies and films.

Macro
1 The close-up range giving reproduction values of between 1:10 to 1:1.

Noise
Unwanted signals or disturbances in a system that tend to reduce the amount of information being recorded or transmitted.

Pixel
The smallest unit of digital imaging used or produced by a given device.

Push (see Up-rating)

RAM
Random Access Memory. The component of a computer in which information can be temporarily stored and randomly accessed.

Resizing
Changing the resolution or file size of an image.

SLR
Single Lens Reflex. A camera, usually with interchangeable lenses, where you can look through the lens, giving you the most accurate focal and framing control.

Shutter
The mechanism that controls the length of time that light is allowed to expose on a film/DPS.

TIFF
Tag Image File Format. A widely used image file format that supports up to 24-bit color per pixel.

TTL
Through The Lens. Refers to metering off the light that passes through the lens.

Up-rating
To rate a film at higher speed than the manufacturer's recommendation.

USB
Universal Serial Bus. A standard for connecting peripheral devices, such as a digital camera, to a computer.

Index

Acknowledgements

Without wishing to sound like I've just received an Oscar, there are several people that deserve thanks for their contributions to this book.

My sincere thanks to my fellow photographers, Jim Brandenburg, Art Wolfe, and Paul Harcourt Davies, for giving your time and sharing your wisdom so fully and so freely. It has been both an honour and a delight to work with you on this project.

Special thanks to Heidi Brandenburg-Ross at Brandenburg Gallery/Ravenwood Studios, and to Christine Eckhoff at Art Wolfe, Inc.

I am also greatly indebted to the following friends: Chris "Bearman" Morgan, Stu "Don't tell the Missus" Porter and Justyna "The Missus" Porter, Riann de Villiers, Ann and John Porter, Phil, Maggie, and Emma Gooden, and Peter James.

My gratitude to Jane Nicholson at Intro2020 for her continued support of my photography, and to Kevin Wheatley at Wildlife Watching Supplies in the UK. Also to April Sankey, Luke Herriott, Kylie Johnston, Theresa Brooks, and the rest of the team at RotoVision for giving me the opportunity of producing this title and for working so tirelessly on its completion.

And finally, to those that get left behind while I gallivant around the globe: Fraser Lyness for keeping the office going and my library intact; and to Claire and Josh, without whom nothing would make any sense.

Further reading

Attenborough, David *The Life of Mammals*. Princeton University Press, 2002

Benyus, Janine M.*The Secret Language and Remarkable Behavior of Animals*. Black Dog & Leventhal, 1998

Breiter, Matthias *The Bears of Katmai*. Graphic Arts Center Publishing Company, 2001

Brandenburg, Jim *Chased by the Light*. Northwood Press, 2001

Brandenburg, Jim *Sand and Fog*. Sagebrush Bound, 1999

Burian, Peter & Caputo, Bob *The National Geographic Photography Field Guide*. National Geographic, 2003

Craighead, Frank C. *For Everything There is a Season*. Falcon, 2001

Estes, Richard D. *The Safari Companion*. Chelsea Green Publishing Company, 1999

Halfpenny, David *Yellowstone Wolves in the Wild*. Riverbend, 2003

Harcourt Davies, Paul *The Complete Guide to Close-up and Macro Photography*. David & Charles Publishers, 2002

Harcourt Davies, Paul *The Complete Guide to Outdoor Photography*. David & Charles Publishers, 2002

MacDonald, David (Ed.) *The New Encyclopaedia of Mammals*. Oxford University Press, 2001

Mari, Carlo & Croze, Harvey *The Great Migration*. HarperTrophy, 1995

Mari, Carlo & Collar, Nigel *Pink Africa*. Harvill Press, 2000

Mitchell, John G. *National Geographic—The Wildlife Photographs*. National Geographic, 2001

Mowat, Farley *Never Cry Wolf*. Harcourt School Pub., 1999

Thapar, Valmik *Land of the Tiger*. University of California Press, 1998

Wolfe, Art *Africa*. Wildlands Press, 2001

Wolfe, Art *The Art of Photographing Nature*. Three Rivers Press, 1993

Wolfe, Art *The Living Wild*. Wildlands Press, 2000

Wolfe, Art *Migrations*. Beyond Words Publishing, 1994